PICTORIAL EFFECT

IN

PHOTOGRAPHY

PICTORIAL EFFECT

IN

PHOTOGRAPHY

BEING

HINTS ON COMPOSITION
AND CHIAROSCURO FOR PHOTOGRAPHERS

BY

HENRY PEACH ROBINSON

WITH A NEW INTRODUCTION

By Robert A. Sobieszek

[1869]

HELIOS

PAWLET

1971

First Edition 1869

London: Piper & Carter, 15 & 16, Gough Square,
Fleet Street; Marion & Co., 22 & 23, Soho Square

Reprinted 1971 by

H E L I O S

Pawlet Vermont 05761

I S B N 0 879 31002 2
L C N 76-164013

Printed in U.S.A. by
NOBLE OFFSET PRINTERS, INC.
NEW YORK 3, N. Y.

INTRODUCTION

Henry Peach Robinson was perhaps the most influential voice in nineteenth century photography. No other photographer so consistently produced major works of art, was bestowed with so many commendations and medals, and was so much a proselytizer of a coherent theory of photographic art. During the last decade of his career, he was presented with numberless tokens of honor and praise: "... so far as art can be taught, Mr. Robinson has taught us."[1] Or: "In England and on the continent, for nearly half a century (1857 to 1900) no single influence has been greater than his in shaping the progress of pictorial work. ..."[2] While much in his pictorial work may not be congruent with more modern tastes, his pictures do represent the sensibilities of the public and many of the aspirations of the Victorian photographer. Even more important than his pictures, however, Robinson's writings stand as the first complete photographic art theory in the English language.

Robinson's life overlaps by some years both the very beginning of photography with Daguerre and Talbot and the commencement of Alfred Stieglitz' modernizing activities in the medium. He was born July 9, 1830 in Ludlow, a small town in Shropshire, England, where at one time both John Milton and Samuel Butler resided. As a youth he published articles and sketches in the *Journal of the Archaeological Society* and in the *Illustrated London News*. Having studied art, he had one painting accepted by the Royal Academy for exhibition in 1852, the only one of his career.[3] It was in the same year that he was introduced to photography, and five years later that he

[1] Andrew Pringle, "Mr. H. P. Robinson." *Sun Artists*, no. 2 (January 1890), p. 12.

[2] Thos. Harrison Cummings, "H. P. Robinson." *Photo Era*, vol. VII, no. 1 (July 1901), p. 1.

[3] Royal Academy Exhibition, 1852, item 250: *On the Teine near Ludlow*. See: Algernon Graves, *The Royal Academy of Arts*, London, 1906, vol. 6, p. 337.

opened his photography studio in Leamington.

Robinson's reputation and partially his success came from the exhibition of his "combination" photograph, *Fading Away*, in 1858. The technique of using more than a single negative to piece together an homogeneous print which was to become his hallmark, in addition to the presentation of a scene showing a young girl on her deathbed, were sufficient to give his name an amount of public currency. That the picture was a *tour de force* of composition, chiaroscuro and expressive sentiment, and was followed by a successive series of no lesser achievements made him one of the most popular and respected picture-makers of the century.

During the 1870's, he was elected to the Council of the Royal Photographic Society, of which he was made Vice President in 1887. In 1892, he along with several other members seceded from the Society and formed one of the most important of the Pictorialist societies, the Linked Ring. Robinson severed himself from this organization by the end of the decade, and in 1900 was again in the Royal as Honorary Fellow. One year later, on February 21, 1901, he died at Tunbridge Wells where he had maintained his home and studio since the 1860's.

Throughout his long career, Robinson had published eleven volumes on photography and numerous articles in both American and British journals. Many of his books went through various editions and revisions over the years; at least two were translated into French and another two into French and German. His writings were particularly instrumental in crystallizing the aesthetic formulations of such *fin-de-siècle* Pictorialists as Robert Demachy and Commandant Puyo in France, Heinrich Kuehn in Austria and Clarence White in America. Yet it was his first published book, *Pictorial Effect in Photography*, that was not only the most republished of his works, but also the most seminal and complete.[4]

Pictorial Effect in Photography is in the tradition of Renaissance and Post-Renaissance treatises on art, such as Du Fresnoy's *Art of Painting*, Reynold's *Discourse on Art* and Burnet's *Treatise on Painting*. In fact, ideas and citations from these three authors and others abound in Robinson's work. Neither manuals of operations and techniques nor disinterested studies in aesthetics, all of these works remain immediately practical in the sense that practicing artists wrote them to be useful. They are also theoretical to

[4] British editions: 1869, '79, '81, '93; American: 1881, '92; French: 1885; German: 1886.

the point of considering the nature of the art, its meaning and the limitations of its expressive effect. This sort of work was not unprecedented in the young art of photography. Two other photographers had produced art treatises of comparible size: Disdéri's *L'art de la photographie* of 1862 and Marcus A. Root's *The Camera and the Pencil* of 1864. But whereas these latter two books concentrated almost exclusively upon portraiture Robinson's was directed to the distinct problems of landscapes and of figures in landscapes. Only after these are discussed does he consider the portrait at any length. In short, Robinson's comprehensiveness superseded the earlier works as a general textbook for photographers for at least twenty years. The book's publication record succinctly demonstrates the popularity and importance of its ideas.

The guidelines established in *Pictorial Effect in Photography* were based directly on the standard art education system of the Royal Academy, where art was taught by "those broad principles without regard to which imitation, however minute or however faithful, is not picturesque, and does not rise to the dignity of art." (p. 10) Robinson continually emphasizes the need for the photographer to be an educated, cultivated individual, to study his art and diligently apply himself to the acquisition of its principles. The principles of photographic art are much the same for Robinson as those of traditional mid-nineteenth century painting; oneness of purpose, story and thought; the unity line, light and shade; a subordination of extraneous details to the general truthfulness of the picture; and a fitness and appropriateness of all elements to the overall scheme. The basic rules of order and composition that held in painting had to be applied to the photograph if the operator wished to achieve art. This did not mean that the two media were alike; on the contrary, Robinson saw that the camera did have certain limitations. Unlike, say, the best of Turner's paintings the photograph could never reach the level of an awe-inspiring sublimity. It could not represent colors nor any flights of the fanciful, and without rigid control it was much too facile in delineating minute details. The most aesthetically proper mode for photographic art was clearly apparent to Robinson: the picturesque that is found in narrative genre and pastoral landscapes. For it was in the camera that the picturesque had "never had so perfect an interpreter." (p. 15)

Artistic expression in picturesque photography was still difficult to attain; technical limitations greatly hindered the photographer's ability to select and arrange the parts of his picture in a pleasing fashion. There was, how-

ever, a means of overcoming some of these limitations, a method that is one of Robinson's most significant contributions: "combination printing." By using this technique of combining various negatives to make one print the picture-maker could print in well exposed skyscapes, arrange figures in various natural landscapes or even position large groups of figures in more exacting compositions. Essentially a type of photomontage, combination printing allowed "much greater liberty to the photographer and much greater facilities for representing the truth of nature." (p. 198) The additional chapter on combination printing that was published with the first edition of *Pictorial Effect in Photography* remains as the best description of this technique's use in the nineteenth century.

The advent of more sophisticated equipment and films and the general acceptance of a doctrine of unadulterated, unmanipulated photography placed Robinson in the ignored and forgotten past during most of the present century. Approximately one hundred years after *Pictorial Effect in Photography* first was published, photographers, emancipated from the rigidity of "straight" photography, are again investigating many of his ideas and techniques—most notably those pertaining to sentiment, narrative story telling and combination printing. But even more universally, when Robinson tells us that he wishes "to show that it is the photographer's business to *see* . . .," (p. 18) he is talking about the most vital concern of any photographer whose pictures are something more than mere documents.

ROBERT A. SOBIESZEK

Eastman House
Rochester, New York
August 1971

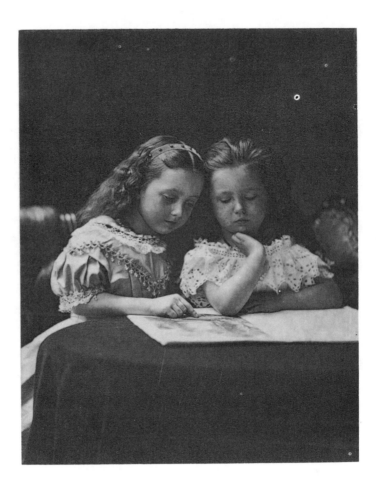

PICTORIAL EFFECT

IN

PHOTOGRAPHY:

BEING

HINTS ON COMPOSITION AND CHIAROSCURO FOR PHOTOGRAPHERS.

TO WHICH IS ADDED A CHAPTER ON

COMBINATION PRINTING.

By H. P. ROBINSON.

"As our art is not a divine gift, so neither is it a mechanical trade. Its foundations are laid in solid science: and practice, though essential to perfection, can never attain to that which it aims unless it works under the direction of principle."—*Sir Joshua Reynolds*.

> "And, as he goes, he marks how well agree
> Nature and Arte in discord unity,
> Each striving who should best performe his part,
> Yet Arte now helping Nature, Nature Arte."—*Spenser*.

LONDON:

PIPER & CARTER, 15 & 16, GOUGH SQUARE, FLEET STREET;
MARION & CO., 22 & 23, SOHO SQUARE.

———

1869.

TO

HUGH WELCH DIAMOND

M.D., F.S.A., ETC.,

ONE OF THE FATHERS OF PHOTOGRAPHY,

THIS BOOK,

CONTAINING HINTS ON THE PRINCIPLES OF PICTORIAL EFFECT, AND THEIR APPLICATION TO
THE ART OF WHICH HE WAS ONE OF THE CREATORS,

IS INSCRIBED,

AS A TRIBUTE OF THE SINCEREST AND WARMEST RESPECT AND ESTEEM.

PREFACE.

ONE of the greatest difficulties in writing a book for beginners
in any art is to make it simple enough. Nine out of ten
photographers are, unfortunately, quite ignorant of art ; some
think manipulation all-sufficient, others are too much absorbed
in the scientific principles involved to think of making pictures ;
while comparatively a few only have regarded the science as
a means of giving pictorial embodiment to their ideas. It is
for the first-mentioned that I have dwelt so long, in Chapters
III., IV., and V., on what may be termed the initial idea of
composition—Balance and Contrast. It is denied by some that
art and photography can be combined, and these ridicule the
idea that a knowledge of the principles of art can be of use to
the photographer. It is to counteract these erroneous notions
that I have insisted so strongly on the legitimacy and necessity of
understanding those guiding laws in composition and chiaroscuro,
which must, in all forms of art, be the basis of pictorial effect.

In the choice of illustrations, I have selected, chiefly from copies of familiar pictures, those by which I could best elucidate a principle or assist in the description of a process, rather than those which may be regarded as simply pretty pictures. In the photographic illustrations by various processes, I have endeavoured to show that the principles laid down could be embodied by means of photography.

For the rest, I have aimed to make a useful, rather than a pretentious, book. I believe it will be an aid to photographers, in which case I am satisfied it must aid in elevating an art in which I have a profound faith.

H. P. ROBINSON.

TUNBRIDGE WELLS, AUGUST, 1869.

CONTENTS.

CONTENTS.

PICTORIAL EFFECT

IN

PHOTOGRAPHY.

CHAPTER I.

INTRODUCTORY.

"All arts having the same general end, which is to please; and addressing themselves to the same faculties through the medium of the senses; it follows that their rules and principles must have as great affinity as the different materials and the different organs or vehicles by which they pass to the mind will permit them to retain."

"Every opportunity should be taken to discountenance that false and vulgar opinion that rules are the fetters of genius; they are fetters only to men of no genius; as that armour which, upon the strong, is an armament and a defence, upon the weak and mis-shapen becomes a load, and cripples the body which it was made to protect."—*Discourses of Sir Joshua Reynolds.*

"In a word, every art, from reasoning to riding and rowing, is learned by assiduous practice; and if principles do any good, it is proportioned to the readiness with which they can be converted into rules, and the patient constancy with which they are applied in all our attempts at excellence."—*Dr. Thompson's Outlines of the Laws of Thought.*

THERE has been so much written on art in its relation to photography, which, when attempted to be applied, has been found to be of very little use—so much talking, as Carlyle says, "from the teeth outwards," upon this matter—that it was with the greatest diffidence and reluctance I consented, some time ago, to write a series of papers on the subject for the *Photographic News*, a journal which, without neglecting the strictly scientific detail upon which mechanical photography depends, has always urged upon photographers the study of art as of vital importance to success in their profession, and has constantly advocated its claims to rank as a near relation to sculpture and painting. My aim was to set forth the laws which govern—as far as laws can be applied to a subject which depends in

B

some measure on taste and feeling—the arrangement of a picture, so that it shall have the greatest amount of pictorial effect, and to illustrate by examples those broad principles without regard to which imitation, however minute or however faithful, is not picturesque, and does not rise to the dignity of art. Upon these papers this work is based.

Two principal objects should be kept in view by those who endeavour to impart knowledge in any art : the soundness of the instruction given, and the simplicity of the language in which that teaching is propounded. In promising, at the outset, to be as practical as possible, I know I am sacrificing some advantages to myself, and much ease of writing, besides the *éclat* that often follows and rewards the inventor of grandly-sounding sentences, easy to write, but difficult to read, and still more difficult to understand. Those who represent art as a kind of mystery, an inspiration, a gift of the gods to special favourites, often receive the credence of the ignorant, as, in assuming the language of the oracle, they are supposed by the uninstructed to possess the inspiration, and hence, until the imposture is discovered, they receive more attention than he who endeavours to show that there is a pathway open in the direction of the temple of art which all may tread, even if all do not reach the inner sanctuary. Notwithstanding this, my object will be to write as clearly and definitely as possible, that I may be understood by, and be of use to, all those who (whether using photography either as a profession or an amusement) honour me with their attention.

It has often been asserted that the artist, like the poet, is born, not made ; and, within certain limits, the assertion is doubtless true : without a natural capacity for pictorial perception no study and no amount of industry would produce an artist. "Patience and sand-paper," Ruskin remarks, "will not make a picture." But, no matter how great the natural capacity, or how undoubted the genius, certainty in excellence, and permanent success, cannot be attained without a knowledge of the rules, and a study of the principles, upon which pictorial effect depends. No mistake is more fatal than a reliance upon genius instead of effort, upon "inborn taste" instead of culture and the application of recognized and certain laws.

I shall have not a word to say on the poetry of art; that is a question on which it is difficult to write so as to be really understood, except by those who have had a long education in art. I shall confine myself to what may be called the construction of a picture: in fact, I propose to deal with the body, or perhaps the skeleton, and not the soul; with the tangible, not the intangible; with that which can be taught, not that which must be felt. Neither shall I attempt to go into the extreme subtleties of the science of composition, which only could be of use to painters, who have command over every line that appears in their works. Photographers, although a wide scope for artistic effect is open to them, have not the facilities which other artists possess, of making material alterations in landscapes and views embracing wide expanses, neither have they so much power of improvement in figure subjects, although much may be done by skill and judgment; but they have open to them the possibility of modifying, and, being free agents, they have the power of refusing to delineate, subjects which, by no efforts of theirs, will ever make effective pictures. It is a too common occurrence with photographers to overlook the inadaptability of a scene to artistic treatment, merely because they think it lends itself to the facility, which their art possesses, of rendering, with wondrous truth, minutiæ and unimportant detail. To many this rendering of detail, and the obtaining of sharp pictures, is all that is considered necessary to constitute perfection; and the reason for this is, that they have no knowledge of, and therefore can take no interest in, the representation of nature as she presents herself to the eye of a well-trained painter, or of one who has studied her with reverence and love.

It must be confessed, and distinctly understood, that photography has its limits. Whilst it will be necessary to explain the fundamental laws of composition in their entirety, the applicability of these laws in photography is limited by the comparatively scant plasticity of the photographer's tools—light as it can be employed by lenses and chemicals. Therefore, as I proceed with the rules of composition as far as they have been reduced to a system, or rather a *quasi* system, it will be my aim to endeavour to indicate what can be done by photography, and how; assuming throughout, however, that the student is familiar with photography and the capability

of the appliances at his disposal, asking him to remember that great technical knowledge is only a means by which artistic power can be exhibited, and not the end and perfection of the photographer's art. In doing this, I shall bear in mind the Italian proverb, " He is 'a fool who does not profit by the experience of others," and shall not hesitate to avail myself of hints from any author who contains ideas worth placing before my reader, illustrating my remarks with engravings from the works of well-known painters, with occasional sketches of photographs in which the principles defined by the art of composition have aided the photographer in his choice of subject, in the arrangement of his sitter, or in his management of light and shade.

It has been often alleged that, except in its lowest phases and in its most limited degree, art can have nothing in common with photography, inasmuch as the latter must deal with nature, either in landscape or portraiture, only in its most literal forms; whilst the essential province of art is to deal with nature in the ideal, rendering that which it suggests as well as that which it presents, refining that which is vulgar, avoiding that which is common-place, or transfiguring and glorifying it by poetic treatment. Photography, it has been said, can but produce the aspects of nature as they are; and "nature does not compose: her beautiful arrangements are but accidental combinations." But it may be answered, that it is only the educated eye of one familiar with the laws upon which pictorial effect depends who can discover in nature these accidental beauties, and ascertain in what they consist. Burnet observes, "Nature unveils herself only to him who can penetrate her sacred haunts. The enquiry, 'What is beautiful, and why?' can only be answered by him who has often asked the question." The same writer, speaking of Turner's early efforts, describes them as something like very common-place photographs; they were water-colour landscapes, "aspiring only to topographical correctness, the unadorned representations of individual scenes." It was only subsequent study, and a higher knowledge of the resources of art, which " gave him a hint that selection of a situation, and clothing it with effective light and shade, ennobled the picture, and placed it more in the rank of a composition than a plain transcript." The same is equally true of

portraiture. Although likeness is the quality of first importance, artistic arrangement is scarcely second to it. In some cases, indeed, art excellence possesses a wider and a more permanent value than mere verisimilitude. The portraits by Titian, or Velasquez, or Reynolds, live rather as pictures than as likenesses, and the Gervartius of Vandyke excites the admiration of thousands who scarcely bestow a thought on the identity of the original. Art-culture, however, materially aids in securing likeness, by teaching the eye rapidly to seize the salient features, to determine the most suitable view, and to arrange the light so as to bring out the effect of character; at the same time giving force and prominence to natural advantages, and concealing or subduing natural defects.

To admit that photographers had no control over their subjects would be to deny that the works of one photographer were better than another, which would be untrue. It must be admitted, by the most determined opponent of photography as a fine art, that the same object represented by different photographers will produce different pictorial results, and this invariably, not only because the one man uses different lenses and chemicals to the other, but because there is something different in each man's mind, which, somehow, gets communicated to his fingers' ends, and thence to his pictures. This admitted, it easily follows that original interpretation of nature is possible to photographers—limited, I admit, but sufficient to stamp the impress of the author on certain works, so that they can be as easily selected and named by those familiar with photographs, as paintings are ascribed to their various authors by those who have an intimate knowledge of pictures.

It is of importance, at the outset, to prove that superior results are produced by superior knowledge, not only of the use of the materials employed in photography, but by an acquaintance with art, or the whole purpose of the present treatise falls to the ground.

Given a certain object—for example, a ruined castle—to be photographed by several different operators: no exact point of sight shall be indicated, but the stand-point shall be limited to a certain area. What will be the result? Say there are ten prints: one will be so much superior to the others that you would fancy the producer had everything—wind,

light, &c.—in his favour; while the others will appear to have suffered under many disadvantages. This picture will be found to have been taken by the one in the ten who has been a student of art. By his choice of the point of view, by the placing of a figure, by the selection of the time of day, or by over-exposure or under-development, or by the reverse, producing soft, delicate, atmospheric effects, or brilliant contrasts, as may be required, the photographer can so render his interpretation of the scene either as a dry matter-of-fact map of the view, or a translation of the landscape so admirably suited to the subject, as seen under its best aspects, as to give evident indications of what is called feeling in art, and which almost rises into poetry; the result often differing marvellously from the horrors perpetrated by means of our beautiful art in the hands of those whose knowledge of photography extends to this, and this only, that if a piece of glass is prepared and treated in a certain manner, it will result in the production of an image of the object which has been projected on the screen of the camera by the lens.

It is not only the cultivated and critical eye that demands good composition in works of art, but the ignorant and uneducated feel a pleasure—of which they do not know the cause—in a sense of fitness and symmetry, balance and support.

CHAPTER II.

THE FACULTY OF ARTISTIC SIGHT.

" This laborious investigation, I am aware, must appear superfluous to those who think everything is to be done by felicity and the power of native genius."—*Sir Joshua Reynolds.*
"Let me see, let me see, let me see ! "—*Shakespeare.*

It is an old canon of art, that every scene worth painting must have something of the sublime, the beautiful, or the picturesque. By its nature, photography can make no pretensions to represent the first, but beauty can be represented by its means, and picturesqueness has never had so perfect an interpreter. The most obvious way of meeting with picturesque and beautiful subjects would be the possession of a knowledge of what is picturesque and beautiful; and this can only be attained by a careful study of the causes which produce these desirable qualities. He who studies the various effects and character of form, and light and shade (to a photographer the addition of colour would only be complication), and examines and compares those characters and effects, and the manner in which they are combined and arranged, both in pictures and nature, will be better qualified to discover and enjoy scenery than he to whom this study has never appeared necessary, or who looks at nature alone without having acquired any just principles of selection. However much a man might love beautiful scenery, his love for it would be greatly enhanced if he looked at it with the eye of an artist, and knew *why* it was beautiful. A new world is open to him who has learnt to distinguish and feel the effect of the beautiful and subtle harmonies that nature presents in all her varied aspects.

Men usually see little of what is before their eyes unless they are trained to use them in a special manner. In *Modern Painters*, vol. i., Mr. Ruskin has given a fine chapter, in which he shows that the truth of nature is not to be discerned by the uneducated senses. He says :—" The first great mistake

that people make in this matter, is the supposition that they must *see* a thing if it be before their eyes. They forget the great truth told them by Locke, book ii., chap. 9, § 3 :—' This is certain, that whatever alterations are made in the body, if they reach not the mind, whatever impressions are made on the outward parts, if they are not taken notice of within, there is no perception. Fire may burn our bodies, with no other effect than it does a billet, unless the motion be continued to the brain, and there the sense of heat or idea of pain be produced in the mind, wherein consists actual perception. How often may a man observe in himself, that whilst his mind is intently employed in the contemplation of some subjects and curiously surveying some ideas that are there, it takes no notice of impressions of sounding bodies, made upon the organ of hearing, with the same attention that uses to be for the producing the ideas of sound. A sufficient impulse there may be on the organ, but it not reaching the observation of the mind, there follows no perception, and though the motion that uses to produce the idea of sound be made in the ear, yet no sound is heard.' And what is here said, which all must feel by their own experience to be true, is more remarkably and necessarily the case with sight than with any other of the senses, for this reason, that the ear is not accustomed to exercise constantly its functions of hearing; it is accustomed to stillness, and the occurrence of a sound of any kind whatsoever is apt to awake attention, and be followed with perception, in proportion to the degree of sound; but the eye during our waking hours, exercises constantly its function of seeing; it is its constant habit; we always, as far as the *bodily* organ is concerned, see something, and we always see in the same degree; so that the occurrence of sight, as such, to the eye, is only the continuance of its necessary state of action, and awakes no attention whatsoever, except by the particular nature and quality of the sight. And thus, unless the minds of men are particularly directed to the impressions of sight, objects pass perpetually before the eyes without conveying any impression to the brain at all; and so pass actually unseen, not merely unnoticed, but in the full clear sense of the word unseen. And numbers of men being preoccupied with business or care of some description, totally unconnected with the impressions of sight, such is actually the case with them ; they receiving from nature only

the inevitable sensations of blueness, redness, darkness, light, &c., and except at particular and rare moments, no more whatsoever."

Not only to the artist, but to all students of the sciences which relate to the outward aspects of nature, comes a more vivid enjoyment than to him who, because he knows not how to direct his attention, looks but sees not. The botanist detects beauties in weeds, unseen and trodden down by others; the entomologist finds unsuspected wonders in every grub that crawls, and every moth that flies; the geologist discovers how worlds were made in the stones over which he stumbles in his walk.

Take an illustration of how much more an acute observer of nature must enjoy than the dull man who jogs on through the world with his eyes open, but his mind blind. Can it be doubted that Shakespeare more infinitely enjoyed the amusement he derived from his study of character than common observers? Combinations of incidents and characters must have struck him much more forcibly, and must have afforded him keener enjoyment, than they would those who had not the capacity of seeing and appreciating the humours of the times in which they lived. His works point out to us many scenes that would escape us in real life. So also the trained artist will discover and reveal beauties that others pass by without notice, in our walks abroad and in our every-day existence. How often does it happen that a photographer will take his camera and dozen dry-plates to a district he has been recommended to visit because it contains so many picturesque objects and artistic bits, and has returned at night unsatisfied and gloomy, with "no game in his bag," declaring the place dull and uninteresting, without a single object worthy of his attention; again, another photographer, who, like Beatrice, "can see a church by daylight," but little else, will walk through the land photographing every object, so that it *is* an object, he meets with. But then what he means by an object is something very definite; it must be a castle, or abbey, a stone cross, or mansion— something you can "put a name to." It is of no consequence to this collector of negatives whether his subject has anything in it capable of artistic treatment, whether a few yards to the right or left would improve the effect, or whether a little more sky or a little more foreground would increase or diminish the apparent size of the subject he is about to secure;

c

his only anxiety is that the house or castle he is photographing shall come in the middle of his plate, and that nothing shall come in the way of his getting a good plan of its elevation. This is no fanciful picture I am sketching, but I have so many originals for it in my mind's eye that it can scarcely be called the portrait of an individual. Yet another photographer will scarcely care where he goes; he has learnt to select, and finds pictures everywhere. He does not do this by instinct or any inborn faculty; he has had to acquire his knowledge; he has learnt to know what he wants, and picks it up the moment it is before him—he has learnt to see. It must not be inferred, from what I have just said, that because art has to be learnt, I consider it possible for all to learn alike; the capacity for acquiring knowledge is not given equally to all. It is not possible for one in a thousand to attain a perfect knowledge of art; but it is certain that all, especially those whose instincts have turned them to a kindred study like photography, may learn sufficient to save them from making any very serious blunders in their works. All men have to learn. "Art," as Sir Joshua Reynolds has said, "is not a divine gift." The power of acquiring it perfectly undoubtedly is.

These observations may appear dull to the student who is anxious to get to the practical details of composition, but they are the keynote of all I have to say in future chapters. I wish to show that it is the photographer's business to *see*; to do which he must learn to see, that by seeing he may appreciate, and that the power of artistic sight may be, as it were, artificially cultivated by the study of those rules and axioms which have guided the greatest painters, sculptors, and architects in the production of their finest works.

But, before I proceed, I must warn you against a too close study of art to the exclusion of nature and the suppression of original thought. Whoever studies art alone will have a narrow, pedantic manner of considering all subjects, and of referring them to this or that style of composition, or this or that order of picture. This class of student looks at nature only through the medium of famous painters' pictures: a calm sunset is always a Claude; anything wild or confused is Turneresque, in his last period (it shows knowledge to speak of the "periods" of a master). "What a

delicious Wilson or Ruysdael!" one will say as he looks at a waterfall; "Quite a Landseer!" another will exclaim at the sight of a sheep-dog or deerhound; and so on. Nature can only remind them of some class of picture. This is a perversion of study, and tends to degrade nature to the level of her imitators, instead of assisting to elevate her students to the level of the humble distance from her perfections to which it is possible to artists to attain. What I want here to impress is, that art should be a guide only to the study of nature, and not a set of fetters to confine the ideas or to depress the faculty of original interpretation in the artist, whether he be painter or photographer; and a knowledge of the technicalities of art will be found the best guide.

There is a tendency amongst young artists to despise rules, and to trust to instinct and a feeling for art; but it is not only well to do right, even if that were possible, by instinct alone, but it is also pleasant to *know* you are doing right; and, although it is not well to curb rising genius, a knowledge of principles which, from their universal adoption for ages, must be sound, must be an addition to the powers an artist, in whatever material, has to bring on his subject. Sir Joshua Reynolds, in his sixth discourse, has some excellent remarks on this subject, which are much more forcible than anything I could hope to say myself.

" It must of necessity be, that even works of genius, like every other effect, as they must have their cause, must likewise have their rules; it cannot be by chance that excellencies are produced with any constancy or any certainty, for this is not the nature of chance; but the rules by which men of extraordinary parts, and such as are called men of genius, work, are either such as they discover by their own peculiar observations, or of such a nice texture as not easily to admit being expressed in words, especially as artists are not very frequently skilful in that mode of communicating ideas. Unsubstantial, however, as these rules may seem, and difficult as it may be to convey them in writing, they are still seen and felt in the mind of the artist; and he works from them with as much certainty as if they were embodied, as I may say, upon paper. It is true these refined principles cannot be always made palpable, yet it does not follow but that the mind may be put in such a train that it shall perceive, by a kind of scientific

sense, that propriety which words, particularly words of unpractised writers such as we are, can but very feebly suggest."

Having endeavoured to show that the faculty of artistic sight does not come by nature, but that it is a cultivated sense, I shall aim, in succeeding chapters, to become more specifically practical, and endeavour to give you some ideas of those forms of lines, and of masses of light and shadow, that constitute composition in art. These forms, which produce balance, unity, and harmony, may often seem intangible, and the student may be tempted to ask—

> "If shape it might be called, that shape had none
> Distinguishable in member, joint or limb,
> Or substance might be called that shadow seemed,
> For each seemed either?"

But to the instructed eye, each intangible line, and light, and shadow, plays its definite part in forming a perfect composition.

CHAPTER III.

BALANCE OF LINES AND CONTRAST.

" Thus we are agreed :
I crave our composition may be written."—*Shakespeare.*
" Form is matter bounded by lines, which may be either angular or curved."—*Sir Thomas Dick Lauder.*
" The accidental compositions of heterogeneous modes are dissolved by the chance which combined them ; but the uniform simplicity of primitive qualities neither admits increase nor suffers decay."—*Dr. Johnson.*

COMPOSITION in art may be said to consist of the selection, arrangement, and combination in a picture of the objects to be delineated, so as to produce an agreeable presentation of forms and tones, to tell the story which is to be elucidated, and to embody the spirit of what it is intended the picture shall represent or suggest. The principal objects to be sought are harmony and unity, so set forth that pleasure may be given to the eye without any sacrifice of the truth of nature. By the preservation of a harmonious balance of lines and light and shade, several objects are attained. The first and simplest result is the production of pictorial effect, which satisfies the eye without reference to the meaning or intention of the picture. But a higher purpose is also served. The preservation of harmony necessarily involves the idea of subordination, or a consideration of the relative importance of all the parts of the picture, the principal objects being made prominent, and the minor objects made auxiliary to that prominence by the arrangement of lines and masses of light and shade. By a proper distribution and balance of these, the principal objects in the picture will be brought prominently forward, and those of less consequence will retire from the eye, and will support or act as a foil to the chief objects of interest. As the quaint old writer on art, Lairesse, recommends, " Let the king or prince have the first place, and next his retinue or other proper persons ; if there be yet another party to be introduced of lesser moment than these, and yet essential to the composition, put them in the shade without more ado." In short, the grand fundamental laws of composition may be summed up very briefly. They are unity, balance, and the

adaptability of the whole to breadth of light and shade, by which the principal object in a picture—such, for instance, as the head in a portrait—is brought forward most prominently, yet united with the other parts, so that the eye may first see the point of chief interest, and be gradually and agreeably led over the picture. In addition to the above primary necessities in composition, there are many subdivisions belonging to harmony—such as repose, unity, subordination, repetition, variety, &c.—which will be treated of in their place, after the broad principles have been clearly understood.

It is a curious fact that the pictures by all artists who have lived during the last three centuries—or, at least, all those pictures that have come down to us—appear to have been designed on some fixed principle; and from a consideration of the best works of the great masters it has been found that the most pleasing and agreeable compositions are formed, more or less, on the leading idea of the triangle or pyramid, the diagonal line and its contrasts (which is a variation of the same thing), and the circle, with its various modifications. From a study of these facts, Burnet and other writers on the subject have divided the art of composition into angular and circular, whilst many of the finest examples are a combination of both forms.

As being of the first importance, and constituting, in fact, the skeleton on which all other parts of this subject hang, it will be well to first call the student's attention to a consideration of the balance of lines.

All lines should be balanced or compensated. Without a due regard to this important quality a picture would appear ready to fall to pieces.

Example: Lines running in one direction, whether parallel or otherwise, would give a weak and awkward appearance. A sense of falling is conveyed to the mind by lines repeating each other thus ///// When lines of this character occur, it will always be found possible to produce compensating lines in other parts of the picture thus // \ or if lines run diagonally down a picture thus ⟍⟍ᴬ ⟍⟍ /ᴮ a compensation for the lines A is found in the line B. There are many other ways in which

oblique lines may be compensated, in a great measure depending on the ingenuity and skill of the artist. Here is an example in a portrait

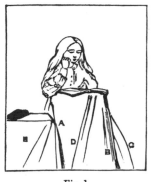

Fig. 1.

(fig. 1): A girl kneeling on a *prie-dieu* chair is reading a book placed on the back, which faces the spectator. The lines of the head and shoulders above the chair are perfectly compensated by the line of the arm, which runs in an opposite direction; but the lines of the chair, A and B, and of the dress, C, running in nearly the same inclined direction, would have given the effect of insecurity to the figure; and it would be painfully felt that the girl and chair would topple over, which would not have a pleasant effect. To counteract this sense of danger, the lines A, B, and C have been balanced by the line of the drapery, D; and, this not being sufficient, the table, E, has been introduced, while the dark spot caused by the book also helps to support the composition, as will be further explained in this chapter. This example is taken from an actual photograph, and shows, as I hope to show by other sketches also taken from photographs, how it is possible for the photographer to apply these rules to his art.

Sometimes the repetition of lines without balance is useful. A good illustration of this is to be found in Frost's picture of Sabrina and her attendant nymphs descending to the halls of Nereus, engraved and published by the Art Union some years ago, and already familiar, or readily accessible, to the student. In this picture all balance of lines and equilibrium of base have been purposely omitted, and the figures appear to descend through the water—an effect necessary to the story.

It may be said, that as diagonal or pyramidal lines require compensating, why use them? Why not use the horizontal and vertical lines? To which it may be answered, that there is not sufficient variety in the last-mentioned lines; a square is much less picturesque than a pyramidal form, as may be seen by comparison of a modern house of square elevation with a Gothic church and spire. Besides, nature never composes in squares; even the horizontal line of the sea is broken by the lines of the clouds and the waves,

and that of the plain by trees, uplands, and mountains. Again, a row of standing figures all of the same height, although it is often to be found in photographs, is eminently monotonous and disagreeable; and the very fact that groups of figures are so often photographed in this manner shows the necessity for this work.

The diagonal line (fig 2) is very suitable in the composition of landscape; it lends itself so admirably to the receding lines of perspective.

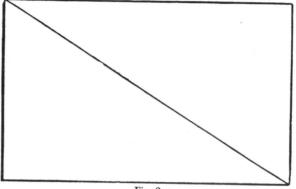

Fig. 2.

Nearly allied to balance of lines is contrast, which may be described as the opposing of things of different aspect to each other, so as to bring out

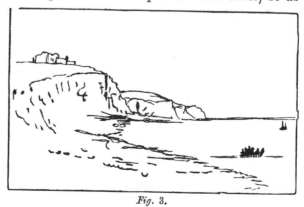

Fig. 3.

the fullest and best effect of each; such as the position and variety of heads, youth and age, light and shade, &c. Indeed, contrast sometimes

supplies the place of balance, as in the sketch (fig. 3), which shows the leading features of a photograph by Mr. Blanchard (whose marine views are always well composed, showing the power of the photographer over subjects consisting chiefly of sea and sky), where the darkest spot—the boat—is opposed to the highest light, and, being the nearest object, is opposed to the most distant, thus giving effect to each other, and, being also at the base of the angle, supports the whole, and acts as a kind of key-note to the entire frame-work of the composition. This form of composition, with the endless variations of which it is capable, is most valuable to the landscape photographer.

In concluding this chapter, I must remind the student that in following up the above hints in his pictures he must not allow the art to become too evident, the effect of which would be painful. Just as the conversation of a very learned person is sometimes dull, so would his work be if the student made too great an effort to show his knowledge. He must not leave room for the critic to say—

"Nature in him was almost lost in art."

The axiom that those who use most art betray the least, is, to a certain extent, true enough; but, on the other hand, too great an effort to conceal the art might lead to weakness, and destroy simplicity and character. That which hits the happy medium will be the greatest success.

CHAPTER IV.

BALANCE.—EXAMPLE.

"It is quite singular how very little contrast will sometimes serve to make an entire group of forms interesting, which would otherwise have been valueless."—*Ruskin.*

"The arts themselves, as well as their varieties, are closely related to each other, and have a tendency to unite, and even lose themselves in each other ; but herein lies the duty, the merit, the dignity of the true artist, that he knows how to separate that department in which he labours from the others, and, so far as may be, isolates it."—*Goethe.*

"BECAUSE things seen are mightier than things heard," to quote Tennyson, and because an actual example visible to the eye is better than pages of written words, I propose in this chapter to give a slight illustration how an artist, even in such a trivial sketch as the subject engraved on this page, conforms to the usages of art, and the value which his work gains by such treatment. I take this subject because it follows and illustrates the rule of balance given in the last chapter.

The two engravings represent the same subject—Windsor Castle—and are identical, with the exception that the sharp spots of black—the boat in

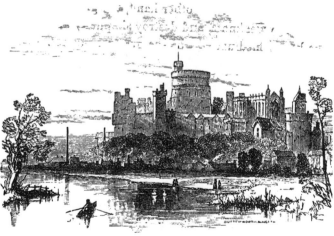

Fig. 1.

the river, and the bit of bank and tree—which appear in the one, are removed in the other. It will be observed that the diagonal line starting in the

lower left-hand corner, following the tops of the tall chimney and the distant towers, runs up to the flagstaff, from whence the eye is carried across the picture by the little white cloud over the chapel, thus completing the diagonal line given in the last chapter (p. 24). By a comparison of the two, the value of the small points of extreme dark at the lower point of the angle formed by the perspective lines of the castle and the river will be at once felt. In fig. 2, from which the balance supplied by the boat and

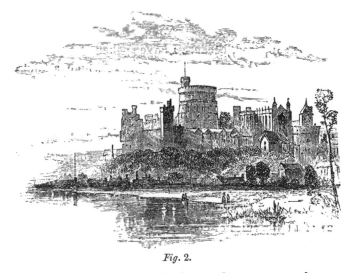

Fig. 2.

bank with the tree has been removed, the castle appears to have nothing to stand upon, no solid foundation. The lines running to a point in the distance appear to want collecting together and regulating; the distance itself comes forward into the foreground, and parts do not take their proper relation to one another. In fig. 1, where the spots of black, or key-note, is supplied, everything falls into its proper place, and there is a sense of completeness which fig. 2 lacks. The most eminent painters of landscape have adopted this form of composition. Cuyp, who generally painted sunrises or sunsets, almost invariably adopted this arrangement; and in his pictures, the point of dark being placed near to and opposed to the point of greatest illumination, gives extreme value to his highest lights. The same method is almost invariably found in the landscapes of the Dutch school. In

Turner's magnificent pictures of sea and sky the wonderful luminosity is, in a great measure, due to the darkest black being opposed to the highest light.

It is not necessary that the point of dark should consist of one object only; it is sometimes convenient to introduce a group of figures or a mass of rock; but it must always be remembered that a judiciously placed mass of dark in the foreground not only gives balance to the composition, but also increases the effect of the gradations of the middle and extreme distances.

It must not be supposed, because I have spoken of a point of dark in the foreground, that this is the only possible form in which a landscape should be composed. The principle may be applied in exactly the opposite manner : light may take the place of shade, and perform the same function. The picture may be generally dark, with a mass of light in the foreground by way of balance. For instance, the picture of a dark, gloomy castle may be relieved by a flood of light in the immediate foreground, breaking up and enlivening the otherwise monotonous shadows. Neither is it absolutely necessary that the landscape should rigidly follow the diagonal line ; there are endless variations of the principle ; but I give this, the plainest and most obvious of all the rules of composition, first, because it is a key which, once mastered, will enable the student to unlock the secrets of the most complicated designs, and render his future studies easy.

As I proceed with my subject, I foresee that a little difficulty may possibly arise. The chief danger I appear to incur in writing definitely is that of being mistaken when I describe all pictures as composed in regular shapes, such as the diagonal, pyramidal, circular, and similar forms ; but it is only by this means that I am able to put anything tangible before the student, who, when he is sufficiently acquainted with formulæ, and knows how to classify and combine them, may experiment with originality of composition upon his own account. As I said at the outset, rules are not intended as a set of fetters to cripple those who use them, and it is not intended that the student should absolutely abide by them. The object is to train his mind so that he may select with ease, and, when he does select, know why one aspect of a subject is better than another. To some readers

it may appear superfluous to thus look upon nature as a thing to be arranged before any satisfaction can be derived from its contemplation, or from its representation; but when the student begins to analyse the cause of the beautiful and pleasing effect of some pictures, and the disagreeable effect of others, equally perfect as far as finish and manipulation are concerned, he will find that he can assign the reason to some agreement or disagreement with the rules of art, however remote.

An attention to rules will assist the artist in keeping his picture in tune. The small mass of dark or light, whichever it may be, in the near parts of a landscape, acts as a sort of keynote, as I have already said, and the pleasure good composition gives to the educated eye is not unlike that the ear derives from perfect harmonies in music; and if the arrangement of a picture is not obvious at a glance, if that which is equivalent to *melody* does not strike the eye at once, rely upon it that if the picture is pleasing, the composition is there, although it may be in a minor key. As music is only sound under governance of certain laws, so is pictorial effect only the combination of certain forms, and lights, and shadows, in like manner harmoniously brought together.

The moral to the landscape photographer is, that in many cases he must endeavour to obtain in his foreground some object, or mass of objects, that will act as a keynote to keep the whole in harmony; and if nature does not supply such object, the pictorial requirement may often, without violating material truth, be furnished by art. On this point more in another chapter.

CHAPTER V.

BALANCE.—Examples—(*continued*).

"We cannot, as I have heard a great man express himself on another occasion, *see at sight*. A tolerably correct understanding of the construction and leading principles of an object is requisite, even to the seeing it properly."—*Opie*.

"Divested of design, art becomes a mere toy, a mechanical bauble, unconnected with either the head or the heart, uninteresting to the wise and good, unprofitable to all, and amusing only to the weak and idle."—*Barry*.

IT is not necessary that the ruling point should be absolutely at the side of the picture, and under the extreme distance. It will be found, by an examination of the best landscapes, to vary very considerably; but, if it be an important object, it will never be found exactly in the centre, or under, or in a line with, any other important or prominent form of the same size or character.

 The little sketch subjoined illustrates how balance may be obtained by opposition of lines and light and shade, referred to in the last chapter. The lines of the tree and foreground oppose the lines of the mountains, and the light on the near objects contrast the dark distance.

I take for further illustration a river scene, the construction of which the student will be able to perceive for himself. He will notice that it is diagonal in form, and that the balance is preserved by the boat. He will also notice that the masses produced by the principal trees are repeated by the sail, and the light cottage is echoed by the distant church.

In teaching any art it is always well to point out not only what to do, but also what not to do; and there is a slight example of what to avoid here. It will be seen that the cloud immediately behind the top of the central tree exactly follows the shape of the upper branches, and the cloud just above partly repeats the same form. Now, repetition is a valuable quality in art, as we shall see further on, and helps to give one part of a picture relation to the other parts; but repetition should consist of a faint echo, and not of

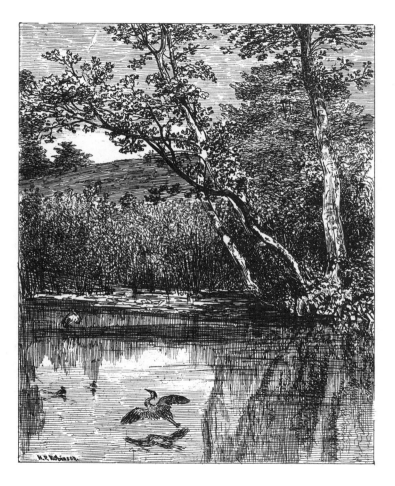

exact imitation of lines, or forms, or tones; this would look too much like artifice, even if agreeable to the eye, which it would not be; and art, however much it may regulate the representation of nature, should never make nature look artificial.

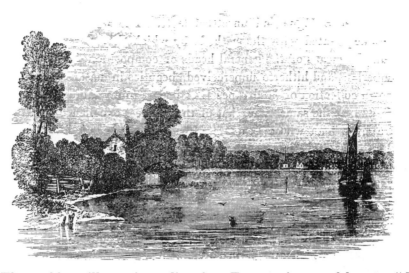

The etching, illustrating a line from Tennyson's graceful poem, "The Brook"—"The haunt of coot and hern"—is another example of balance obtained by the introduction of a dark spot or spots in the immediate foreground. It would, of course, be difficult, if not altogether impossible, to represent a flying "hern" in a photograph, but this sketch will serve to illustrate the principle as well as one copied faithfully from a photograph from nature. The lines of the trees overhanging the water fall in one direction, and without the water-fowl, would have nothing, artistically, to support them; and without them the sketch would have a weak effect; but the dark spots formed by the heron and the two coots perform the office of the boat in fig 3, page 24, and afford the necessary balance.

Having, I hope, carried the student with me so far, I should advise him, at this point, to study good pictures and engravings, and, analyzing them for himself, see how far the simple rule—beyond which we have not yet got—of a small spot of dark, or an opposing line, acting as a balance to the

whole, has been observed, especially in representations of landscape. I venture to assert that if he does this appreciatively for the first time he will be astonished at the regularity and frequency with which this principle is observed. A study of pictures at the present stage will have a better effect on the student than a study of nature, which could, without guidance, only produce in him a vague and unsettled taste. The study of pictures will make him acquainted with the methods by which they were produced, and guide him, by means of the general heads of composition, in his search for the numberless, and hitherto unperceived, beauties in nature. Taking the best known collection of landscapes that occurs to my mind at the present moment, and, at the same time, that of the greatest excellence, and because they are by a man whose genius was sufficient to carry him above and beyond all rules, if he had thought it right to reject rules, I would recommend the student to go to the National Gallery, and make a careful examination of the Turner collection; or, if he is not able to see the original paintings, let him look through the last half-dozen volumes of the *Art Journal*, in which many of these wonderful pictures are admirably engraved. Let him forget, if he can, the gorgeous colouring, and the poetry and imagination which appear in so eminent a degree in Turner's works, and prosaically examine the construction of the pictures; or, rather, at present, let him confine himself to the one point I have suggested, and, when he is well grounded in that, he may advance another step without fear of having to turn back.

Taking a few examples at random, let me first direct attention to the lovely Devonshire landscape, " Crossing the Brook," where the dog in the stream forms the balancing-point of the composition; then turn to the " Temeraire," and notice how the buoy performs the same function. In " Brighton Chain Pier," " The Sun Rising in the Mist," " Ancient Rome," " Spithead," " St. Michael's Mount," " Stranded Vessels off Yarmouth," " Fishing Boats," and other sea views, a buoy, barrel, anchor, boat, or piece of wreck will always be found doing the same duty. In the " Polyphemus," the dark prows of the galleys cutting against the sky give wonderful power to that glorious sunrise. It is the same with the landscapes proper. Look at " Petworth Park," and observe how the dark form

of the doe standing against the light in the foreground appears to have been the last thing done, but without which the harmony would not have been complete. In the curious picture, representing a scene in Boccacio, called " The Birdcage," it will be found that a *white* spot—the music-book on the ground—has been used to complete the balance. Notice how, almost invariably, he places his darkest dark in immediate juxtaposition with his highest light, of which his " Dutch Boats in a Gale " is a good example. Notice, also, and remember how, in his wildest fancies, painted when some people think his genius had deserted him, or almost amounted to insanity, Turner strictly obeyed the simple rules of composition; for example, in the " Whalers," and that weird and wonderful picture of so prosaic a thing as a railway train, to which he has given the name " Rain ! Steam ! Speed ! " And if the greatest landscape painter that ever lived could approve of these rules, and bend his great genius down to them, it is not for the tyro in art, or even the advanced student, to say, " Art is above rules, which only act as a drag on invention, and as a curb to the imagination."

Having arrived at this point, having attained some knowledge of elementary pictorial construction, and having observed in pictures how that construction has been observed by painters, the student may now turn to nature, look on objects indoors and out of doors, carefully analyse any object or group of objects that appear to have a pleasing effect, and he will find, in some degree, that the cause of the pleasure he experiences in looking upon them begins to dawn upon his mind. Let him ask himself whether, even at this early stage of his knowledge, he looks upon nature with the same indifference he formerly did, and if he has discovered new sources of pleasure, through the medium of art, with which hitherto he has been unacquainted, and for which he never cared. If he has discovered new sensations and new enjoyments, he has put these lessons to the purpose for which they were written, and may go on with those that are to come; if not, he had much better give the matter up, or " try back." I ask this question thus early because if the subject of the last three chapters be not quite mastered, all I have further to say will appear but as so much confusion.

E

CHAPTER VI.

UNITY.

"In the fine arts that composition is most excellent in which the different parts most fully unite in the production of one unmingled emotion, and that taste the most perfect where the perception of this relation of objects, in point of expression, is most delicate and precise."—*Alison.*

"The unlearned eye first admires painting as an art of imitation; it is only from the progress of our sensibility and the practical cultivation of our minds that we begin to comprehend the greater compositions of genius, after which the *unity of expression* is felt to be the great secret of the power of painting."—*Sir Thomas D. Lauder.*

"The great object of composition being always to secure unity—that is, to make out of many things one whole—the first mode in which this can be effected is by determining that *one* feature shall be more important than all the rest, and that the others shall group with it in subordinate positions."—*Ruskin.*

IN a former chapter I spoke of unity as one of the essential constituents of a successful picture. In some respects it would have been better to have considered what was meant by unity in that place, but it would have delayed me in placing before you the law of balance and contrast, in which I was anxious to secure your interest at the outset.

In speaking of unity as one of the essential elements of composition, I did so from a firm conviction that whatever beauties a picture may contain, however exact its imitation of nature, correct its arrangement of lines, beautiful its colour, extreme its finish, or great the dexterity of handling manifested, no perfect sense of satisfaction will be conveyed to the eye if the lights are scattered, if breadth of light and shade be not preserved, or if two or more episodes, unconnected with each other, appear on the same canvas.

Unity has been well defined as "the keystone of nature, and expresses the harmony of the Divine mind as rendered in creation." Unity can only be attained by a study of first principles. It is the law of nature that principle shall precede details; in the account of the creation of the world the general design is described as first laid down, and the details as following. Unity is so simple that it is often overlooked; but no success in any other qualities desirable in a picture, as I have already said, will compensate for its absence. In photographs, where there is no colour to distract the attention from the design, it is especially necessary. It is the

absence of unity in the arrangement of the figures in a photographic land-scape that so frequently mars the beauty of an otherwise effective picture. It is too often the practice to scatter figures, dressed inharmoniously with the scene, over the foreground of a landscape, without any reference to one another, or the propriety of their being there at all, and so unity is disregarded and lost.

Like most of the elements which constitute a good picture, unity is a quality more easy to feel than describe ; but I think I shall not be far wrong if I define it as the fit connection of all parts to a perfect whole. The province or function of unity is to combine and bring to a focus the secondary qualities, such as variety, contrast, symmetry, &c. It is equally opposed to scattered ideas, scattered lines, or scattered lights in a picture. In nature, light, when broken in its passage, though the amount be diminished, is rendered more irritating to the eye. We can bear the full, uninterrupted splendour of the setting sun, but when its rays are cut up and divided by passing through a screen of leaves and branches, the irritation affects the least educated eye. This feeling of irritation, caused by spotty lights, more properly belongs to the subject of light and shade, and will be spoken of in its proper place ; but there is a unity of lines and a unity of action that must be considered, more especially in the composition of figures ; but unity of purpose is as necessary in the expression of a landscape as unity of action is in the figure-subject. All objects must assimilate in one point, however dissimilar they may be in themselves. There must be some conformity of tone and relation of line, however great the variety in the leading characteristics of the view.

In photographing any object, whether landscape, portrait, or group of figures, one leading idea must be maintained. The fact that has to be stated must not be clouded with confusion. The work should constitute one whole; it should fully pronounce its own meaning; there should be nothing left for verbal explanation. A picture should not require a showman; a picture that does not tell its own story is as tiresome as a volume overlaid at all parts with notes and annotations to explain that which should need no explanation. In a landscape will always be found some object of more importance than the rest, to which all other parts are

subordinate, and to which all other objects lead. It will be the duty of the photographer to choose such a position for his camera as will increase this effect, so as to make the most of the principal object, or the subject of the picture, and to allow no rival to be near to detract from the full effect. A very common instance of the loss of unity in photographic landscapes is in the position and action in which figures are placed. I have an example in my portfolio, a description of which will illustrate how much mischief may be done by this disregard of unity.

The scene is a rural lane, crossed by a brook, and closed in with trees. Halfway down the lane, growing on the flower-covered bank, are seen the trunk and gnarled roots of a grand old oak, which receive the principal light; this light is repeated in the water, and gradually diffused through the picture. Stretching from the left are the dark and graceful branches of a sycamore tree, which, extending partly over the trunk of the oak, by the opposition of their dark leaves in shadow, increase the brilliancy of the chief mass of light, and assist in leading the eye to the principal object. There is no mass of light so large or so high in tone as that on and around the tree trunk—not a line out of place; and it is altogether one of those scenes on which the eye loves to linger, and which can be quite expressed by photography. And yet this is one of the most irritating pictures I ever saw. The cause of the irritation is supplied by comparatively a very small

part of the whole; but it is there so palpably, that I keep the picture only as a warning, and never look upon it for pleasure. In the centre of the picture, cut out sharply against the light, looking straight into the camera, having no part in, and, apparently, caring nothing for, the lovely scenery around, is this figure. And thus one of the most beautiful photographs I know is spoilt by a ridiculous incongruity, which destroys all unity. If two or three village children had been introduced, naturally engaged picking flowers from the bank, or engaged in any other rural occupation, they would have appeared like a rich cluster of jewels in an appropriate setting.

The same remarks apply equally to portraits or groups, of which more in the proper place, as the subject will receive fuller treatment in the section devoted to light and shade.

In this chapter I direct attention to a principle rather than to mere rules, which can be expressed in so many words. But I must impress thus early upon you this dominant idea : that if a picture is to be successful, it must have a oneness of purpose or intention, a oneness of story, a oneness of thought, a oneness of lines, a oneness of light and shade. Everything must have a meaning, and the meaning must be *the object* of the picture ; there must be nothing " to let."

I am more desirous you should " feel " what unity is, because unity and balance together constitute the chief mechanical elements of pictorial effect, and may exist altogether apart from any story to be told, or intention to be expressed, in a picture, although the telling of a story rightly is a part of unity, which seems paradoxical. These two, balance and unity, should, therefore, be thoroughly understood first, and other elements of harmony, such as refer to intention, subordination, keeping, &c., are not the less important, but will be all the more perfectly understood and expressed after the student has thoroughly grounded himself in the more mechanical elements ; as, however prolific a man may be in ideas, he cannot express these ideas intelligibly until he has learned a language and its grammar, or laws of construction. Balance and unity are principles of construction, upon which must be based every intention to be expressed in the picture. I lay the greater stress upon this initial idea, because it has too often happened that the art-teaching which has been supplied to photographers has dealt rather with the thoughts to be expressed than on the modes of expressing them ; and it is of little use endeavouring to teach a man to write poetry until he has learned to spell.

CHAPTER VII.

EXAMPLES (*continued*).—EXPRESSION.

"In the study of our art, as in the study of all arts, something is the result of our own observation of nature; something, and that not little, the effect of the example of those who have studied the same nature before us, and who have cultivated before us the same art, with diligence and success."—*Sir Joshua Reynolds.*

HAVING commenced this book with the determination to connect all I have to say on pictorial effect with photography, and to demonstrate the application of the different forms of composition with our art, this seems a proper occasion to give a sketch from a photograph, showing in what manner the rules of art—as far as already expressed—have guided the photographer in the selection of his subject. The sketch on the next page gives the leading features of a delicious little photograph of a scene in the lake district—" Derwentwater, Cats Bells in the distance "—by Mr. Mudd. And I may point out, as a singular instance of the possibility of the photographer moulding his materials to his wishes, the fact that a landscape by Mr. Mudd is rarely to be met with the composition of which is not nearly perfect. From a large collection of his works now before me, I am not able to select more than two or three in which there is felt any want of balance, unity, and harmony; and this small minority consists of local views, or portraits of places interesting from their association, but which do not appear to have been tractable in the hands of the artist. Although the art is properly concealed, the trained eye can discover and admire the many ingenious devices he has adopted to hide a defect, to discover a beauty, or to throw more prominently forward the chief point of his subject. All have admired Mr. Mudd's charming pictures, but few have cared to enquire to what their excellence was chiefly due, but have been content to attribute it to his perfect manipulation of the collodio-albumen process, a method of working which he has made his own, but which, notwithstanding its excellence, does not account for the skilful arrangement of his subjects. The same remarks are equally true of the pictures of Mr. Bedford. In the works of these gentlemen nothing appears to be done without a purpose. If a figure is

introduced, it performs some important function in the composition, either to lead the eye, to emphasize a point, to throw back the distance, or to

collect some scattered lights or darks together, by which breadth is gained, and confusion avoided. If the point of view admits of a picturesque

foreground, whereby an unpictorial principal object may be made into an interesting picture, it is secured; nothing seems to be forgotten that could increase the effect, or help to please the eye. And as this occurs in the larger number of views taken by both gentlemen, it cannot be laid to the account of chance, but must be the result of knowledge.

The sketch gives a very faint idea of the original photograph. It is printed from a phototype block by Mr. Griggs, of the India Museum. The relief was taken from a rough sketch, made experimentally to test this process, and sufficient care was not taken to produce a finished drawing, the draughtsman being under the impression that a rather coarse sketch was necessary, instead of which a drawing full of detail would have produced a much better result. However, the photograph is in the hands of, or has been seen by, so many of my readers, that this slight and imperfect sketch will suffice to recall the original to their memories; and I apologise to Mr. Mudd for presenting such an imperfect translation of his beautiful picture.

The first thing that will strike the reader of these lessons, as he looks on the original, is the admirable way in which balance has been obtained by the boulders in the foreground; the next, the immense distance that is felt between the foreground and the distant mountains. This effect is almost entirely produced by the arrangement and opposition of the dark stones in front. If the stand-point for the camera had been shifted a few feet either to the right or the left, a very different and much less valuable picture would have been produced. The stones in the one case would have been excluded from the picture, and the distance looked flat; in the other, the stones would have been either in the centre, or weakest point, or on the right side of the picture, under the dark trees in the middle distance, thus having all the dark on one side of the picture, and all the light on the other.

As I am writing, a young friend, who has just commenced his study of art by reading " Howard's Sketchers' Manual," tells me the removal of the stones to the other side would produce the " wedge " form of composition, which, he is told, is much used by landscape painters. This is quite true, and agrees with all I have yet said, because all angular composition must,

more or less, partake of the form of the wedge, which is the basis of many of the finest compositions. Let the student bear in mind, however, as an axiom, in arranging his masses in this form, that *the point of the wedge must be supported.* Without such support the picture will convey the uncomfortable impression that some of the principal masses will slip down. And I would here guard my readers against the error of my young friend : that of jumping to the hasty and imperfect conclusions which a superficial familiarity with the technical names by which various forms of composition are designated, without an understanding of the principles upon which all pictorial effect must be based. I would strongly recommend the student of these lessons to blend his reading with practice, endeavouring to produce photographs in which art rules are embodied and illustrated. Above all things, avoid the glib, parrot-like parade of art terminology, which, without art practice, is such a contemptible thing to all earnest men.

One of the most precious qualities of the photograph, which has suggested these remarks, is its perfect *expression.* It is not that of repose, so much as of perfect serenity. It suggests to the mind one of those lovely days, of which not a dozen occur in a twelvemonth, when the sun shines with a *white* light, and the breeze is hushed so still that you can hear the bee hum and the trout leap in the lake—one of those days when, to the photographer, fortune helps art, but also one of those days on which, with such a photographer as Mr. Mudd, who is not content with mere unselected looking-glass truth, art helps fortune.

I have spoken of the expression of this picture. Some may doubt that such a thing was possible in landscape photography ; but it is so, to a very great degree. Some scenes demand that they should be rendered in a sparkling and lively manner ; others, such as portraits of places, with all the dry matter-of-fact of mechanical art ; others, again, are better expressed under the gloom of approaching twilight. I have before me two photographs : the one so absolutely expresses the effect of early morning that you feel the chill, bracing air as you look at it. It is difficult to explain how this is obtained. The scene represents the outskirts of a distant town round which runs a river. The distance is composed of hills. The sun, shining on the slate roofs of the distant houses, causes so many glittering spots of

light, which, however, are well grouped together. The river also shimmers in the sunlight, forming a broad curved line of light stretching across and into the picture; the foreground is composed of a steep bank. The photograph in this state would look scattered, and without unity; but on the bank is placed the figure of a girl, with a basket, gathering ferns. The figure is by far the blackest spot in the picture, but possesses touches of the highest lights caused by the strong sunlight, which gathers together and repeats the lights in the distance and on the river. This figure has the effect of reducing the whole into harmony. The conclusion is, that the glittering lights, like sparkling dew, give the effect of early morning; but these lights, if not corrected, would have a scattered and disagreeable effect; this is quite compensated for by the figure, which brings them into a focus.

The other picture is a view of the pool at Burnham Beeches, in which the effect of the commencement of twilight is perfectly given. The sun is sinking behind a screen of trees, defining the branches and trunks with a thin edge of light. The darkest mass of shadow is in the centre of the picture, relieved by some white ducks on the bank of the pool, which serve to enliven the only part of the picture that was in danger of dullness. No figure is introduced, and the whole expression is that of solitude and gloom.

In looking over my portfolio I meet with another photograph which will also illustrate what I have advanced. In this picture, which is by Mr. Durrant, a breezy day is perfectly expressed. It has not that appearance of petrified motion which is sometimes the defect of instantaneous photographs of the sea, but you feel that the wind is stirring the trees, although it is evident that nothing moved while the picture was being taken, and the exposure must have been considerable. The clouds, from a separate negative, appear to skim through the sky with a very lively motion. These examples will, I hope, tend to show that photography, even in landscape, need not be the lifeless thing we find it in average productions.

CHAPTER VIII.

PRACTICE.—THE CHOICE OF A SUBJECT.

"What is beautiful must be decided by each man for himself and at his peril. There are some who maintain that all nature is beautiful. Fortunately, we can now disprove this monstrous position by our daily experience of photographs. Even if they were *quite* true in effect, form, or expression, they would often be none the less ugly. They are usually planned and made by men of some chemical knowledge, but tasteless and entirely unacquainted with fine art. Consequently, the photographers unconsciously offer us the mean and ugly mixed up with some beauty."—*Fine Art Quarterly Review.*

COMPOSITION based on the diagonal line—the form of arrangement to which the foregoing chapters have been principally devoted — having been considered, it appears to be a fit time to say something on landscape composition generally; the more so, seeing that I have already urged the student to accompany his study of these lessons by practical attempts to carry out the instructions from time to time brought under his attention. A few hints on his general mode of procedure in attempting landscape work may, therefore, be of service here.

Elegance in landscape composition, in views where no extraordinary object suffices in itself to engage the attention, appears to demand free sweeps of lines contrasting each other; a fine vigorous foreground, which— especially in photography—should be made use of to govern and correct those parts of the picture beyond the control of the artist; a middle distance that delicately melts into the distant mountains and into the sky. Lines, and light and shade, should be so arranged that the eye is led into the picture, and allowed something to rest upon; that something should be the *theme* on which the picture is built. If there are any ugly lines in the view that cannot be got rid of by change of position, or by opposing lines, or masses of light or shadow in the foreground, then the background of the landscape—the sky—must be made use of, and, by the disposition of the clouds, much bad composition may be remedied.

There are several things worthy of the careful consideration of the landscape photographer before he packs up his traps and takes the field. The first is a meteorological one.

Without a favourable state of the weather, the most perfect

manipulation and skilful arrangement would be worse than useless; they would be thrown away upon subjects that might have been better done under more propitious circumstances. Nothing is more annoying to a conscientious photographer than to know that a greater degree of perfection might have been attained than that which he has effected, except, perhaps, the possession of a negative too good to destroy, but not good enough to print—a negative just so much short of perfection as to cause regret that it ever was done.

The most perfect day for pure landscape operations is one on which the wind is still; and when I say pure landscape, I do not include sea-views, which are, perhaps, more grand, if not more beautiful, under the influence of wind, than in a placid condition. It has been said that nature is insipid when in a quiescent state, and that it would be better to sacrifice sharpness than to tolerate tameness; but, apart from all photographic considerations, what can be more beautiful than the majestic calm of a still landscape? The great charm of a fine twilight consists more in the serenity and quietude that reign at that period of the day when

" All the air a solemn stillness holds,"

than in the fading light and in the dying of the day Incidentally, and in connection with twilight, a fine effect of contrast may be here mentioned. Who, when taking an evening walk in the country, has not felt the effect of the twilight calm increased and enhanced by the sudden sound of the slamming of a distant gate, or the bark of a dog in a neighbouring farmyard?

Of all faults photographs possess as pictures, that caused by the motion of the object photographed is one of the worst. This is especially true of foliage; and if a negative is found to have this defect to any degree, it should be rubbed out at once. Still waters, as a rule, are best on quiet days. Gusts of wind partially skimming over a lake add surface to the water, and vivacity and life to a picture, it is true, but there is great beauty in the grand reflections in still water, which is so exquisitely rendered by our art.

The light, usually held to be of the first consideration in photography,

is here placed second, because if the subject be not in a fit condition to be photographed, it would be useless to have it well lighted. It should be taken as an axiom, that most landscape subjects should be sun-lighted. Nature certainly looks more beautiful in sunlight than in shade (there are, of course, exceptions). A landscape without sunlight, especially if it be an extensive view, is usually flat and low in tone, and this tameness would certainly not be lessened in the photographic transcript, for if a subject have not sufficient breadth of light and shade to give relief, the landscape photographer's powers of producing that desirable quality are very limited, and the attempts to do so generally result in hardness; besides, who would prefer the cold, dull, prosaic effect of daylight, to the warm, cheering glow of " nature's smile " ?

In selecting a sunny day, it is not necessary that a cloudless sky should be chosen; on the contrary, a dark blue sky is, to a certain extent, non-actinic, and a day on which white clouds float lazily over the heavens, occasionally obscuring the sun, a day that often comes after rain, when nature looks fresh and cheerful, is the best that could be chosen for landscape photography.

The choice of a subject is the next thing that should claim the attention of the photographer; and now will be the time when the student will show his capability in artistic treatment. Here let me earnestly entreat you to follow my advice in one thing: determine to be content at first with one subject; to work at it with all your heart and soul until you have got the best possible representation of it. Even if it take a summer, make up your mind to produce a masterpiece. A complete triumph over one subject is worth more, both as a study and as a picture, than the indiscriminate picking up of any quantity of dull and feeble commonplaces. If a lot of mere photographs are wanted, it is better to send a man to manufacture them; it will be found much cheaper also; but the study necessary for the production of a perfect photographic landscape is worthy of the attention of a superior intellect.

Now comes the question how to produce this masterpiece.

It is of no use taking a camera with you the first time you visit unknown ground in search of subjects. When you have selected your

subject, and are satisfied it will make a good picture, let it command your undivided attention. Consider it as a painter would, if he were going to make a large and important picture of the scene; consider the best time of day; visit it several times during the day, to notice how the changing position of the sun alters the light and shade and shape of the masses. It is too often the practice of photographers to work with the sun behind the camera, so as to get all the light possible on the subject, forgetting that it is not light alone that they want, but light and shade. The charm of sunlight depends very much upon aspect. This must be carefully considered by the student. Some subjects are better with the sun coming on the side, and others with the sun more behind the view, skimming the edges of objects only with its rays. Having chosen the subject, then fix the exact spot for your point of view; this will give you less to think of when you bring your camera next day. Remove any obtrusive boughs that appear likely to interfere with the view. And, lastly, think if there is anything you could do to improve the already well-considered composition. Make up your mind if a dark or light spot is required in the foreground to give balance, and if a figure would answer the purpose, and what kind of figure, bearing in mind that broadcloth and black hats are no improvement to a country landscape, and that harmony between animate and inanimate nature must be imperatively preserved.

When you are perfectly satisfied that your view presents the best possible aspect, that you have your figures and all else quite ready, you may begin to think of your chemicals, which I would rather you consider as tools, over which you have perfect command, rather than as a series of scientific problems, on which you are about to make experiments.

CHAPTER IX.

SIMPLE RULES.

"It is sometimes admitted that the mere imitation of nature is not sufficient to make a picture, and that some art in the treatment is required, but nevertheless contended that students should confine themselves to the imitation, without any reference to the pictorial effect. But it will require a strong argument to support the position that amateurs should be limited to that portion which requires incessant application, and debarred from those licenses to make their productions agreeable which are freely admitted in the works of professed artists. Moreover, it is difficult to discover why the end should not always, and from the first, be kept in view."—*Howard.*

IN making a pictorial representation of a scene from nature, there are many particulars to be borne in mind, some of which are self-evident, but which, for the sake of order, and for the information of those who have not arrived at even the elementary stage of art, may be as well mentioned here.

Parallel lines are objectionable. If the horizon is bounded by a straight line, the middle distance or foreground should be undulating. This is often easily managed by a change of position, so as to get a perspective view of the foreground. A move of a few yards will often entirely alter the lines of a picture.

A front elevation of an object is seldom so picturesque as the same object seen in perspective, as the following example will illustrate. Fig. 1 is from a stereoscopic slide, slightly exaggerated for the sake of making

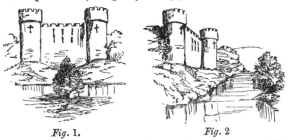

Fig. 1. *Fig.* 2

the defective composition more palpable to the student. The parallel lines of the towers are at right angles with the parallel lines of the river, and the alder bush occupies a prominent position in the centre: an arrangement than which nothing could be worse. A position taken forty or fifty yards along the bank of the river would present a view as represented in fig. 2, which entirely agrees with the rules of composition as set down in former

chapters. Some writers argue that, because the artist is not greater than the Divine Maker of nature, he should make no attempt to improve or select nature. Now, photographs taken from either of the stand-points indicated by these sketches would be equally true, but fig. 1 is probably the way in which these writers would represent the castle, and fig. 2 is how the same object would be presented by an artist. I leave you to select which you would prefer.

However objectionable straight lines may appear when many of them run parallel with one another, a few straight lines are exceedingly valuable in a landscape, giving variety by opposing the more graceful curves, and presenting a feeling of stability in the picture. Sometimes a few parallel lines in the distance and sky afford a pleasing contrast to the undulating lines in the landscape. A small portion of straight lines is often of extreme value in a picture containing many curves. The lines of a building on an eminence, or seen through trees, always add to the picturesque effect. In the interior of a cathedral or church the straight lines of the columns many times repeated give an idea of stability and solemnity to be obtained by no other way.

If a picture were divided down the middle, one half should never be a facsimile of the other. For instance, if a photograph were taken of the nave of a church from the centre of the aisle, this effect would be produced. The repetition of the receding pillars produces grandeur, but the exact repetition of the same pillars on the opposite side would produce monotony.

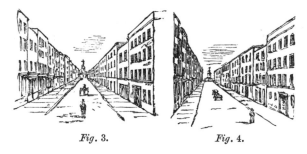

Fig. 3. Fig. 4.

The same observations will hold good in a great variety of instances. A representation of a view extending down an avenue of trees, down a river,

or down a street, should never, if it is possible to avoid it, be taken from the centre. On a comparison of figs. 3 and 4, the difference of result will be seen at a glance. The awkward effect of placing leading objects, such as the figure, cart, and church in fig. 3, one above the other in a line, will also be apparent.

A picture should also always, when it is possible, be properly closed in.

Fig. 5.

The centre of an arch should never be left without any other support than the side of the picture, as in fig. 5; but if no more of the landscape can be included, the picture should finish at the abutment of one of the piers of the bridge. No doubt the imagination of the spectator will supply the missing abutment or support, but it is very much better to show it in the picture. The same remark also applies to arches in interiors.

The choice of the position of the horizon is often a matter for serious consideration, but it may be taken as a rule that it should never be equidistant from the top and bottom of the picture; that is, the plane should not be equally divided between earth and sky. The exact position—whether the horizon is above or below the centre—must be determined by the subject; but I have noticed that the majority of photographs seem to demand that the greatest space should be devoted to the earth; while, on the other hand, the majority of paintings and drawings have the horizon low. This difference may probably be accounted for by the fact that hitherto the sky has been a difficulty with photographers: first, because their endeavour has been to produce photographs so cheap that they could not afford to print in skies from a second negative; and secondly, because, although there is very little mechanical or chemical difficulty in the production of natural clouds when they exist, it is very rarely that a fine and suitable sky is found behind a landscape.

CHAPTER X.

FIGURES IN LANDSCAPE.—TRUTH.

" Connection is a principle always present to the painter's mind, if he deserve that name; and by the guidance of which he considers all sets of objects, whatever may be their character or boundaries, from the most extensive prospect to the most confined wood scene; neither referring everything to the narrow limits of his canvas, nor despising what will not suit it, unless, indeed, the limits of his mind be equally narrow and contracted; for when I speak of a painter I mean an artist, not a mechanic."—*Sir Uvedale Price.*

"'*What is Truth?*' said jesting Pilate; And would not stay for an Answer."—*Bacon.*

BEFORE placing figures in a landscape, the artist should first make up his mind whether the composition requires the introduction of any object to add to its completeness. If it does, do not let anything induce him to take the view without the figure, because he will be doing something that he can see could be done better with the assistance of a little more trouble ; above all, he should avoid incongruity, and never, for the sake of pleasing a friend by putting him in the picture, introduce an element of discord, such as was illustrated in the chapter on Unity. The figures should look so right where they are placed, that we should have no supposition that it would be possible to place them anywhere else.

If perfect pictorial success is to be expected, no more figures than are absolutely necessary should be introduced. One figure more would be a useless blot, and injure the effect. Care must be taken that the figures compose well in relation to themselves, as well as to the landscape. In too many photographs, figures are to be seen straggling over the foreground, perfect strangers to each other, to all appearance, united by no purpose whatever, except that of having their portraits taken at a great disadvantage. It, of course, may happen that, in some scenes in nature, figures may be found scattered over the ground in the way set forth in many photographs, and a picture of them may be quite true, and would, therefore, satisfy the desires of the matter-of-fact truth-at-any-price school, who scoff at the idea of art knowledge being of any use to photographers; but it is the purpose of the artist to represent agreeable truth, or, at least, truths that do not irritate the eye, as false quantities jar upon the ear in verse. I

am quite aware, and go as far as any in agreeing, that the real enjoyment of art is in proportion to its entire truth. I hold, with Mrs. Elizabeth Barrett Browning,—

" Truest Truth the fairest Beauty,"

but the agreeable sensations produced by pictorial represensations are dependent, in a very great degree, on the spirit and knowledge with which that truth is rendered. Form only will not give this, neither will light and shade alone; but the union of both, although colour may be absent (but which is necessary to *perfect* beauty), suggests that truth to the mind which is one of the great functions of art. The best quality of photography is this perfect truth, this absolute rendering of light and shade and form; and a knowledge that he is debarred the charms of colour should cause the photographer to be more careful to make the most of the qualities which his art possesses, and which are beyond the reach of the painter and sculptor. It is not open to the photographer to produce his effects by departing from the *facts* of nature, as has been the practice with the painter for ages; but he may use all legitimate means of presenting the story he has to tell in the most agreeable manner, and it is his imperative duty to avoid the mean, the base, and the ugly; and to aim to elevate his subject, to avoid awkward forms, and to correct the unpicturesque. Having digressed thus far in search of " what is truth," we will return from the bottom of the well to our figures.

The figures and the landscape should never be quite equal in interest or pictorial value. The one should be subordinate to the other. The picture should consist of figures with a landscape background (if they are represented in the open air), or of a landscape in which figures are introduced merely for the sake of impressing a point or adding life to the more important scene. It is true, indeed, that pictures are sometimes produced, with good effect, the converse of this, and the figures vie with the scene in interest; but the subjects must be fine, and the skill of the artist great, or the success will be hazardous.

As an example of the possibility of success when the figure and landscape are nearly equal in interest, I have etched a beautiful little picture

by Mr. Slingsby, of Lincoln, entitled " Rest," which attracted considerable attention when it was shown at the Exhibition of the Photographic Society. The delicacy and beauty of the photograph are lost in the etching, but it will recall the original to the memory of many who saw and admired it. This photograph could only have been produced by combination printing, a process which is attracting more attention daily from those earnest photographers who desire to give a more distinct art character to their work, and who do not care how much trouble they take to attain their end.

It is difficult to give general directions for doing that which must, after all, have a special consideration in each case ; it would, therefore, be next to impossible for me to give more definite directions for the introduction of figures in landscapes than has already been stated in this and former chapters ; but I may sum up the subject by saying that the figure must be *of* the subject, as well as *in* it, in order that unity may be preserved ; that it must be used with a purpose, to give life to a scene, or to supply an important spot of light or dark ; to give balance, or to bring other parts into subordination, by being either blacker or whiter than those parts ; and that what is to be avoided is the indiscriminate dragging in of figures into scenes in which they have no business, and where they do nothing but mischief. Perhaps the best lesson on this subject is to be obtained from the observation of photographs in which figures have been successfully introduced—if with the assistance of a competent teacher, all the better. For this purpose nothing could be better than a few of Blanchard's stereoscopic views, especially the series taken in the Isle of Wight, in which the most subtle art has " grasped the skirts of happy chance," and converted topographical views into gems of most rare quality. Every one of these little pictures that I have seen is *made*, pictorially speaking, by the figures introduced. Not figures—mark the difference !—that the artist has found haphazard, and photographed instantaneously, although they are chiefly so-called instantaneous views, but figures that he has met with on the spot, certainly, but has arranged with great judgment and taste, according to their avocation, or in accordance with the requirements of the scene. Sailors, coastguards, children, or the more prim-looking visitors,

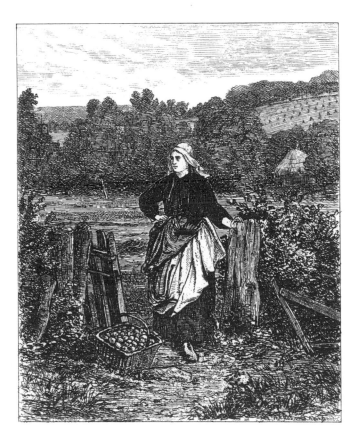

all look what they are, and are doing that which it is their nature to do; and all this, not only without the least sacrifice of arti stic truth *according to law*, but with very great gain from an observation of the laws of light and shade and composition as generally received.

By way of tail-piece to this chapter, and to this branch of my subject—for, with the exception of a chapter on the sky, and incidentally when I come to the consideration of chiaroscuro, I have done with landscape composition—I give a little vignette showing how simple a subject will serve to make a picture. How often do photographers travel over miles of country without finding anything they consider worthy of their attention, although, perhaps, exquisite subjects may exist at every turn of the road! The art of photography has arrived at a sufficient state of perfection, in its own way, to prevent us having any fear in acknowledging that it is not possessed of unlimited power; that the sublime cannot be reached by it; and that its power is greatest when it attempts the simplest things. But if it is not the mountain that it can represent best, what art can equal it in its representation of the molehill? And for this reason I conclude my hints on landscape with an illustration of the class of simple subjects for the representation of which the art is pre-eminent. The illustration will show how a basket, a hamper, a stone, a log of wood, a barrel—all or any of these—may be made valuable when a foreground presents nothing of especial interest in itself, and how, by their presence, they at once give tenderness to the distance, and space to the picture.

CHAPTER XI.

THE SKY.

"Many are the landscape painters who seem, in their studies from nature, as if they had never raised their eyes above the horizon; and among the proofs of the indifference of those who interest themselves in art to the beauty that canopies the earth, may be noticed that, although the composition and light and shade of clouds are as much within the reach of the photographic art as any of the other great things of nature, they are her only beauties it has hitherto neglected. I have seen but two calotypes of skies, and these prove that it is from no want of power in the process that skies are not as common in our photographic exhibitions as any other subjects."—*C. R. Leslie.*

"To admire on principle is the only way to imitate without loss of originality."—*Coleridge.*

WHEN Mr. Leslie wrote his Hand-Book for Young Painters, from which one of the above quotations is taken, very little had been done towards the photographic representation of cloudland. Since the time when the Hand-Book was written (1854), photographers have turned their attention to the sky, and some beautiful results have been produced; but, however, this has been only in a fragmentary sort of way, and not with a steady determination to make the most of it in their pictures.

The importance of the sky as an aid to effect in landscape cannot be over-rated. In a letter to a friend, quoted in the work I have just mentioned, Constable, who was an enthusiastic admirer and follower of nature in his works, and who spent entire summers in painting skies, thus writes, and his observations should be taken to heart by all landscape photographers:—"That landscape painter who does not make his sky a very material part of his composition neglects to avail himself of one of his greatest aids. I have often been advised to consider my sky as 'a white sheet thrown behind the objects!' Certainly, if the sky is obtrusive, as mine are, it is bad; but if it is evaded, as mine are not, it is worse; it must, and always shall, with me, make an effectual part of the composition. It will be difficult to name a class of landscape in which the sky is not the key-note, the standard of scale, and the chief organ of sentiment. You may conceive, then, what a 'white sheet' would do for me, impressed as I am with these notions—and they cannot be erroneous. The sky is the source of light in nature, and governs everything; even our common observations

on the weather of every day are altogether suggested by it. The difficulty of skies in painting is very great, both as to composition and execution; because, with all their brilliancy, they ought not to come forward, or, indeed, be hardly thought of, any more than extreme distances are; but this does not apply to phenomena, or accidental effects of sky, because they always attract particularly."

Although I do not think it advisable to make a too liberal use of quotations, I cannot forbear adding Leslie's own testimony to the value of the sky, and which contains a very beautiful thought:—"Rocks, trees, mountains, plains, and waters, are the features of a landscape, but its expression comes from above; and it is scarcely metaphorical to say nature smiles, or weeps, and is tranquil, sad, or disturbed with rage, as the atmosphere affects her. Hence the paramount importance of the sky in landscape—an importance not diminished, even when it forms but a small portion of the composition."

It often occurs that a view must be taken of a scene that composes badly, and of which, from accidents of the ground, it is impossible to select another point of view. The artistic photographer now has his remedy in the sky, and if he understands the use of it for producing pictorial effect, he may redeem the ugliness of a scene not worth photographing for itself, but which may be interesting from its associations.

It is true that the attempt to add a suitable sky to landscape, as Constable found, presents difficulties which many photographers would be glad to avoid, but they should recollect that the greater the difficulty, if it be successfully surmounted, the greater will be the triumph. In the quaint but beautiful lines of old George Fuller—

> "Who aims the sky, shoots higher far
> Than he who means a tree."

The sky is the natural background of the landscape, and should be of the same use to the landscapist as a background is to a portrait photographer, and should not be regarded as so much waste paper, as is too frequently done, but should be made to throw out and relieve the principal subject, by the direction of the cloud lines opposing the lines of the landscape, by the opposition of light and shade, either to produce relief

or breadth, and to generally assist in the production of pictorial effect : unless, indeed, as sometimes occurs—a fine sunset, for example—the sky be the chief object represented ; then the landscape must be subordinate.

Leaving out of consideration the latter case, let us see how far its employment as a means of effect is legitimate, especially when printed from a separate negative to the landscape to which it is joined in the finished print : the only way, in my opinion, by which the fullest value can be obtained, and the utmost amount of pictorial effect can be produced ; and that not by blind chance, of which Ruskin tells us to be independent—as would be the case if taken with the landscape—but with that certainty which a knowledge of art gives to its votaries. It will not be necessary to give any definite instruction for the use of the sky, as the readers of these articles should, by this time, or will after they have read the chapters on chiaroscuro which are to come, be able to artistically apply an object that is infinitely varied, and, being ever changing in its light and shade and form, is suited to all circumstances of composition.

Many ingenious arrangements have been devised for the purpose of securing the sky on the same plate as the landscape, and I believe there are now, in many instances, no chemical or mechanical difficulties, in securing the two by one operation, which a clever photographer could not successfully combat; but before you cook your hare you must first catch it. Now, however natural any sky that may happen to be in the heavens at the time the photograph is being taken, it only occasionally occurs that it is the best, or nearly the best, for pictorial effect. This being the case, it is for the operator to select a sky that will best suit his picture ; and in doing this he must have a sufficiently critical knowledge of nature, and the various phases she assumes, to prevent him departing from the truth of nature. He must keep strictly to the truth of nature—that is absolutely imperative—but he may select the best and most picturesque nature he can get. The intelligent student will be ever on the look-out for what is beautiful, and, when he sees a fine effect, he will always examine the causes by which it is produced, and note them in his pocket-book, although he may not have his camera with him at the time.

What the photographer has to do, then, is to select and use a probable

sky to increase the beauty of his work; but it must be such a sky as would render it impossible, not only for the carping critic, but also the real man of science, to say it is not true. It must, indeed, be so true as to defy the adverse criticism, as a fact, of the most learned meteorologist. Surely no very impossible task to an observing student!

While the foreground of a picture should contain the key-note of the composition, the sky should always preserve harmonious relation to the whole picture. The various effects of cloud and sky which may be introduced in landscape photography afford a vast scope for the display of the art capacity of the operator. He can, by a well-chosen effect, bring an otherwise unimportant and somewhat tame distance into better keeping with the remainder of the picture; he can by its means supply a deficiency in some of the most important lines of the composition; or he can, especially in pictures with figures in the foreground, use an effect of cloud or atmosphere to give not only relief to the principal object, but to correct the foreground and the distance; for although the sky is really behind the picture, still it may form the connecting-link between any two grades of colour or masses of light and shade.

CHAPTER XII.

THE LEGITIMACY OF SKIES IN PHOTOGRAPHS.

"Nothing is more strange in art than the way that chance and materials seem to favour you, *when once you have thoroughly conquered them.* Make yourself quite independent of chance, get your result in spite of it, and from that day forward all things will somehow fall as you would have them."—*Ruskin.*

"It is often said : Study nature ; but nature does not compose; her beautiful arrangements are accidental combinations, and none but an educated eye can discover why they are so. Nature does, and ought to, supply the materials for fine pictures; but to select and reject, to adapt the individual parts to the production of a perfect whole, is the work of the artist, and this it is that stamps the emanations of genius."—*Burnet.*

THE doctrine once set forth by the matter-of-fact school of critics—now, happily, nearly extinct—who endeavoured, unsuccessfully, to teach that anything beyond mechanical copying or dull map-making was heresy in photography, concerning the impropriety of using any other sky in a photograph—or, indeed, as it must naturally follow, in any other picture—than that which was actually presented at the moment of taking the rest of the picture, although of so little importance as to be scarcely worthy of notice, yet demands a few words, as it may have a detrimental effect on the unthinking, or those whose faith is not quite confirmed in photography as an art.

That this doctrine is utterly wrong—a pestilent error, without even a figment of truth to support it—is capable of easy demonstration. It is, indeed, so absurd, the wonder is that it should have ever found its way to the light. It would be quite beside my present purpose, or beyond the scope of this work, to enter into any elaborate discussion upon the point ; but it will be enough to remind the student that if the idea be carried out in the manner advocated by the school above-mentioned, it comes to this : any landscape is equally beautiful at all times, and, notwithstanding it may be seen under various aspects, a photograph of it, if absolutely accurate, will, in virtue of its accuracy, be a work of the highest art ; so that art becomes no more than a mere servile copying of nature, without even the slightest reference to the aspect under which nature is seen. This doctrine

would reduce all photographs and all photographers to one dead level; but the mind refuses to accept a dull, flat reproduction of common-place nature with the same satisfaction and pleasure as a brilliant, harmonious, well-selected, and well-lighted passage, on which the artist has expended all the resources of his art. And the end to be attained by art is pleasure. "Pleasure," says Mr. Dallas, in his admirable book, *The Gay Science*, "pleasure is the end of all art." It would occupy too much space here to enter into the arguments why this is so. This, the text of his book, is argued in the affirmative through two volumes of brilliant writing and profound thought, and we may accept the axiom. The highest aim of art, therefore, is to render nature, not only with the greatest truth, but in its most pleasing aspect; to show forth the storm in its grandeur, or to gladden the eye with the smile of nature's light. Truth may be obtained without art. The exact representation of unselected nature is truth; the same of well-selected nature is truth and beauty. The former is not art, the latter is.

It is the fashion with the matter-of-fact critics to quote passages from the writings of Mr. Ruskin, and twist their meaning to their own use. In his lessons to beginners, this eloquent writer recommends them, at that early stage, to copy nature accurately, pebble for pebble, and leaf for leaf; neither to suppress nor alter in even the most minute particulars. This he does very wisely, because the pupil has not yet learned to select; but when he writes for artists, he writes in a very different strain. In *Modern Painters*, he calls the pleasure resulting from imitation the most contemptible that can be derived from art. "Ideas of imitation," he says, "act by producing the simple pleasure of surprise, and that not in surprise in its higher sense and function, but of the mean and paltry surprise which is felt in jugglery. These ideas and pleasures are the most contemptible which can be received from art. First because it is necessary to their enjoyment that the mind should reject the impression and address of the thing represented, and fix itself only upon the reflection that it is not what it seems to be. All high or noble emotion or thought is thus rendered physically impossible, while the mind exults in what is very like a strictly sensual pleasure." This is only one of many arguments (too long to quote)

he brings to bear against the mere literal, photographic rendering of nature, without the addition of that soul or feeling which the mind of man can throw into his work, be it painting or photograph.

There is comfort for the artist photographer, then, not only in the quotation from Ruskin, at the head of this chapter, and the one I have just quoted—which entirely neutralizes any extract from the same writer to the effect that nature must be slavishly imitated, whether that nature be a pig-stye or a palace, so that it should *chance* to come before the artist—but in the fact that Turner, who, in the opinion of that writer and many others, could do nothing artistically wrong, or depart in any way from nature, not only improved nature by twisting his views out of all resemblance to the localities they were intended to represent, but actually studied many of his best skies from the end of Margate Jetty, and afterwards fitted them to any picture he thought they would suit.

I may here quote an anecdote related by Burnet of Turner, which is applicable to this question :—" Driving down to his house [Woodburn's] at Hendon, a beautiful sunset burst forth ; Turner asked to stop the carriage, and remained a long time in silent contemplation. Some weeks afterwards, when Woodburn called upon him in Queen Anne Street, he saw this identical sky in his gallery, and wished to have a landscape added to it ; Turner refused the commission—he would not part with it. Wilkie used to call these studies ' his stock-in-trade.' His skies look like transcripts of nature, but they are the result and remembrances of his contemplation. They are composed of many combinations and changes in the heavens, drawn from the retentive stores of his memory ; they are adapted to the picture in hand by the different qualities required. If the subject is indifferent, he trusts to the richness and composition of the sky to give it interest ; and if the scene is complicated, and consists of many parts, he makes use of the sky as the seat of repose."

It must be remembered that nature is not all alike equally beautiful, but it is the artist's part to represent it in the most beautiful manner possible ; so that, instead of its being death to the artist to make pictures which shall be admired by all who see them, it is the very life and whole duty of an artist to keep down what is base in his work, to support its weak parts,

and, in those parts which are subject to constant changes of aspect, to select those particular moments for the representation of the subject when it shall be seen to its greatest possible advantage.

I have not, in this work, advocated the use of artificial skies, or painting in skies on the negative, although I believe in the legitimacy of either method, and it is the constant practice of our best landscape photographers—Bedford, England, Mudd: need I mention more?—to improve their negatives, in the sky and other parts, with the brush. I have not done so, because I believe the natural sky, added from a separate negative, to give the most complete results; but I see no reason whatever why the negative should not be improved, if it is found necessary, without any departure from truth.

Before photography was discovered, artists used to paint skies to their pictures; indeed they then, as now, painted their whole pictures; but now that photography has asserted its claim to mechanical accuracy in its transcripts of nature, there has sprung up with it a class of men who would have us believe that to touch a photograph with a paint-brush is almost the greatest sin a man can commit, and they would hardly shrink from even taxing a man with immorality and want of religious principle who, having taken a good photograph, should, by a few strokes of the pencil, judiciously applied, make it, as well as a good photograph, a good picture.

In conclusion, I cannot refrain from quoting part of a letter on the sky in the *Photographic News*, September 22nd, 1865, by an admirable writer, who, under the *nom-de-plume* of "Respice Finem," favours us too seldom with his views on our art; after which let us turn to the consideration of something more practical.

"The clouds have to play a far more important part in photographic landscapes than they have yet done. I do not say that a photograph without a sky, or with a mass of white for the sky, is altogether unnatural, but, to me, it is very tame, insipid, and unpoetical. How a photographer with a conception of the enormous resources he possesses in the clouds can ever neglect them in his landscapes, I cannot understand. They have such a varied beauty in themselves; they give to the artist such a command in

balancing and harmonizing his composition; if well managed, they so assist everything else in taking its place, that I cannot understand their frequent neglect by the photographer. One reason is, I know, the difficulty of securing them in the same negative as the foreground. If I am right in my former letter on the legitimacy of combination in photography, then there should not be a second opinion as to the propriety of using a second negative, looking to it, however, that the clouds harmonize with the picture, and involve no impossibility or practical solecism. To avoid this, a careful and constant study of nature, as well as art, will be necessary. Heed not, I would say to the photographer, the thoughtless objector, or bogus critic, who tells you that the landscape can only harmonize with that sky with which it was illumined when you obtained your negative. Remember that the portion of the sky which produces lights or shadows on your landscape is rarely that which the eye sees in looking at that landscape. How far this is true you will ascertain by the study of nature; and of all the studies of beauty known to man, there is none so grand, so lofty, and so varied, as the study of the aspects of the sky and the glories of the clouds. And when, with Ruskin, you have gazed on a glorious sunset, 'through its purple lines of lifted cloud, casting a new glory on every wreath as it passes by, until the whole heaven, one scarlet canopy, is interwoven with a roof of waving flame, and tossing vault beyond vault, as with the drifted wings of many companies of angels; and then, when you can look no more for gladness, and when you are bowed down with fear and love of the Maker and Doer of this, tell me who has best delivered his message unto men.' "

CHAPTER XIII.

THE COMPOSITION OF THE FIGURE.

"Nature, everywhere, arranges her productions in clusters; and to this end she employs a variety of means. The heavenly bodies are grouped by attraction, flowers and trees by the natural means by which they are propagated, while the social instincts congregate man and most other animals into societies; and the same instincts impel, in man as well as in many of the inferior creatures, the grouping of their habitations. Grouping is, therefore, a universal law of nature; and though there are cases in which a scattered display of objects may, in parts of a composition, greatly aid, by contrast, the more compact portions, and cases in which scattered objects may help to tell the story, yet in the composition of a picture, taking the whole together, a scattered general effect is always a fault."—*C. R. Leslie.*

ANY very obvious geometrical form, either in masses of light and shade, or bounded by lines, would necessarily be a defect of arrangement; but a certain degree of regularity, such as that arising from a proper appreciation of the rules of composition, and resulting from the concentration and grouping together of the parts, is, undoubtedly, greatly to be preferred to that kind of irregularity which would be made apparent by the promiscuous scattering of objects over the plane of the picture.

It may be objected, that few landscapes will fall into these convenient forms for the benefit of the photographer. This I am quite ready to admit; but when he is acquainted with those forms that are known to produce picturesqueness, he will be ready to take advantage of accidents of position and of the various effects produced by light and shade at different times of the day. Besides, forms of objects alter with the point from which they are observed. Twining, who has written a readable if not very practical treatise on the philosophy of painting, says:—"Form itself depends, in a great measure, on the position selected by the observer, on the direction of the lights, and the transparency or mistiness of the atmosphere. From such causes as these the mountains may become more elevated, the plains more vast; depth, space, and distance may be increased; and the artist, who thus adds to the grandeur or beauty of a subject, by availing himself of means borrowed from nature herself, instead of tantalizing the mind, and engendering an admiration based, in a great measure, on ignorance in

matters of art, instructs, at the same time he diverts, his admirers." This is equally true for the photographer as for the painter.

But if the landscape will not arrange itself at the photographer's bidding, he has more power and command over his materials when his subject is a figure or a group. If he be not perfect master of the expression of his sitter—and some photographers show by their works that a complete command of that most difficult thing is possible—he has in his hands the possibility in a very great degree of governing the disposition of the lines and the light and shade. If he find several lines running in one direction, he has the opportunity of altering the position of the body or the drapery so as to create opposing lines, and he has great scope in the artistic arrangement of the accessories and background in preserving balance, either by lines, or light and shade; and yet how often are these advantages neglected, or, rather, how very seldom are they employed! For many years (and, indeed, to a great extent at the present time) a plain background without gradation was looked upon as very successful work, and nothing but insipid and monotonous smoothness was aimed at by photographers, with the exception of those who already had a feeling for the picturesque, or those who were not too proud to take a lesson from the works of others. It is encouraging to see that many photographers are alive to the necessity of doing something more creditable to the art; and the many imitations that have been shown in recent exhibitions—although few of them have yet risen above the level of mere imitation, or at all approached the great originals—of the productions of M. Adam-Salomon, give indication that some improvement may be expected.

It is always well, when possible, to teach by example, and I append an outline of a well-known portrait, of which large quantities have been distributed, chiefly because of the celebrity of the subject, and partly, no doubt, because of the excellence of the technical qualities of the photograph. I do not indicate this picture more distinctly, because I think that when I feel compelled to use any particular photograph as "an awful example," it is scarcely fair to the author to mention his name, although my remarks would be more easily understood if the original could be placed before the student instead of an outline wood-cut.

It will be seen that most of the lines, although not parallel, run in one direction. There is no balance whatever, no variety of lines, no relief, and the space behind the figure is "to let." There is no employment for so much space, except to make the picture the regulation size. The background in the original is perfectly plain— one unbroken tone from the top to the bottom. You see any part of the picture as soon as, or before, you see the head, and the figure appears to be inlaid, or sunk into the background. It would have taken no trouble to alter all this if the operator had possessed a sufficient knowledge of the requirements of art, and, what is quite as necessary when engaged with an eminent sitter, the presence of mind to use it.

This, or a similar position, more full-faced, one hand on a table and the other on the knee, is to be seen in nine out of every ten photographs of the sitting figure; in fact, it appears to be the traditional position of the photographic sitter handed down from the earliest times, and religiously followed by photographers who are not observers, or who do not know how to invent positions for themselves. But, supposing it necessary to maintain the figure in nearly the same position as that in the sketch, what should have been done to produce a more agreeable composition? A very slight change in one of the accessories would have done nearly all that was required. At present the lines run nearly in the same direction, without any opposing lines to balance them, and there is a space behind the figure that requires filling, while the table and vase carry the eye out of the picture to the left, and overcrowd that side of the composition. If the table had been moved to the right side of the picture, stability would have been given to the figure; the numerous weak and almost similar curves of the figure and chair would have been opposed by the straight lines of the table, the space that was to let would have been filled, the lines of the figure would have been properly balanced, and the table, which crowded the left of the picture, would be doing service to the general effect, and the figure,

although turned slightly away from it, would still have the effect of being seated naturally near the table; while, if some attention to light and shade and gradation had been observed in the background, everything would have been brought into harmony. There is another defect which should be carefully avoided: the curves of the chair-back exactly follow the curves of the arm.

As a contrast to the foregoing, I introduce a little sketch by Sir Noel Paton, in which it will be observed that balance has been strictly considered, and the figure is admirably supported. Notice how the lines of the leaning figure are contrasted by those of the arms, and, for fear these should not be sufficient, two trees have been introduced, to perform the same function in the composition. And the hat and plants on the ground perform the part of the point of dark so often mentioned in the chapters on landscape.

This simple little figure serves very admirably to show the difference between a figure represented "just as it sat," and a picture produced by one who conforms to the rules of art.

CHAPTER XIV.

PYRAMIDAL FORMS.

"The axiom that the most perfect art is that in which the art is most concealed, is directed, I apprehend, against an ostentatious display of the means by which the end is accomplished, and does not imply that we are to be cheated into a belief of the artist having effected his purpose by a happy chance, or by such extraordinary gifts as have rendered study and pains unnecessary. On the contrary, we always appreciate, and therefore enjoy, a picture the more in proportion as we discover ourselves, or are shown by others, the why and the wherefore of its excellencies; and much of the pleasure it gives us depends on the intellectual employment it affords."—*C. R. Leslie.*

HAVING, in the last chapter, had a slight glimpse of the value of a knowledge of composition in arranging a figure, we now come to a consideration of pyramidal forms, a method of composition very suitable to single figures and groups.

It is, perhaps, as well to begin with a complete subject; therefore, as an example containing almost every element of formal artistic composition, and as a subject to which it will be useful to return again and again for the illustration of various points to be commented upon, I have selected Wilkie's "Blind Fiddler" for my illustration. Well-known and familiar as it is to all, there is scarcely another picture in the whole range of art so useful to the teacher, or from which the student of the art of picture-making could learn so much. This is not because of the subtilty or ingenuity of the arrangement, but quite the reverse. To those who have the slightest inkling of composition, the art displayed is very noticeable, defying the teaching of those who say "the greatest art is to conceal the art," and that all the artist has to do to produce a work of art is to take a bit of nature, no matter what, and imitate it faithfully.

There is no doubt that the maxim that the art should be concealed is good enough, but it is one of those rules that the student should use with judgment, or it will cripple him. It should be taken in the sense of a protest against academical formality. Burnet says, on this subject, "Concealing the art is one of its greatest beauties; and he best can accomplish that who can discover it under all its disguises. I ought, however, to

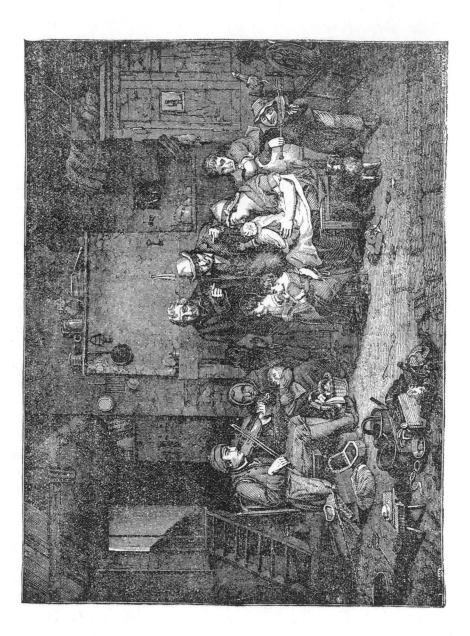

caution the young artist, on this hand, not to be too fastidious in trying to conceal what can be obvious only to a small number; for in endeavouring to render his design more intricate, he may destroy character, simplicity, and breadth; qualities which affect and are appreciated by every one." And the quotation at the head of this chapter is much to the same purpose.

As regards composition, the pictures of Wilkie may be taken as safe guides by the student. Artists of every shade of opinion unite in regarding them in this one respect as perfect. Even Haydon, whose enthusiasm for grand art, and contempt for subjects of a domestic character, almost amounted to insanity, acknowledges that, as an artist, Wilkie will be a teacher and an example for ever. Speaking of this great artist, in one of his lectures, he says, "His composition is perfection; there the youth may consider him infallible: it was the composition of Raffaelle in a coarser style." And adds, "My not seeing the beauty of his works at first was entire ignorance; as my knowledge increased, my admiration went with it: exactly as I understood Raffaelle, I understood the beauty of Wilkie's art."

The "Blind Fiddler," as far as the arrangement of its materials is concerned, would have been possible in photography; it is, therefore, a picture of which a long study and analysis will much benefit the photographer.

The composition consists of a series of pyramids built up on, and combined with, one another. The fiddler himself forms a pyramid, and, being the motive of the picture, he is more isolated than any other figure, which gives him greater prominence, although he is not the chief mass of light; so that what Ruskin rather fantastically calls the "law of principality" is observed. But he is not left quite alone, but is connected with the principal group by the figures of his wife and child, and the basket at his feet. This basket is made light, to strike the eye, partly to unite the two groups, but chiefly because it is the supporting point of the angle of which the old grandfather's head in the centre is the apex, and which is led up to by the boy in shadow warming his hands at the fire. The two little girls form a pyramid, and so do the mother and child, supported by the dog, which is again continued by the man snapping his fingers, again by the old man, who caps and perfects the whole group. Notice particularly how the line

of one side of the pyramid formed by the mother and child is carried on by the stick in the little girl's hand. All the figures are connected together in one grand pyramid by the dark and light spots formed by the cooking utensils over the fire-place; and the diagonal line is still further carried on by the slanting beam to the left, which, again, is balanced by the steps leading to the door. The perpendicular lines of the wall give stability to the composition, and the group of kitchen utensils and vegetables in the foreground, being darker than any other part, give delicacy and distance, as well as scale, to the rest of the picture, and, by contrast, perfect balance to the group.

I have pointed out the leading lines only of this famous picture, sufficient to guide the student in his further analysis of its governing forms; but he will discover that there is not a line, however insignificant, that has not its equipoise and contrast; not two articles together but what have others added to form the group. A good example of this will be seen in the way the sieve and frying-pan on the wall are connected together and grouped by the gridiron and cup, which subordinate group is connected with others, and so on throughout the whole composition. I shall return to it again, to help my explanation of other details of composition, such as repetition, harmony, and repose.

What could be more formal, regular, and artificial than this group, and yet what more entirely natural? If art—art regulated by laws—were antagonistic to nature, this would not have been the most popular picture of its year, 1806; nor would it have retained its popularity, and become, as it perhaps is, the best known picture ever painted in England.

CHAPTER XV.

VARIETY AND REPETITION.

"How great a share variety has in producing beauty may be seen in the ornamental part of nature. All the senses delight in it, and equally are averse to sameness. Yet, when the eye is glutted with a succession of variety, it finds relief in a certain degree of sameness; and even plain space becomes agreeable, and, properly introduced and contrasted with variety, adds to it more variety. I mean here, and everywhere indeed, a *composed* variety; for variety uncomposed and without design is confusion and deformity."—*Hogarth.*

NOTWITHSTANDING the formality of the composition of the " Blind Fiddler," the great quality without which no pictorial arrangement can be complete—variety—is present in a very marked degree. This is very noticeable in the disposition of the heads and leading points, as will be seen at a glance by the following diagram, in which they are set forth; as will also the pyramidal forms of the groups, and the way in which they fall in with and harmonise one another, continually piling up until they form one great irregular pyramid, supported by the group of dark objects in the front. The extreme care Wilkie has taken to get his pyramid complete will be seen in the disposition of the fiddler's bundle and stick on the one side, and the spinning-wheel on the other. Every variety of aspect in the heads is given, from the full face of the grandfather to the back of the head of the fiddler's son warming his hands at the fire. Every position is represented—standing, stooping, leaning, sitting, lying—as well as every degree of expression, from lively action to repose, "from grave to gay, from lively to severe;" and every age, from the octogenarian to the infant, youth being directly opposed to age in the centre of the group.

That variety is a necessity in good composition is so apparent that it need scarcely be dwelt upon at any length. It must be obvious that the reverse of variety—that is, monotony—would be fatal. One definition of composition might be, that it teaches the proper use of variety. A line running in a given direction must be balanced and opposed by a counteracting line. Full faces in a group should be varied with three-quarter and profile heads. A line of heads "all of a row," as is too often seen in photographs even by the best photographers, is jarring to a sensitive

taste, and is an offence to art. So also with figures dotted about a land-scape without purpose, disturbing repose by directing the eye to objects which are out of all harmony with the view represented.

Variety is one of the chief sources of picturesqueness and beauty. This quality alone would make a dead flat interesting. The ever-varying lines of the waves—varying, however, according to regular laws—make the

level and otherwise tame and monotonous ocean a constant fascination. No tree, however finely grown and vigorous, presenting an unbroken mass of foliage, will interest the artist so much as others, inferior although they may be in size, but presenting variety in their outline and intricacy in their details. Without variety of form there cannot be variety of light and shade.

Notwithstanding the absolute necessity of variety, as one of the chief sources of beauty, it may be, and frequently is, carried to excess. All great painters have guarded against this by introducing the opposing element to variety—repetition—repetition as an echo, not that resemblance which produces monotony. Picturesque effect will allow, and demands, a greater amount of variety than does the higher form of nature—beauty—which appears to require a greater amount of simplicity for its success.

Variety of attitude should be studied for the sake of contrast; but simplicity, especially in photographs, must not be lost; the peculiarity of the art itself supplies sufficient intricacy and detail. No amount of ingenuity in varying the positions and aspects of the figures will compensate for loss of simplicity and repose. Photography does not admit of much action. In painting, the model is forgotten; in photography, it is different. It is well known to everybody that the figures represented actually stood for some seconds in the attitude shown—except, indeed, in instantaneous pictures, where art often has to accept much from chance (we cannot get away from that fact, even if we desired to do so)—whilst painting or drawing represents something that need not have been seen for more than an instant by the artist; indeed, it is not necessary to the enjoyment of a painting to know that the original ever existed.

Simplicity, symmetry, and uniformity, strange as it may appear, are not antagonistic to variety, but are, in the extensive scale of nature, highly conducive to it, especially in scenes composed of many objects. Uniformity in a single figure will produce monotony; but in a scene composed of many figures it will add to the variety, for if the greater number of figures be irregular and varied, the introduction of repetition in some of the objects will actually increase the variety. This is beautifully illustrated in the "Blind Fiddler," in which that "uniformity in variety" necessary

in a perfect work of art is finely shown The following diagram exactly repeats the lines of the fiddler and the woman with the child seated precisely opposite to him.

It will be seen that the position of the body is the same in each—stooping a little forward, with the head bent down; the lines of the arms, the legs, and the chairs exactly correspond, and the line produced by the child's arm reaching up repeats the line of the fiddle-stick, while both

figures, although different in sex, wear caps; the lines of the dress even, especially above the arms, are symmetrical, and in both cases the back leg of the chair is concealed. This uniformity is not accidental, but must have been produced deliberately and with a purpose. There are other similar examples of repetition in this perfect composition; for instance, the boy imitating the action of the fiddler with the poker and bellows; the delight of the human beings repeated in the face of the dog; and, if you like to be fanciful, the rude art of the fiddler echoed in the rude art of the caricaturist in the picture of the soldier on the wall

CHAPTER XVI.

VARIETY AND REPETITION—(*continued*).—REPOSE.—FITNESS.

"Another important means of expressing unity is to mark some kind of sympathy among the different objects, and perhaps the pleasantest, because most surprising, kind of sympathy, is when one group imitates or repeats another; not in the way of balance or symmetry, but subordinately, like a far-away and broken echo of it."—*Ruskin.*

"In things the fitness whereof is not of itself apparent, nor easy to be made sufficiently manifest unto all, the judgment of antiquity, concerning with that which is received, may induce them to think it not unfit."—*Hooker.*

THIS law of repetition will be found to pervade all great pictures, perhaps more notably in colour, but also, to a great extent, in the disposition of lines and light and shade. The repetition of incident is almost invaluable in telling a story, of which both Wilkie and Hogarth were great masters. In Wilkie's picture of the " First Ear-ring," now in the gallery at South Kensington, in which a woman is performing an act more worthy a savage community than a civilized nation—that is, boring a hole in a child's ear, that jewellery may be hung in the flesh, under a mistaken notion of ornamentation—the action is repeated, or at least alluded to, by the spaniel on the ground scratching his ear with his paw ; and in the first of the series of Hogarth's great pictorial epic, now in the National Gallery, the "Marriage à la Mode," the indifference of the intended bride and bridegroom, who turn their heads away from each other, is repeated in the two dogs at their feet, linked together, but of different minds. The way in which Hogarth made insignificant objects perform a double purpose, and help to tell the story, is simply wonderful. Instances must occur to all admirers of his works, and may be imitated by photographers. In Leslie's *Handbook* many instances are cited ; the following, referring to two of the best known works, I quote :—" In the marriage scene in his ' Rake's Progress,' in which the hero, having dissipated his patrimony, appears at the altar with an ancient heiress, we are shown the interior of Old Marylebone Church, at

that time standing in an out-of-the-way part of the suburbs, and, therefore, resorted to for stolen marriages, or marriages of which either of the parties had any reason to be ashamed. The church, a very small one, is in a neglected condition, and cracks in the walls, mildew, and cobwebs, would occur to an ordinary painter; but Hogarth has shown a fracture running through the table of the Commandments; the Creed is defaced by damp; and he has placed a cobweb over the opening in the charity-box. Again, an empty phial, labelled 'laudanum,' lies at the feet of the expiring viscountess, in the last scene of the 'Marriage à la Mode;' but this was not enough,—he has placed close to it the 'last dying speech of Councillor Silver-Tongue,' suggesting that it was the death of her lover, and not her husband, that caused her to swallow poison."

Laws become hurtful when they are carried to excess, and repetition becomes caricature when observed so closely as to verge on mockery. There is a curious instance of this in one of Turner's etchings, reproduced by Ruskin, and commended in his *Elements of Drawing*. In the fore-ground, standing on a bridge, are a man, a boy, and a dog; and in the distance, at the top of a hill, are a man, a boy, and a dog, the boy and dog in exactly the same position as those in the foreground. This is an example of repetition and symmetry which should not be repeated, and with which it is impossible to sympathise. In the same book, Ruskin mentions a picture by Vandyke, exhibited at Manchester, in 1857, representing three children in court dresses of rich black and red. The law of repetition was amusingly illustrated in the lower corner of the picture, by the introduction of two crows, in a similar colour of court dress, having jet black feathers and bright red beaks.

The true end of variety is to give relief to the eye; repetition is harmony until it becomes monotony; then variety should step in to relieve the tired and perplexed attention. Deviation from uniformity in the outlines of nature gives greater zest to the pleasure arising from the contemplation of order and regularity. Alison, in his essay on "Taste," observes, "Beautiful forms must necessarily be composed both of uniformity and variety; and this union will be perfect when the proportion of uniformity does not encroach upon the beauty of embellishment, and the

proportion of variety does not encroach upon the beauty of unity." Which sentence, properly understood, contains the essence of the art of composition.

Repetition is one of the principal elements of repose in art. No picture can be considered to have attained any approach to completeness that has not repose, and, for many reasons, it is still more necessary in photography than in any other means of representing nature. I am not certain that any perfect photograph—that is, one that has produced a perfect sense of completeness in the beholder—has ever been done which has not this quality to a very great extent. In the "Blind Fiddler," the expression and use of repose is perfect. The relief given by the happy serenity of the old man and the fiddler's wife and children is a very agreeable contrast to the action of the man snapping his fingers and the boy with his improvised musical instruments. I am aware that very exquisite large pictures of waves in motion have been published by Le Gray and others. I also know that Blanchard, Breese, Wilson, and one or two more, have attained very great success in representing moving objects in pictures for the stereoscope; but, even in its highest flights, art can only suggest motion; it cannot represent it. The pictorial representation of a moving mass depicts as immovable that which is in motion. The representation is, therefore, false. This is, perhaps, allowable in painting, where a certain licence is not considered improper; but for the photographer to do so is entering upon doubtful ground, and requires grave consideration. To represent the *result* of motion would be legitimate. It is a rule in sculpture that the right moment for representation is that of *arrested* or *suspended* action. If photographers would also observe this rule, it would save their works from the risk of any appearance of extravagance, or any suggestion that they represented a doubtful truth.

The last paragraph suggests that a word or two on what it is fit to represent by our art may not be out of place here.

The proper adaptation of means to an end—or, in other words, "fitness"—is a great source of beauty. Not only is fitness the proper application of means, but—especially in our art—the production must be a fit result of the means employed to produce it. Photographs of what

it is evident to our senses cannot visibly exist should never be attempted. The absurdity of representing a group of cherubs floating in the air, for instance, is felt at once. It would be possible, by double printing, to make a very passable photograph of a centaur or a mermaid, but the photographer would discredit his art; he would not be believed, and would deserve to be set down amongst charlatans and Barnums. He would be worse than the great showman, who, to his credit, confessed himself a humbug, while the photographer would expect the world to believe his work to be a truth. I am far from saying that a photograph must be an actual, literal, and absolute *fact;* that would be to deny all I have written; but it must represent *truth.* Truth and fact are not only two words, but, in art at least, they represent two things. A fact is anything done, or that exists—a reality. Truth is *conformity* to fact or reality—absence of falsehood. So that truth in art may exist without an absolute observance of facts.

A great part of the emotion of beauty, which we feel in regarding nearly all manufactured articles that aspire to this quality, has its origin in fitness. Decorative beauty depends, in a great measure, on fitness, and the beauty of proportion is also to be ascribed to this cause. Objects which are disgusting in themselves may become beautiful to the eye which sees their usefulness or fitness. For instance, we hear the surgeon talk of a " beautiful preparation," or a beautiful instrument.

It is no fault in a photographer that his art will not carry him as far as paints and brushes do the painter. His productions would only be defective when he failed to do what was possible in his art—an art in some respects more difficult than that of the painter, because, like sculpture, more circumscribed and limited. The photographer must not let his invention tempt him to represent, by any trick, any scene that does not occur in nature; if he does, he does violence to his art, because it is known that his finished result represents some object or thing that has existed for a space of time before his camera. But any " dodge, trick, or conjuration " of any kind is open to the photographer's use, *so that it belongs to his art, and is not false to nature.* If the dodges, tricks, &c., lead the photographer astray, so much the worse for him; if they do not assist him to represent

nature, he is not fit to use them. It is not the fault of the dodges, it is the fault of the bungler.

To conclude this subject, the painter may imagine new worlds, and interpret his imagination with his pencil; he may paint an embodiment of that which has not yet occurred, such as the last judgment, for example; he may represent angels and cherubim, and he does not commit a very great mistake, or, at least, one that has not already been condoned by artistic opinion. But, on the contrary, if the photographer—who could, if he had the skill, with the means at his disposal, follow very closely after the painter in representing his ideas of things unseen—attempts to do so, he holds his art up to ridicule and contempt; the reason being, that he violates "fitness."

CHAPTER XVII.

PORTRAITURE.

" Every man is always present to himself, and has, therefore, little need of his own resemblance, nor can desire it but for the sake of those whom he loves, and by whom he hopes to be remembered : this use of the art is a natural and reasonable consequence of affection, and though, like other human actions, it is often complicated with pride, yet such pride is more laudable than that by which palaces are covered with pictures that, however excellent, neither imply the owner's virtue, nor excite it. Genius is chiefly exerted in historical pictures, and the art of the painter of portraits is often lost in the obscurity of his subjects ; but it is in painting as in life : what is greatest is not always best."— *Dr. Johnson.*

PHOTOGRAPHY has been employed to represent everything under the sun and that is illuminated by his light ; nay, it has gone farther than this, it has brought pictures out of the caves of the earth, where the light of heaven never enters, and where the only source of actinism has been coiled up in a wire ; it has even compelled the pyramids of Egypt to give up some of their secrets, and the catacombs of Rome pictures of their dead. The earth, the sea, and the sky it delights to render ; it multiplies the works of genius, whether the original vehicle has been paint or marble, or that "frozen music" of which the great architects of old piled up their marvellous temples. The pirate and tne forger have called in its innocent assistance to help them in their dirty work, but for which photography has returned the compliment by assisting justice to execute the law ; and so truthful does the law consider its evidence, that it is accepted as an unquestionable witness which it would be useless to cross-examine. It helps the trader to advertise his wares, it aids the astronomer to map the stars, and compels magnetism to write its own autograph ; and all this in such a way as no other has ever yet approached. But of all the uses to which it has been put to benefit and delight mankind, none can compare with its employment for portraiture, the chief object to which its inventors intended it to be applied, and for which it appears to be most thoroughly adapted.

The portrait has always been the favourite *picture* with the world. It is an especial favourite in England, because it appeals to the domestic sympathies ; and this is the most domestic nation on earth. Johnson is

reported to have said he would rather have the portrait of a dog he knew, than all the historical pictures ever painted. Horace Walpole gives excellent reasons for preferring portraits to other pictures: " A landscape, however excellent in its distribution of road, and water, and buildings, leaves not one trace in the memory; historical painting is perpetually false in a variety of ways—in the costume, the grouping, the portraits—and is nothing more than fabulous painting; but a *real* portrait is truth itself, and calls up so many collateral ideas as to fill an intelligent mind more than any other species of painting."

Without disparaging other branches of art, as the author of the above sentence has done, there is no doubt of the extreme popularity of the portrait, and photography has only developed and encouraged a desire for representations of those we love, honour, or admire, by giving us the means of producing portraits, not only within the reach of the humblest purse, for their cheapness, but that we can believe in, for their truth. Before the birth of our art, those who could not afford to employ a Reynolds, a Gainsborough, or a Lawrence, had to be content with the merest suggestions of likeness, executed in the most miserable style. Even when the portrait was painted by a master, it required considerable faith to enable a person who did not know the original to believe in the fidelity of the resemblance. The friends of Sir Joshua Reynolds often used to express their surprise that he had courage to send home portraits that bore so little likeness to their originals. And from his painted portraits we have nothing like the faith in the personal appearance of Shakespeare we should possess had we a resemblance of him produced by photography. How are we to believe that the portraits of Lely are faithful likenesses of the ladies he painted, when they are so like each other that they appear to be one vast family of sisters? Kneller's portraits also appear like so many prints from one plate. Are we to believe that in the time of these two painters nature forgot her variety, or departed from her rule that no two men or women should ever be the same in form, feature, colour, or proportion? This mannerism, which tended to destroy faithfulness in portraiture, injured, more or less, the works of all painters, until photography came to teach them individuality.

L

The application of photography to portraiture has reformed and almost revolutionized that art throughout the world; yet ninety-nine out of every hundred photographic portraits are the most abominable things ever produced by any art, and the originals of them may often truly say, with the old Scotch lady who saw her own portrait for the first time, "It's a humbling sicht; it's indeed a sair sicht." This is not the fault of the art itself, but of those who, on the strength of being able to dirty a piece of glass with chemicals, are pleased to dub themselves artists. The late depression in the *trade* has done good in one respect, if it has borne rather hardly on some : it has killed off the weak ones—those who never should have left the occupations for which only they were fit, to discredit, by their miserable productions, a noble profession; for photography *is* a noble profession, although it is a mean trade. Photography has hitherto been a refuge for the destitute—

> "A mart where quacks of every kind resort,
> The bankrupt's refuge, and the blockhead's forte."

Again, the photographer has not often the advantage, enjoyed by the painter, of making the acquaintance of his sitter before he takes the portrait. He often sees him for the first time as he enters his studio, and has done with him in a short quarter of an hour. It requires great perception of character and great fertility of resource to enable him to determine at once, and at a glance, what is best to be done, what expression he should endeavour to call up, and what position would best suit his sitter. Great painters usually commence operations by dining with their subject, the value of which is shown in the following anecdote of Sir Joshua Reynolds, related by Leslie.

A matchless picture of Miss Bowls, a beautiful, laughing child, caressing a dog, was sold a few years ago at auction, and cheaply, at a thousand guineas. The father and mother of the little girl intended that she should sit to Romney, who, at one time, more than divided the town with Reynolds. Sir George Beaumont, however, advised them to employ Sir Joshua. "But his pictures fade," said the father. "No matter," replied Sir George, "take the chance; even a faded picture, by Reynolds, will be the finest thing you can have. Ask him to dine with you, and let him become

acquainted with her." The advice was taken, the little lady was placed beside the great painter at the table, where he amused her so much with tricks and stories that she thought him the most charming man in the world, and the next day was delighted to be taken to his house, where she sat down with a face full of glee, the expression of which he caught at once, and never lost; and the affair turned out every way happily, for the picture did not fade—a phenomenon occasionally met with even in photography—and has, till now, escaped alike the inflictions of time and of the ignorant among cleaners.

There are two morals to this little anecdote: the one is, that if all proper means are taken to secure a good portrait, *glass*-plate cleaning is not the *first* operation. The preliminary proceeding is to dine with your sitter; the disadvantage being, that the photographer's appetite should equal the extent of his business, which is not always possible, even in the present slack times. The second moral is, that the fading of pictures did not originate with photography. Sir Joshua Reynolds' pictures were known to fade even in his lifetime; which means, that it is possible for paintings in oil to deteriorate quite as quickly as photographs. It is not much consolation to the kettle to know that the pot is also black, but it is comforting to know, as we have known for the last year or two, that there is no more necessity for photographs to fade than there is for paintings.

CHAPTER XVIII.

PORTRAITURE—THE MANAGEMENT OF THE SITTER.

"In such cases there will be found a better likeness, and a worse; and the better is constantly to be chosen."—*Dryden*.

"The body of beauty is as essential as the soul of truth—truth without beauty cannot make art. * * * Without beauty there is no art. Over both the choice of subjects and their execution, this canon is inflexible. No other consideration in the choice of a subject, and no other merit in its execution, can atone for the neglect of beauty. Mere accuracy of portraiture is draughtsmanship, not art. The artist is he who above all men has an eye for the beautiful, and can embody the beautiful in some art form."— *Tainsh*.

As I am dealing with principles, I shall not, in these chapters on portraiture, give any illustrations of poses, which could be of very limited application, and would only induce in the student a habit of servile imitation, very detrimental to originality, and unworthy of him who would call himself an artist. An inferior photographer may find a few illustrations of different poses of some use to him, inasmuch as they may assist him in varying his *one* pose; instead of the one pose beyond which his feeble imagination will not allow him to venture, they may give him the use of three or four; but if he will take the trouble, or has sufficient ability, to master principles, he will find himself possessed of a continual fund of ideas ready for use, as is necessary in successful portraiture, at a moment's notice; if he have not the ability and patience to master the few principles on which his art is based, I hope he will excuse me if I hint that he had better try some other means of being of use to his fellow-creatures, for he would be only doing mischief to photography by continuing in the profession.

Besides being of very little use, there is also actual harm in a "set" of poses the structure of which is not understood, as will be seen if a sitter is allowed to select the position in which he will be taken—a pose, exactly suited as it might have been to the person represented, but, probably, no more proper for him than would be the costume attitude of a mediæval warrior to a modern merchant, or than the simple elegance of a Greek statue to a sea-captain.

Sitters often want to be made to look like other people; or, rather, they think that if they sit in the same position, and attempt the same expression, however unsuitable, they will look as well as some example they have seen.

It constantly occurs that persons will come into the reception-room, and, selecting a portrait of another, totally unlike in age, style, and appearance, will say : "There, take me like that." Peter Cunningham gives an anecdote that may, possibly, be out of place here, but is too good to omit. "When Bernard Lens was drawing a lady's picture in the dress of Mary Queen of Scots, the fastidious sitter observed : 'But, Mr. Lens, you have not made me like Mary Queen of Scots!' 'No, madam,' was the reply ; 'if God Almighty had made your ladyship like her—I would.'" The same may be said on behalf of the *lenses* of the present day!

Other sitters endeavour to improve their faces by all manner of contortions : stare with their eyes to make them larger, and screw up their mouths to make them smaller. Opie was once troubled with such a sitter, and he quickly said to him (so Haydon tells us) : "Sir, if you want your mouth left out, I will do it with pleasure." Instead of blunt wit of this kind, the photographer will find it answer better, and will involve less trouble, to make the sitter forget his mouth altogether. This cannot be done if the sitter is constantly reminded of particular features. Many photographers keep a cheval glass in their studios, to enable sitters to look at themselves while the exposure is proceeding. There are rare cases where the practice may be beneficial, but on the majority of subjects it has a very bad effect. I have tried it in my own practice, and found it was a great temptation to the sitter to make the most ridiculous contortions of the face, in the hope of calling up a satisfactory expression. King Lear's wise fool was, perhaps, not far wrong when he said, "there was never yet fair woman but she made mouths in a glass." The effect of "sitting" on the "sitter" has often been noticed, perhaps never more quaintly and forcibly than by Webster, the author of *The Duchess of Malfi*, who makes a character in one of his plays say—

> "With what a compellèd face a woman sits
> While she is drawing ! I have noted divers
> Either to feign smiles, or suck in the lips,
> To have a little mouth ; ruffle the cheeks,
> To have the dimples seen ; and so disorder
> The face with affectation ; at next sitting
> It has not been the same. I have known others
> Have lost the entire fashion of their face
> In half an hour's sitting."

A good deal depends on the temper of the sitter at the time of sitting. If he come in a great hurry, and feel bored by the operation, good results cannot be expected. Engagements should be made, that sitters should not be kept waiting. This is not so difficult to manage as may appear. Be punctual, and exact punctuality. Do not accept pictures to do in half an hour that should have more than double that time allotted to them. It is impossible to make a hungry man look happy. It may be said of a man whom the photographer has kept away from his dinner, as Menenius Agrippa said of Coriolanus :—

> "*He was not taken well :* he had not dined :
> The veins unfilled, our blood is cold, and then
> We pout upon the morning, are unapt."

It almost constantly happens that the photographer sees his sitter for the first time as he enters the studio. Thus he has no opportunity of studying the characteristic attitudes or expression, or the best general arrangement or effect. This difficulty is almost insurmountable, but can be most nearly overcome by an intimate acquaintance with the rules of art, which will enable the artist to think quickly, and make all his arrangements without hesitation, thus allowing him more time to study character. The figure should not be posed until everything is ready, and then the final arrangements should not take a minute. This can only be done when the operator quite knows his business, and has thoroughly made up his mind what he is going to do. He should be able to see the finished result in his mind's eye from the beginning. There is nothing so irritating to a sitter as being kept waiting after being posed; he begins to feel he is in a ridiculous position, when it should be the object of the photographer to prevent him thinking that he is in a position at all. A well-posed figure may be easily upset by a bungling use of the head-rest. Much depends on the judicious employment of the head-rest. (Let us lay it down as an axiom that this instrument is indispensable, even for short exposures, say of five or six seconds.) The rest should be understood, in ordinary cases, to be a delicate support, not a rigid fixture against which the figure is to lean. There is another rule that photographers should regard as axiomatic : *the rest should be moved to the head, not the head to the rest :*

first the pose, then the rest; not first the rest, and then the pose. In my own practice, I prefer a very light, simple rest, of the old American pattern, without any complications; one so light that I can carry it about after the sitter without trouble.

It must be borne in mind that, in a good photographic portrait, as in a painted one, it is expected will be produced—

"Not the form alone
And semblance, but, however faintly shown,
The mind's impression, too, on every face."

Here the educated photographer has a great advantage over those who are less fortunate. He will endeavour to so entertain his sitter that he will feel more at ease than if he were taken into a strange room, fixed incontinently in a chair, and photographed. It will be found that not only the expression will be improved, but that pictorial effect, as regards arrangement of lines, will also be much improved by the increased ease the sitter feels as he becomes more familiar with the studio and the student. I have known many persons who, after months of persuasion, have consented to have their portraits taken, and who came in fear and trembling, but who, by judicious treatment, have eventually so positively enjoyed the operation, that it has become almost a passion.

It is more than probable that this objection to "sit" has been engendered by the brusque manners, and rough, uncourteous, and conceited behaviour, of photographers themselves. A certain amount of self-confidence, if there is any basis for it, reacts favourably on the sitter, but it should not be carried too far, or some sensitive people may consider it amounted to rudeness.

A good deal depends on such an apparent trifle as the manner of taking off the cap of the lens and exposing the plate; and there is as much difference in the method of performing this simple operation, as there is difference of opinion amongst photographers on any other circumstance connected with their art. One will shout: "The exposure's agoing to begin!" in such an angry and threatening tone, that you feel inclined to call the police; while another will so smother you with the suavity of his manner, that you feel ashamed of troubling him. The first rarely

succeeds in anything but disgusting his customers; the other oppresses them by over-politeness. It is evident that some course between these two is the correct one. The photographer must have a strong will to enable him to carry out his idea as to arrangement, and sufficient subtlety to do so, and, at the same time, please his subject. His motto must be, *suaviter in modo, fortiter in re.*

It may be asked: What has all this to do with "Pictorial Effect in Photography"? Simply this: it is the province of the artist to secure the most characteristic, the most truthful, and the most pleasing aspect of every subject; and that, without regard to the matters to which I have been directing attention, character, truth, and beauty, will alike be wanting in photographic portraits, whether the originals be common-place or distinguished.

CHAPTER XIX.

PORTRAITURE—THE POSE.

"Peculiar toil on single forms bestow,
Then let expression lend its finished glow."—*Du Fresnoy.*

PORTRAITURE may consist in the representation of a single figure, or of a group of persons. We will first consider the composition of a portrait picture in which one person only is represented.

Long experience will show that the two sides of every face differ. This is very evident in many faces, and in all, however regular the eyes may seem, or however straight the nose may appear, close observation will discover that one side is better than the other. It is this side that should be taken. Even in a full, or nearly full, face this variation should always be noticed and taken advantage of. These deviations from exact correspondence of the sides of the face have not been considered blemishes by great painters, who invariably noticed and recorded them. It is notably so in the portraits by Reynolds. It may be seen in the print from the Ugolino, where it increases the look of fixed despair, and in the front face of Garrick, in which the difference of the eyes strikingly assists the archness of the expression.

In photographic portraiture the face should, as a general rule, be turned away from the light. If the face is turned to the light, however delicate the half-tones may be, the line of the nose will be partly lost in equal light on the cheek behind it. Painters occasionally represent faces in this position as regards the light, but then they have the advantage of colour to produce relief. The only exception to this rule—that the face should be turned from the light—is in the case of a profile, or the profile showing a glimpse of the off eye when the nose comes clear against the background. For these reasons—that is, because it is necessary to choose which side of the face is to be represented, and because the face must be turned from the light—it is well to have a studio so constructed that the light can be obtained from the right or the left; in a ridge-roof studio, with one side

M

glass and the other opaque, both ends should be available for use. It is also well to have it sufficiently wide to enable the operator to work diagonally, and thus get a modification of the shadows without the use of reflectors.

Having decided the side to be taken, which also determines the general direction of the light, the next consideration is that of attitude. As regards the position of the head, Burnet observes: "Every one who takes the trouble to reflect must perceive that all faces contain two points of view, where the character is more or less developed—a profile, and what is termed a front view; and that the seat of a strong likeness lies sometimes in one greater than in the other. They must also perceive that what is called a three-quarter view of the head gives the artist an opportunity of representing both; independent of which advantage, it has a greater variety in the forms, and gives an opportunity for introducing a greater breadth of light and shade, and also of showing the ear, which is often a beautiful feature." A full face is seldom so agreeable in photography as one slightly turned away.

In selecting and arranging an attitude, the application of the general principles I have dwelt on in previous chapters will be of more value than any recipe that could be given; in fact, as I have said before, any specific directions or plans of portraits—thus will we arrange a man, thus will we arrange a woman, or thus will we arrange a child—would interfere with individual characteristics, and do more harm than good. But a few general remarks may be useful.

A single figure should be complete in itself; it should not appear as though it had been cut out of a group, and it should be incapable of having another figure added to it without injury. The head being the chief object, every line should be composed in relation to it, and the student will find the rules of pyramidal composition invaluable to him here. He must consider contrast of lines and balance, variety, repose, and, above all, unity and simplicity. All the rules for the composition of a group—such as the "Blind Fiddler"—hold good for the single figure, bearing in mind that the head is the principal object, to which everything is to be subordinate, which is to receive the sharpest focus, the highest light, and the chief attention; after which, the hands will claim consideration. The hands will be found very useful in repeating, in a minor and subordinate degree, the mass of

light presented by the face. They have the advantage, in one respect, of not being of so much importance as the face; they may be displayed (always without affectation) if they are fine in form, or they may be hidden if necessary. Just as, in the "Blind Fiddler," no head is exactly under another, so ought not the hand to be exactly under the head. A great deal of character can be given to the hand, if properly treated. Sir Walter Scott, writing to Wilkie of a picture he had seen at Windsor, says : " There was a picture of the Pope, which struck me very much. I fancied if I had seen only the hand I could have guessed it not only to be the hand of a gentleman and a person of high rank, but of a man who had never been employed in war, or in the sports by which the better classes generally harden and roughen their hands in youth. It was and could be only the hand of an old priest, which had no ruder employment than bestowing benedictions." Sir Charles Bell, in his Bridgewater Treatise on the Hand, says :—" We must not omit to speak of the hand as an instrument of expression. Formal dissertations have been written on this ; but were we constrained to such authorities, we might take the great painters in evidence, since by the position of the hands, in conformity with the figure, they have expressed every sentiment. Who, for example, can deny the eloquence of the hands in the "Magdalen" of Guido ; their expression in the cartoons of Raphael; or in the "Last Supper," by Leonardo da Vinci ? We see there expressed all that Quintilian says the head is capable of expressing. 'For other parts of the body,' says he, 'assist the speaker; but these, I may say, speak themselves. By them we ask, we promise, we invoke, we dismiss, we threaten, we intreat, we deprecate, we express fear, joy, grief, our doubts, our assent, our penitence ; we show moderation, profusion ; we mark number and time.'"

The action of the figure should be that which is most common to the individual—such a position as shows it to the best advantage. No violent action should be allowed; no appearance of strain. Some photographers seem to think that grace consists of twists, and make spirals of their figures, especially ladies, by causing them to turn their heads over their shoulders, and try to look down their backs out of the corners of their eyes. The absurdity and affectation of this position is caused by exaggeration. A position approaching to it, but without the strain, is exceedingly graceful

if the figure should be sufficiently easy and pliant to allow of this pose. It cannot be too strongly impressed on the student that the possibilities of the figure must be considered before the attitude is chosen ; every figure will not allow of every attitude, any more than a decrepid old man of eighty or ninety could perform the feats of a skilful acrobat. Some figures are graceful in one position, while they would be awkward in another, probably still more graceful in a figure it suited. However graceful a figure may appear which has cost some effort in the sitter to attain, it does not compensate for the unaffected air and repose derived from the head and body placed in one direction, as we see in the grand portraits of old men by Titian, Vandyke, and Raphael.

It must not be supposed, from this last remark, that I advocate that every figure should be presented with the head and body exactly in one direction, although it is very suitable for some persons ; but it will be found that a very slight difference of direction between the head and the figure—as in the illustration—will be sufficient to give animation without disturbing repose.

The student will do well to observe attitudes assumed in every-day life, and adapt them to his art. When he sees a beautiful attitude, let him

speculate upon the cause of its being beautiful, and he will find that it depends for its effect on its consistency with the rules of composition ; and although these rules will not supply him with imagination sufficient to enable him to perpetually invent new arrangements, he will find they aid him very materially in giving expression to his inventions, and will prevent him being extravagant or exaggerated in his arrangements of the form. He should also store his mind with incidents suitable to his sitters, and he may then, perhaps, be able to give less occupation to the eternal book we see in the hands of photographées almost as often as a roll of paper is represented in the statues of statesmen.

Remarks on the treatment of the single figure should also contain something on the subject of vignettes, a style of portrait usually confined to the head and shoulders, a kind of picture so simple as apparently to require very little consideration, but I have seen them done so badly that a few words may be of service.

A vignette head, when nothing more than the head and shoulders is seen, should never convey the impression that the sitter was lounging in a chair or leaning on a table; the reason being, that as the table or chair is not visible, the figure would appear out of shape and deformed. As a general rule, the shoulders should appear level, as though the subject was standing. A little variation between the direction of the head and shoulders will always give variety and animation. The lighting should be more delicate than that suitable for other portraits, and the background should always be light. If the white margin to the vignette be very slightly tinted in the light after printing, the delicate effect will be increased ; but, when this is attempted, it is usually overdone, and then the effect becomes heavy, and worse than if the white paper had been left pure.

In conclusion, make it a constant practice, before removing the cap from the lens, to first give a rapid glance at the sitter, to see whether the outline of the figure composes well, that the light and shade is massive and round, and that there appears some indication of the expression you desire on the face of the sitter. If there is a lack of either of these qualities, do not waste your plate until you have got them before your lens.

CHAPTER XX.

PORTRAITURE—GROUPS—PROPORTION.

" *Grouping.*—My advice to photographers on the subject is something similar to *Punch's* celebrated advice to persons about to marry: 'Don't!' Except in very small pictures, it is almost impossible to secure a satisfactory group of more than two persons at once by photography. It tasks the skill and attention of the photographer quite enough to see that the arrangement, lighting, and expression of one figure are perfect."—*Rejlander.*

" If there be no room, thrust away the meaner parts, and give praise that thou retaineth the chiefer portion."—*Lairesse.*

THE composition of a portrait group depends very much upon the character of its constituents. Two or three children, if they are not excessively stupid samples, are very easy to group together, and, when well done, make the most agreeable and natural pictures ; while two adults, especially of the male kind, although easier to photograph, seldom make an effective composition.

The great art in the composition of a group is in so arranging the figures that they shall have some relation to each other, as well as the ordinary elements of pictorial construction. There should be some bond of union between those who compose the group ; some incident should be represented in which they are mutually interested; or something must be imagined out of the picture to attract the attention of both, if only two are represented, or of many of them, if there is a number. The figures should be massed together, and not scattered over the picture so as to make it necessary to examine each portrait in detail, until it has been seen, and the effect agreeably felt, as a whole. Nothing has a more disagreeable effect than two figures in one picture which may be cut in two without much injury to either half—two figures, like Enid and Geraint in the wild land,—

> " Apart by all the chamber's width, and mute
> As creatures voiceless, thro' the fault of birth,
> Or two wild men supporters of a shield,
> Painted, who stare at open space, nor glance
> The one at other, parted by the shield."

It is not necessary, in representing two persons in conversation, that

they should be looking at each other; the effect of listening can be rendered without putting them to that trying ordeal. It constantly happens that in conversations even on the most important subjects, the talker and the listener do not look at each other, although, even if the sounds were not heard, it would be obvious from their appearance that the persons were in conversation. One point which should command the attention of the student is, that there should be variety in the heads, not only as regards profile, three-quarter, or full face, but in their position on the paper. Thus, it is difficult (although possible) to obtain much pictorial effect out of two figures of exactly the same height standing together; in such a case variety must be got in the lines of the different figures by varying the direction of the bodies, by the arrangement of the arms and hands, and by the disposition of the accessories and background.

It is by the amount of perfection with which he succeeds with groups that the photographer will discover the power that is within him. If, after repeated attempts, he fail, or do not succeed to his satisfaction, he will do well to confine himself as much as possible to vignette or medallion heads, a style demanding some taste and care, but taxing the artistic powers much less than more elaborate compositions. Many photographers have so studied the best methods of treating the head, and the head alone, that they have succeeded to admiration, and attained high reputation by this class of work. They have preferred to succeed by doing a simple style well, rather than a more complex style imperfectly.

Some artists prefer to have to make a group of three persons rather than two. I confess that the more figures I have to deal with in portrait photography, the more difficult I find my task. More than three or four figures should never be attempted in one negative, if it is necessary that every person should be a good portrait. I leave out of consideration, here, large out-door groups taken on the hit-or-miss principle. It is impossible to get more into an upright carte-de-visite without crowding. I have seen a dozen or more figures in a card portrait; but we are speaking of composition here, not of figures thrown together in a heap, with a head appearing here and there just as it gets the opportunity. If more than four figures must be included in the small dimensions of a carte-de-visite, it would be much

better to turn the camera on its side, and make a horizontal picture of it. I have seen some most delightful little gems of pictures of this kind by Angerer, in which the interior of a large drawing-room of people—full without crowding—was represented. I should much like to see pictures of this kind introduced into England, but the large size of the glass room required would, I fear, prevent all but a few attempting them.

When the picture is larger than a carte-de-visite or cabinet size, it is always better and much easier to produce a group by combination printing. Photographers appear to have been afraid of the difficulties of this method; but I am glad to see it is coming very much more into use, as photographers obtain a more intimate knowledge of the capabilities of their art. To accomplish this, a sketch should be made of the composition, no matter how roughly done, so that the artist knows what he intended by it, when he looks at it a second time; or the figures may be placed in position, and a small photograph taken of the arrangement. They should be so grouped that the joining should come in unimportant places. Although it is possible to make a perfect join, even in such a difficult place as down the line of a delicate profile,* it is better, if possible, to keep the mechanism of the art out of sight. When a sketch or small photograph of the complete arrangement is obtained, the groups or single figures should be photographed in detail, by preference against a white or very light screen, if a background is also to be put in. If the background is to be an interior, it will be found most convenient to take it with the figures, the accessories being so arranged that the lines of junction will not be seen.

A natural background may be introduced behind a single figure with great effect, and it has been lately shown that it may be used with advantage for pictures so small even as a carte-de-visite.

A great deal of the effect of a portrait will depend on the position the figure occupies in the picture. A glance at the illustrations will show this.

* In the presentation print—"Watching the Lark"—produced for the Photographic Society, a join down the outline of a profile was purposely arranged, to show that it was possible. The copies were printed entirely by assistants, and not five per cent. were discarded in consequence of defective joining.

As a general rule, if the head be not equidistant from the sides of the picture, there should be more space allowed before the face than behind, as in fig. 1. The awkward effect of the reverse of this will be seen in fig. 2.

Fig. 1.

Fig. 2.

A disregard of this rule has spoilt the effect of many otherwise good pictures. In some photographs we see the figure walking almost out of the picture, for the sake of showing the last coils of the long caudal appendages with which ladies sweep the dust, thus sacrificing the head for the tail.

The apparent height of the person represented depends almost entirely on the position of the figure on the plane of the picture. The taller the person, the nearer to the top should the head be placed, and, if the figure be a full length, less of the ground should be shown. A short person should be brought lower in the picture. In figs. 3 and 4 the contrast is shown.

It often happens that the figure is made much too big for the picture. I have seen some cartes in which the head nearly touches the top of

the picture and the feet the bottom, so that, when they were inserted in an album, some part must be covered, perhaps a foot cut off, or perhaps half the head. This is done, I suppose, under a mistaken notion on the

Fig. 3.

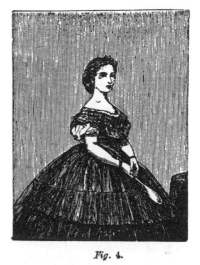

Fig. 4.

part of the photographer, that he is giving enough for the money, a principle to which I have no objection, but let the " enough " be in quality rather than in quantity. A carte-de-visite displaying proportion, taste, and a right feeling for art, is of much more value than a life-size picture, whether by painter or photographer, that does not possess these desirable qualities.

There has been a notion prevalent that all figures must be taken to scale ; thus, if a six-foot figure be represented in a carte-de-visite as three inches long (about the right proportion), a child three feet high must therefore be represented as half that height, or one inch and a-half. If it be necessary to make elevations of (say) a family, to send to friends at a distance, to compare with others taken some time before, to demonstrate the fact that the children are growing, then this method must be followed ; but the photographer should never forget that it is his business to make pictures, and that a figure one and a-half inches high will not fill a picture

of the usual card size with anything like effect; I therefore advise that a little licence should be taken in this particular, and that when a child is to be photographed, all consideration of how much of the picture would be filled by a grown person, with the camera at a certain distance, be forgotten, and that nothing but the child, the object then before the photographer, should engage his thoughts.

The same disregard of proportion exists amongst landscape photographers; many would prefer to sacrifice effect rather than cut away a little of the foreground, and thus depart from their regulation size.

CHAPTER XXI.

BACKGROUNDS.

"By the choice and scenery of a background we are frequently enabled to judge how far a painter entered into his subject, whether he understood its nature, to which class it belonged, what impression it was capable of making, what passion it was calculated to rouse. Sometimes it ought to be negative, entirely subordinate, receding, or shrinking into itself; sometimes, more positive, it acts, invigorates, assists the subject, and claims attention."—*Fuseli.*

IN portraiture, the background, often neglected and considered as but of little moment so that it be clean and smooth, should hold a very important place when the composition and chiaroscuro of the picture are considered. The backgrounds of his portraits were thought to be of so much consequence by Sir Joshua Reynolds, that he frequently declared that whatever preparatory assistance he might admit in his draperies or other parts of the figure, he always made it a point to keep the arrangement of the scenery, the disposition and ultimate finish of the background, to himself. The most carefully manipulated portrait, exhibiting the most delicate photography, and the most refined light and shade and composition, may be destroyed, or its beauty much impaired, by an ill-chosen background; or it may be efficiently aided and supported by a proper and suitable arrangement of form and light and shade in this important portion of the picture.

The general practice with most photographers, until lately, has been to employ a perfectly plain, even-tinted background, or badly-painted representations of interiors or landscapes; but the large collection of pictures by Adam-Salomon in the Paris Exhibition of 1867 convinced photographers of the extreme value of light and shade, gradation and tone, behind the figure, to relieve some parts and to hide others, to give breadth and concentrate attention to the principal feature, the head. Other photographers have known the value of this effect, and have exhibited their results, but never so large and convincing a collection as the one I have mentioned.

In using a plain background, without any variation of light and shade,

the photographer throws away a great advantage. Nothing could be more antagonistic to breadth, atmosphere, and richness—nothing could so surely secure a flat, inlaid effect to the figure—than a plain background. It would be difficult to find a surface without gradation in nature. Take the plain surface of the wall of a room as a background, and you will not find it easy to discover a sufficient space for a background on which a shadow modifying its even tint does not fall. The cloudless sky is marvellously gradated from the zenith to the horizon; and so you may go throughout all nature till you surprise yourself with the discovery that the only plain, blank thing in this world is a photographer's background, on which the equal light falls from a broad expanse of glass. Ruskin, in his *Elements of Drawing*, has a fine passage on gradation of colour, which is equally applicable to light and shade, and, therefore, to our subject:—" Whenever you lay on a mass of colour, be sure that however large it may be, or however small, it shall be gradated. No colour exists in nature, under ordinary circumstances, without gradation. If you do not see this it is the fault of your inexperience; you will see it in due time if you practise enough. But in general you may see it at once. In the birch trunk, for instance, the rosy-grey *must* be gradated by the roundness of the stem till it meets the shaded side; similarly, the shaded side is gradated by reflected light. Accordingly, you must, in every tint you lay on, make it a little paler at one part than another, and get an even gradation between the two depths. This is very like laying down a formal law or receipt for you; but you will find it merely the assertion of a natural fact. It is not, indeed, physically impossible to meet with an ungradated piece of colour, but it is so supremely improbable that you had better get into the habit of asking yourself invariably, when you are going to copy a tint, not 'Is that gradated?' but, 'Which way is that gradated?' and at least, in ninety-nine out of a hundred instances, you will be able to answer decisively after a careful glance, though the gradation may have been so subtile that you did not see it at first. And it does not matter how small the touch of colour may be, though not larger than the smallest pin's head, if one part of it is not darker than the rest, it is a bad touch; for it is not merely because the natural fact is so that your colour should be gradated; the preciousness

and pleasantness of the colour itself depend more on this than on any other of its qualities, for gradation is to colours just what curvature is to lines, both being felt to be beautiful by the pure instinct of every human mind. * * * What the difference is in mere beauty between a gradated and ungradated colour may be seen easily by laying an even tint of rose-colour on paper, and putting a rose-leaf beside it. The victorious beauty of the rose, as compared with other ﹒flowers, depends wholly on the delicacy and quantity of its colour gradations, all other flowers being either less rich in gradations, not having so many folds of leaf, or less tender, being patched and veined instead of flushed." Further on he says :—" You will not, in Turner's largest oil pictures, perhaps six or seven feet long by four or five high, find one spot of colour as large as a grain of wheat ungradated ; and you will find in practice that brilliancy of hue and vigour of light, and even the aspect of transparency in shade, are essentially dependent on this character alone : hardness, coldness, and opacity resulting far more from *equality* of colour than from nature of colour."

It is thus with photographs and pictures in monochrome : an isolated mass of dark is not rich, neither is a separated space of light brilliant ; it is opposition and gradation of the one with the other that produce richness and brilliancy. Therefore a plain background is the most destructive to pictorial effect that could be placed behind a figure. A glance at the illustrations to the preceding chapter will show that one of the effects of a plain background is to represent the figure as cut out and stuck down on a piece of plain grey paper.

Haydon called the background the most hazardous part of the picture, and a subject that required as much consideration as the figures, because, be the figures ever so good, their effect may be seriously injured by ineffective support. There is a story told of Rubens by which it will be seen that he also considered that to the effect of the picture the background is of the greatest importance.

A young painter, being anxious to enter Rubens' studio as a pupil, induced an influential friend to recommend him, who did so by informing the great painter that he was already somewhat advanced in art, and would be of immediate assistance to him in his backgrounds. The great painter,

smiling at his friend's simplicity, said, that if the youth was capable of painting his backgrounds, he stood in no need of further instructions; that the regulation and management of them required the most comprehensive knowledge of art.

It would be impossible to give definite instructions for the management of the background, but the treatment of different artists may be alluded to. The system adopted in most of his pictures by Adam-Salomon, following the plan of many of the most famous portrait painters, appears to be that the lightest side of the figure shall be relieved by dark, and the darkest side by light. The upper corner of the picture, on the side from which the light comes, is intensely dark, the shadow being gradated diagonally across the picture into middle tint behind the head; this middle tint is again more abruptly opposed and carried away into dark by the accessories, or is again allowed to die away into shade. He also appears to appreciate the value of a vertical line in the background, to give stability to the composition, usually obtaining it by the straight lines of a fluted column (an objectionable accessory, in my opinion, for reasons which I shall give in the next chapter). There can be no doubt that these pictures of M. Adam-Salomon are the most effective portraits, containing all valuable qualities, that have yet appeared in photography, and afford a most valuable lesson to photographers.

The backgrounds to the portraits of Sir Joshua Reynolds are always worthy of study. Some of his finest and richest pictures have a dark ground, on which the head shines like a jewel; many are relieved in the manner employed by Adam-Salomon; and it is to be noticed that in nearly every picture in which the background is gradated, he has introduced one or two vertical lines to aid the composition, generally a dark line and a light one, a mere suggestion of a pilaster. His landscape backgrounds are always singularly appropriate and natural, although the horizon in many instances is lower than we should feel justified in representing it in such a truthful art as photography. Although his practice was to relieve the dark side of the figure with light, and the light with dark, in one of his discourses he advocates an opposite treatment, one which is to be found in the work of Correggio and other painters of his school. In commenting on

the precept of Leonardo da Vinci, that the shadowed side of the figure should be relieved by light, Sir Joshua says :—"If Leonardo had lived to see the superior splendour of effect which has been since produced by the exactly contrary conduct—by joining light to light and shadow to shadow—though without doubt he would have admired it, yet, as it ought not, so probably it would not, be the first rule with which he would have begun his instructions."

On whichever principle you arrange your background, you must remember that it should relieve the figure, and not produce an inlaid effect, and that it should present with the figure an agreeable breadth of light and shade.

When will background manufacturers supply gradated screens? They all tell you that it is impossible to produce them. This I know to be an error. They are difficult to paint, but I know from actual experience that the thing can be done. If photographers would insist upon having what they wanted, they would get it. They should not be content to use anything with which the manufacturers choose to supply them.

CHAPTER XXII.

ACCESSORIES.

"Fit it with such furniture as suits
The greatness of his person."—*Shakespeare.*
" It shall be so my care
To have you royally appointed, as if
The scene you play were mine."—*Shakespeare.*

PERHAPS in no other one part of their art have photographers so outraged nature as in the choice of accessories and the make-up of their pictures.

Let me turn over the leaves of an album, and describe one or two of the pictures contained therein.

No. 1. A portrait of a lady in an evening dress, walking on the sea-shore ; in consideration of her thin shoes, that part of the sands on which she is standing is carpeted.

No. 2 represents a veteran photographer standing on a terrace. The terrace is carpeted, and on it stand a pedestal and column, round which is festooned a curtain elaborately tied up in various places with cord and enormous tassels. The distant landscape is delicately and well done, but adds force to the absurdity of the curtain in the open air.

No. 3. A gentleman standing before a profile balustrade and pillar, with landscape behind representing distant mountains. The light on the figure is from the right, that on the balustrade from the left. The shadow of the column falls on the distant mountains, which are much more clearly defined than the head of the figure.

No. 4. A lady reading at a window, but the light comes from the opposite direction. The shadow of the window-curtain falls on the sky.

No. 5 represents a gentleman with a gas chandelier, globes and all, sprouting out of the top of his head.

There are one hundred pictures in the book, many of them from the most popular studios. There is a column or balustrade in seventy-eight of these cartes. And yet photographers accurately represent nature, and are surprised their profession is not recognized as a fine art !

A curtain is allowable, because it is possible ; but the use of the column

O

is open to very grave doubt, and the two together are so exceedingly improbable as to be almost absurd. It is true, the employment of these accessories as a background is to be found in the pictures of some great painters, but the tricks of one art may not be applicable to another. The column and curtain are conventional. Now conventionalities may be right in an art like painting, where a good deal of licence has been allowed, and has become sanctioned by custom, but photography is a new art, the results of which are supposed to be taken direct from nature, and is without precedents. It is an art in which departure from truth becomes absurd. We, the workers in the first quarter-century of its existence, are the makers of precedents: let us be careful, then, that they are not misleading and dangerous ones.

Photography is the most imitative of all the arts, and photographers the greatest imitators, as they have shown by the way they have followed and adopted much that is bad in the practice of painters; and perhaps the worst of these imitations has been this column-and-curtain conventionality for most of their sitters, when it is probable that few under the rank of those who dwell in palaces ever naturally have the opportunity of being in the neighbourhood of such accessories. In painted pictures the column is shown with some chance of possibility, but the way in which it has been used in photography has been ridiculously absurd, it generally being placed on a carpet. Now everybody must be open to the conviction that marble or stone pillars are not built on carpets or oil-cloth for a foundation. But there was a lower depth. Wooden columns were not bad enough, nor cheap enough, so recourse was had to imitations of these sham pillars, manufactured out of flat boards and canvas, and painted in perspective that looked every way in vain for the point of sight; if any of the lines were right, it was on the principle that makes a clock that does not go, right at one second of the day at least. The violent light is often represented as coming from the opposite direction to that which illuminated the figure Then, by a stroke of genius, somebody extended the application of these profile slips to the representation of other objects, such as chairs (on which, being flat, it was impossible to sit down), pianofortes, fireplaces, French windows, and everything that was capable of being caricatured in this manner. But the " crowning glory " of

this kind of sham furniture was the *multum in parvo*, or "universal," that Protean construction which was at one minute a pianoforte, and at another a bookcase—a sort of economical houseful of furniture in one piece. This was certainly an improvement on the slips, and if manufacturers would only add a little taste to their cabinet work, suppress the rococo ornamentation, and make them much plainer, they might be of use where the very best work is not necessary.

But if you have any pride in your art, if you desire to do the best that can be done, you must eschew imitations, and have nothing in your studio but genuine furniture of the best kind, and of good design and character. When the photographer is furnishing, he would find it a good plan to fit up, not only his studio, but his reception rooms also, with chairs of different patterns—a "Harlequin Set," as collectors of old china would call it—so that he may be able to make a constant variety in his pictures. He would do well to avoid the elaborately carved, high-backed chairs, so constantly seen in photography, and seldom anywhere else, the high backs of which often stick out round the head like a Gothic glory : if this chair be used at all, it should be so arranged that the head of the sitter is quite clear of it. Dining-room and library chairs are always useful, so also is that kind of chair to which the name of *Prie-Dieu* is given, especially for standing figures. It is very difficult to meet with a good arm-chair suitable for photographic purposes. The chairs of the present day are made more for comfort than appearance, and are so low that the sitter is dwarfed and foreshortened. It would pay manufacturers to employ a good designer to supply them with patterns and make them for the profession.

After chairs naturally follow tables. It is scarcely necessary to say anything against the little round table, about twelve or fourteen inches in diameter, to be seen in many early photographic portraits, the use of which is now gone out, except in the smallest and lowest glass sheds. The furniture in a picture should give an idea that there is space in the room; this is not done when a small table is employed, obviously because there is no room for a larger one. A long, oval table, about three feet six inches by one foot six inches, is a very useful size and shape ; it should be made light, and upon large castors, that it may be easily

moved. This should be provided with one or two good covers of a quiet pattern. In a table-cover, as in the covers of chairs and cushions, violent and "noisy" designs should be avoided. As a change from the plain table, a more elaborate carved oak table may be admitted for occasional use, and so may a judiciously selected cabinet; but it must be always remembered, in introducing these accessories, that it is the portrait of the sitter that is required, and which must be most prominent, and not the magnificence of the fittings of the studio, which may be " richly suited, but unsuitable."

Some photographers employ a table which can be raised or lowered, to suit the stature of the sitter, by means of rackwork. This, in the hands of a photographer of great judgment, may be a very useful accessory, but it is a power that should be employed very sparingly, and within very narrow limits. If it were raised too high, it would dwarf the figure by comparison; or, in the reverse case, by screwing it down too low, it would transform the sitter into a giant, reminding us of the carte-de-visite of the short man whom *Punch* represented as having his portrait taken surrounded by toy furniture. The same principle has also been applied to the pedestal and column.

The great idea of many photographers, in taking standing figures, seems to have been that they must have something to lean upon, and, therefore, the want was supplied by a pedestal that outraged nature, as I have already said, most abominably. It is not necessary to an easy and graceful effect that the figure should appear to be too tired to stand on its own feet. Lounging is no more graceful than is a lisping and insipid manner of speaking gracious, but tends more to what Sir Joshua Reynolds called the most hateful of all hateful qualities, affectation. If people look well in a standing position at all (which some certainly do not, and should never be taken so), they will be found to do so without the aid of a prop; but still, for the sake of variety, and because some people have been so often taken with a support that it has become a custom with them from which they do not like to depart, it is as well to have something of the sort at hand. The best piece of furniture of the kind is a cabinet. A low book-case is not objectionable, neither would be a well-designed what-not, but the ugly

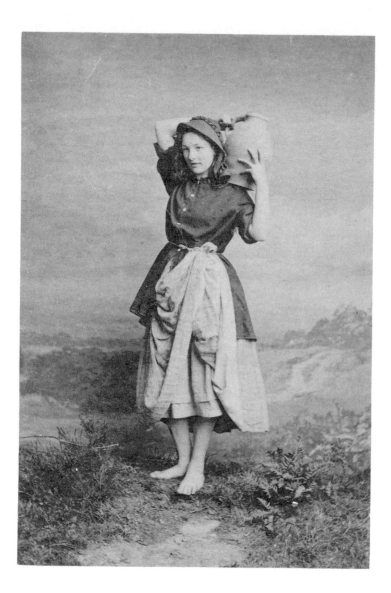

meaningless pedestal should never be used. I should consider I was doing a great service to the art progress of photography if I could induce all photographers who have columns and pedestals to burn them at once. Don't send them to the broker; he may sell them again, to do further mischief.

A few ottomans and footstools of various sizes should always form part of the furniture of the studio. They are especially useful in grouping children. The carpet of the room should be of a small, neat pattern, and contain no great contrasts of dark and light.

A great deal can be done, and very beautiful pictures made, by the mixture of the real and artificial in a picture. Although, for choice, I should prefer everything in a photograph being from nature, I admit a picture to be right when the "effect" is natural, however obtained.* It is not the fact of reality that is required, but the truth of imitation that constitutes a veracious picture. Cultivated minds do not require to believe that they are deceived, and that they look on actual nature, when they behold a pictorial representation of it. An educated observer does not, like that Moor to whom Bruce, the African traveller, gave the picture of a fish, believe that the artist had made a reality, and say: "If this fish at the last day should rise against you and say, 'Thou hast given me a body, but not a living soul,'—what should you reply?" Art is not the science of deception, but that of giving pleasure, the word pleasure being used in its purest and loftiest sense. For this purpose—that is, the mixture of the real with the artificial—the accessories of the studio should receive the addition of picturesque or ivy-covered logs of wood, ferns, tufts of grass, &c., either growing in low pots, or gathered fresh. It will be found easy to make up picturesque foregrounds with these materials, behind which a painted view or sky may be placed. If the background be well painted, it will be found to unite very naturally with the foreground. Care must be taken that linear perspective be avoided, and that the light fall on the figures in the same direction as it does on the painted screen.

* The photograph which illustrates this chapter is an example of this kind of picture. In this instance the foreground was made up of turf, ferns, heath, &c., placed on a platform, which moved, for the convenience of rolling it about the studio, on large castors, the background being a painted screen.

CHAPTER XXIII.

SOME OLD NOTIONS TOUCHING PORTRAITURE.

" And out of olde bookes, in good faithe,
Cometh all this new science that men lere."—*Chaucer.*
"The satirical rogue."—*Shakespeare.*

HAVING concluded my task as far as relates to the composition of lines, and having touched upon photographic portraiture and all concerning it, before I commence what I have to say on chiaroscuro I feel tempted to interpolate a chapter culled from a rare old quarto, a translation of which was published in the last century, and which, from the quaintness of its manner, will be interesting and readable, as well as for the down-right good sense and sound teaching it contains. Much of what I have extracted will be found of great value to the portrait photographer.

The title of the book is "The Art of Painting in all its Branches, Methodically Demonstrated by Discourses and Plates, and Exemplified by Remarks on the Paintings of the Best Masters, and their Perfections and Oversights laid open. By Gerald de Lairesse. Translated by John Frederick Fritsch, Painter." This book was written long before Reynolds, Gainsborough, and those famous painters who revived the art of portraiture, became known to the world. This is what the translator says of his author and his book; he might have been talking satirically of photographic art-teaching in our own day :—" The author's known abilities and great reputation in Holland having justly recommended him to the esteem of the most knowing there, I thought it very proper to make him speak English; and the rather (to use his own reason) for that, though many excellent authors have written on painting, yet, in bulk, they seem rather to cry up the art and the artist than lay down solid rules for attainment. To which I may add, that those authors are mostly useless to an Englishman, and few or none copious enough to answer general purpose; nor at best are of general service in England, where fresh and fair nature is preferred before the brown and warm colouring of some other countries, especially

Italy, where the best books have been written on the subject. But principally for that I think nothing has been published here so learned, full, and complete, and so well explained by plates and examples as the author will be found to be; nor, perhaps, wherein portraiture (a branch which England mightily affects) is so copiously handled."

Passing by some hundreds of pages on pencilling, beauty, ordonnance or composition, colouring, landscapes, &c., let us extract some sentences from Book VII., "Of Portraiture," the subject we have in hand.

Since we meet with no precedence in the art, nor pretend to insist on ceremonies, we shall treat of things as they occur to us, and as clearly and profitably as possibly.

As in music and singing, a good ear is requisite, so in portraiture it is impossible to excel without a good eye; such an one, I mean, as is governed by sedate and sober sensation, and not by self-love and passion. Next, we must be thoroughly judicious in the graceful choice of light, and the place where the person is to sit, that the face may appear to the best advantage; and then the body is to be disposed to the most natural and becoming posture. As for the choice of light, in order to apply it most advantageously for the benefit of either sex, it is certainly a matter of great moment, since the fair sex commonly partake of more delicacy and grace than men, so they must have a light as beautiful and agreeable as their persons.

But our author is heterodox here. He says: "I think those masters have made the best pieces who have chosen a front-light." He should have been painter to Queen Elizabeth. In continuation of the subject of light and shade, he mentions some things that should be avoided by those who imitate M. Adam-Salomon.

We see that many, without difference, be the figure in full proportion or in little, give the touches under the nose so black and dark that it seems as if a black beetle were proceeding thence; whereas it is certain, and nature teaches it, that when the light falls strong on the nose, the nostrils and their ground-shades can never appear so black; and yet some think they have done great feats in using force and strength, and will do it even in a fair and tender face, and no bigger than the palm of the hand, although the deepest black should not have force enough to shade the other objects of a darker colour, such as hair, a cloak, or other garment: by which sort of management the face seems to jump out of the frame, and to desert the wig, hair, and garment. We must not so understand when we teach that the face must have the main light; we mean only that all ought to keep due order, that it may look natural.

On dress, accessories, and the management of the sitter, we have the following capital remarks, which are as applicable to photography as to painting. There will be noticed a curious vein of satire throughout. He is rather hard on the ladies.

Self-conceit and self-love seem natural to all, but especially to the female sex, who, whether their pictures are drawn on their own accounts or through the desire of others, imagine they deserve much

homage; nor stops it here, for although they may possess a tolerable share of beauty, yet that is not satisfactory enough, they must be flattered, and their pictures painted in the most beautiful light; and unhappy is the painter who abates but half a drachm of such a beauty.

For these reasons the master is obliged to have a principal regard to light and shade; but to the light chiefly, since it is well known that nothing gives greater offence to ignorant people than shades, and still more when they are strong and broad; they believe they speak to the purpose in objecting: " Well, how can it be possible that my neck and cheek should have such large shades, when I daily consult my glass and find my skin all of a colour and white? " and then the painter is blamed. But are not such reasons weak and absurd?

It is evident that backgrounds contribute very much to the charming grace of objects; nay, I dare say, that the decorum mostly depends thereon; and though many imagine that a black or dark ground always becomes a portrait, yet it is no rule, since, as before has been said, each individual object requires a particular background; besides, if such things were to be taken for rules, the art would smell too much of an handicraft.

It may not be foreign to our main design to put the artist in mind of the application and right use of such materials as may enrich a portrait and make it look the more noble. This is so great a point in portraiture that when well known we need never be at a stand through the mis-shape or defects we often meet with in the disposition of a portrait, and which sometimes must not be hid, since we have often means enough for obviating them with seeming reason, and without forcing nature; as a long and narrow face may be helped by a hood or other head-dress; a thick and too round a face by the contrary; a figure too lonesome may be embellished by such things as are proper to it, which serve not only for ornament and grandeur, but also to express the sitter's lustre and virtue; but care must be taken that the figure of the sitter, as the principal object of the piece, fill up the major part of it, either by a spreading sway of the posture, or by the addition of some proper by-work, by which means it will have a good effect.

Some persons may be too long and sharp-nosed, or too hollow-eyed; for such, a low light is most proper; but when it is otherwise, an high light. In this manner a judicious master ought to help the defects of nature, without adding to or taking anything from them; yet, to the sorrow of impartial masters, the contrary is too often seen, for with many portrait painters their work is better known by their particular manner than the sitter by his picture.

I think, also, that the common and useful dress of a person is a great addition to likeness; for no sooner is the dress altered but the look does the same, and shows itself either more or less pleasing and agreeable. Some painters keep in their room for the use of all their sitters, be it he or she, without discrimination, certain pieces of cloth and velvet, by which they imitate the Roman manner; but thereby the persons represented become more or less unknown.

The following is capital advice :—

The painter should likewise discover and know, as much as possible, the nature and temper of the person sitting, and in what circumstance lies his favourite pleasure; that he may, when sitting, be entertained with talk pleasing to him, and his air thereby kept steady and serene, and his posture natural and easy; avoiding everything tending towards sorrow or frightful relations, for these are apt to ruffle the mind and so to decompose the face that it cannot easily be got right again; but if the sitter himself do, by his talk, discover his own bent, the painter ought to humour him to the last, whether it be jocose or moderate, without exaggeration or diminution, yet with such a variety as not to prove tiresome and make the face alter.

But to return to the original matter: I must warn the artists not to give in too much to what is common, or humour ignorant people so much as not to reserve to themselves some liberty of doing what they think proper for the sake of reputation. Surely this cannot be strange advice; for a maste

who prefers money before art has no more dangerous rock to split on, since the ignorant multitude usually insist to be drawn according to their own whims. One says to a good master: "Draw me thus, or thus; let me have one hand on my breast, and the other on a table;" another must have a flower in his hand, or a flower pot must be by him; another must have a dog, or other creature, in his lap; another will have his face turned this or that way; and some who would be drawn in the Roman manner must be set off by a globe or cloak on the table, whether such ornaments be proper or not. On mentioning the Roman manner, I find that it signifies a loose airy undress, somewhat savouring of the mode, but in nowise agreeing with the ancient Roman habit.

This is admirable and true. The fine gird at the " Roman" manner is capital. In the author's day it was the custom to have portraits and statues habited in classical costume, with, perhaps, the addition of the immense "Duvilliers" wigs of the period, an absurdity that West, greatly daring, and against the advice of his brother artists, broke through for the first time in his "Death of Wolfe." This manner of trying to make the sitter look a much finer fellow than he really is has its counterpart at the present time, even in our own art, and is followed by photographers who *will* defy nature, and stick to precedent. As our author says:—

Some painters will keep to the old road, because it is difficult to correct a rooted evil; they do as the old woman did, who, being exhorted in her last sickness to embrace the true faith, answered, "She would follow the steps of her forefathers, were they all gone to the devil."

There is a pernicious custom, among some inferior photographers, of collecting together a set of poses, and fitting their sitters to them, or of allowing their customers to select their own, no matter how incongruous the thing may be, so that it is paid for. This is a detestable practice. Photographers should learn the principles of their art, and then invent poses for themselves, instead of crowing in borrowed plumes. The effect is peculiarly ridiculous when the feathers are too fine for the bird, and the "artist" endeavours to make a maid-servant look like a duchess. Here would be a time to introduce your column and curtain, if you like! Lairesse, with the instinct of a true artist, is very severe on a similar practice.

I have discovered a great oversight in some artists, which is, that when the face is finished, they had no further regard to the life, but chose a posture at pleasure out of drawings and prints, without considering whether it suited the person, and whether the figure was proper to the condition and countenance of the sitter; nay, whether the head matched the body; certainly a great heedlessness. If things be done without making distinction of persons and their conditions, the artist will work to his dishonour. He who steals thus may not indeed call the work his own without reproach. Some will object, as Michael Angelo did once to a painter who practised it with success: " *What will become of your pictures at Doomsday, when the parts shall return to their own wholes, seeing your works are made up of stolen pieces ?* "

P

In another place the writer complains of those who take the designs of others, and, by transforming them, make them their own.

What one artist uses in the distance (he says) the other, that it may not be known, brings forward and what he has represented in the open air, the other contrives in a dark room. A poor method of concealment, but it is such men's misfortune to be, in this particular, most out of the way when they think they do best; for, wanting the great master's wit, judgment, and apprehension, they have no true notion of his conduct, and therefore are easily misled, and, like Æsop's raven, exposed to censure.

I have only given a slight skimming of the contents of this rare old book, but I am overrunning my space, and shall conclude with a bit that might have been written anent the doings of some who write on photography and art at the present time.

We find many artists never pleased with other men's works, but, being full of themselves, despise everything they see, and this, perhaps, on no better bottom than a pique against the artist's conversation, talk, dress, or money, or else because of his greater fame; and yet if ten persons happen to applaud a fine picture of this eyesore master, they will at that juncture chime in with them, to screen their prejudice. And, on the contrary, if but a single person afterwards find fault, they immediately turn the tables against ten others. Again, if a piece of their friend be brought on the carpet, though never so faulty, they will applaud and justify it at any rate, though against their own convictions of conscience, if they have any. But this partial and prejudiced humour is most prevalent in those who know least.

CHAPTER XXIV.

CHIAROSCURO.

"The exclusive power of chiaroscuro is to give substance to form, place to figure, and to create space. It may be considered as legitimate or spurious; it is legitimate when, as the immediate offspring of the subject, its disposition, extent, strength, and sweetness are subservient to form expression and invigorate or illustrate character, by heightening the primary actor or actors, and subordinating the secondary; it is spurious when, from an assistant aspiring to the rights of a principal, it becomes a substitute for indispensable or more essential demands."—*Fuseli.*

THE natural and simple effect of light, with its attendant shadow, on objects, is given with greater truth by good photography than by any other method of delineation, although in ignorant hands it may degenerate into weakness, or, as is more often the case, take the form of patches of black and white, unconnected by gradation. However, in these chapters, I assume that the student is a good manipulator, and has a sufficient technical knowledge to render it unnecessary for me to say anything on that part of the subject; I shall, therefore, confine myself to a consideration of how best light and shade may be arranged so as to produce the most beautiful and striking pictorial effect. A knowledge of how to mass light and shade, with its intermediate gradations, connecting one with another, to which the name of chiaroscuro has been given, is most necessary for the student to attain, and can only be thoroughly learnt by careful observation of nature and the study of the works of those masters who have excelled in this important branch of the art; there are a few simple rules, however, a knowledge of which will assist the student in his further studies in this direction. It is to these rules that I now propose to call his attention.

Chiaroscuro not only lends a "something more exquisite still" to the most perfect outline, but clothes an inferior design with a beauty it would not otherwise possess. This is notably the case in the pictures of Rembrandt, often ill-drawn, always vulgar in choice of form, but of priceless value for their marvellous chiaroscuro, the alchemy of his art transforming dross into pure gold.

That which, as a mere sketch, was flat and monotonous, when clothed in cleverly managed light and shade stands forth as a reality. It gives depth, and roundness, and space; it also contributes infinitely to expression and sentiment; likeness, even, can be altered by the way in which this great power is managed. If it be remembered that by the minute modifications in the place, form, and depth of shadows, the whole of the infinite range of expression of the human face is determined, the importance of judicious lighting and skilful disposal of shadows will be pretty well appreciated. Many of my readers will remember the marvellous exhibition of Herr Schultz, at the Egyptian Hall, who exhibited every ethnological type on his own face, principally by the aid of lights and shadows skilfully cast from different directions. The magic of light and shade has become a proverb.

The word chiaroscuro, derived from the Italian, and literally meaning light-dark, by no means clearly conveys the idea of what it is intended to express. Usage has, however, reconciled us to the use of the term to express, not only the means of representing light and shadow, but the arrangement and distribution of lights and darks of every gradation in masses in a picture, so as to produce pictorial effect—just as the word composition is used to express the arrangement of lines.

The objects of chiaroscuro are, first, to give a pleasing general effect to the whole picture, by dividing the space into masses of light and shade, giving breadth of effect, and preventing that confusion and perplexity incident to the eye being attracted by numerous parts of equal importance at the same time. Secondly, to place before the spectator at once the principal object represented, so that the eye may first see it, and be gradually and insensibly led to examine the whole picture; to keep parts in obscurity, and to relieve others, according to their pictorial value. And, thirdly, to aid the sentiment and expression of the picture.

It will be seen that I have omitted relief as one of the objects of chiaroscuro. There is no doubt that a certain amount of relief is of advantage to a picture, but to strive too much for this quality would be sacrificing a much greater advantage—breadth—for the sake of an

effect which could not, in a picture, be made to compete with the perfect manner in which it is given in a toy—the stereoscope. Relief is not the object of the picture. If it were, the artist would have to first see the place where it was to be hung, that he might see the direction in which the light would fall upon it, and his chief consideration would be that the objects in the picture should be lighted by the window of the room, his chief aim to produce an illusion, perhaps the most vulgar thing in art. Twining, in his *Philosophy of Painting*, says, on this subject: "Although relief may be considered as an additional advantage, and deserves attention as long as other points are not sacrificed to it, the artist would decidedly take a false view of the calling of art who would set it up as a goal, directing towards it all his exertions; and, fortunately, to strive, as some have done, for this kind of eminence, generally involves the neglect of other attainments which ought to have stood foremost. We cannot expect to see those powers which, like projection and relief, may be termed practical, imitated in perfection, with those which, like expression and beauty, are fruits of the imagination and sentiment; our physical nature is opposed to it. But in the picture, chiaroscuro, or light and shade, has other purposes to fulfil than those which in nature serve to mark the rotundity and projection of form. A happy distribution of the lights and shades becomes of itself a source of pleasing effect and beauty; at times, by concentrating the effect, and consequently the impressions of the observer, towards a given point; at times by extending the interest, with the dispersing of the lights, over a wider scene. It is towards the attainment of effect that the varied resources of light and shade are thus chiefly directed. Without this enlivening principle the eye of the observer, satisfied with a first glance at a picture, would immediately seek for recreation and amusement elsewhere, so necessary it is that favour and attention should be won in the first place by the external appearance, in order that those more hidden perfections which are the result of profound thought and assiduous study may in turn receive their due consideration."

I may quote a much greater authority to the same effect. Sir Joshua Reynolds says: "This favourite quality of giving objects relief, and

which De Piles and all the critics have considered as a requisite of the greatest importance, was not one of those objects which much engaged the attention of Titian. Painters of inferior rank have far exceeded him in producing this effect. This was a great object of attention when art was in its infant state, as it is at present with the vulgar and ignorant, who feel the highest satisfaction in seeing a figure which, as they say, looks as if they could walk round it. But however low I may rate this pleasure of deception, I should not oppose it did it not oppose itself to a quality of a much higher kind, by counteracting entirely that fulness of manner which is so difficult to express in words, but which is found in perfection in the best works of Correggio, and, we may add, of Rembrandt." Lastly, we have the dictum of Mr. Ruskin, who tells us that this solidity or projection is the sign and the evidence of the vilest and lowest mechanism which art can be insulted by giving name to.

It is admitted by all writers on the subject that mere natural light and shade, however separately and individually true, is not always legitimate chiaroscuro in art. In nature, generally, light is shed indiscriminately on all objects; subordinate objects may be brought prominently forward, and important features may be cast into shade. It is not so with art. Art must select and arrange, or it is no longer art. But although separate truth may not be true art, true art requires that there should be no absence of truth; but the truth must be represented as a whole. Hence arises the indispensable necessity of judicious selection in the subject and treatment of a picture, so that art may be observed, and truth preserved. In no part of art is judicious selection of more consequence than in the choice of light and shade, because chiaroscuro so governs and contracts the effect of a picture, that a subject may be either beautiful or the reverse, according to the way in which it is clothed in light and shade. Photograph a landscape with the sun shining at the back of the camera, and the effect will be flat, tame, and uninteresting; take the same view with the light coming at the side, and the difference will be evident; the magic of chiaroscuro will be at once felt. Barry, speaking of the scenes about Hyde Park, Richmond, Windsor, &c., says: "The difference between a meridian and evening light, the reposes of extensive shadow, the half lights and catching splendours

that those scenes sometimes exhibit, compared with their ordinary appearance, do abundantly show how much is gained by seizing upon those transitory moments of fascination when nature appears with such accumulated advantage. If this selection be so necessary respecting objects intrinsically beautiful, how much more studiously ought it to be endeavoured at when we are obliged to take up matters of less consequence. How many of the deservedly esteemed productions of the Flemish and Dutch schools would be thrown aside, as intolerable and disgusting, were it not for the beautiful effects of their judicious distribution of lights and shades. Art is selection; it is perfect when this selection is pursued throughout the whole, and it is even so valuable, when extended to a part only, as to become a passport for the rest."

It is interesting to note here, incidentally, that Barry does *not* say that art consists in the manner of holding a pencil, or laying on colour, or handling a modelling tool; he does not even say that it consists in the embodiment of . the imagination by means of these implements; but he distinctly states what has been denied by some modern critics when dealing with photography, that *art is selection*, and is most perfect when the selection is the most judicious.

It is the same with portraiture as with landscape photography : beauty will depend in a great measure on treatment. Take a beautiful face, place it fronting the light, and photograph it; the result will be flat and even, in some cases ugly. The most amiable face may be made to look cross, and even savage, by excess of top light. It is strange that the effect of light on the face is not more studied on the stage, where facial expression is seriously interfered with by the unnatual effect of the light coming from below.

Light and shade are always at our command—in portraiture at least, and in some degree in landscape—to compensate for our inability to regulate the drawing to any great extent. I do not say we can, like the enamellers, make an ugly face "beautiful for ever," but we can make a beautiful picture out of ugly objects if we can throw over them the glamour and witchery of perfect chiaroscuro.

CHAPTER XXV.

CHIAROSCURO—DETAIL OR DEFINITION.

" The vocabulary in use relating to light and shade is utterly inadequate to convey that knowledge of its phenomena that a painter requires. It comprises merely the terms light, shade, reflection, half-light, and half-shade. Now all lights—with the exception of those belonging to objects self-luminous, as fire, the sun, &c.—are either the reflections of light from the surfaces of bodies, or transmission of light through those that are transparent or partially so ; the focus of light on a globe is, therefore, as much a reflection as that appearance on its shadowed side which, in ordinary language, is called the reflection ; and as to the terms half-lights and half-shades, they but express, if literally understood, single degrees among the endless gradations from light to dark."—*Leslie.*

ALTHOUGH there are, between white and black, an infinite variety of gradations, it will be convenient to divide them into light (1), half-light (2), middle tone (3), half-dark (4), dark (5). If a picture were composed of

light and half-light only, the effect would be weak and flat. In photographing distant views, which consist principally of light tones, it will be necessary to introduce some dark object in the foreground, to give force and consistency. Turner has carried this principle to perfection. Many of his most beautiful pictures, full of air and space, consisting chiefly of delicate greys and blue, are brought into focus by the introduction of the dark foliage of the stone pine, supported by some dark spots in the foreground, the darks being united to the lights by delicate and infinitely varied half-tones in the middle distance. Rembrandt's method was exactly the reverse of this in practice, but the same in principle ; his pictures are composed of half-dark and dark, having one small focus of brilliant light, united in a magical manner to the darks by half-tone. The marvellous effect of his pictures is due, in my opinion, more to the judicious management of the half-tones than to the strong contrasts and forcible effects of his light

and shade. In his pictures and etchings will always be noticed a wonderful transparency in the shadows, which is almost entirely due to the half-tones with which they are associated. Claude, Turner, and Rembrandt were alike in their management in one respect: they always forced the brilliance of their lights by the opposition of the strongest darks. When Claude and Turner represent the sun, they place near it their darkest dark. This effect will always be seen in nature; if the sun is setting behind a tree, the tree will be darker than any other object in the scene. In Rembrandt's portraits the head is often covered with a black velvet cap, to increase, by contrast, the brilliancy of the face; and it will be observed that the other parts are, although dark, in half-light in comparison. This principle is carried out to a great extent in the pictures of Adam-Salomon, where the dark velvet so often introduced plays a most important part in the economy of light and shade.

Light and shade varies so much with the subject to be represented, that it can scarcely be reduced to anything like a system. But there are a few general arrangements which the photographer would find valuable to have always before him, and they are only, as it were, duplicates of the laws that govern composition.

In chiaroscuro, as in the composition of lines, the centre is the weakest part of the picture. Neither the principal object nor the chief light should be situated in that place where lines drawn from the opposite corners would intersect. A position either immediately above, below, or at the side of this point would better satisfy the requirements of pictorial effect. In a portrait, the head, which is the principal object and light, would be above this position, in a more or less degree, according to the stature of the individual.

When the light spreads through the picture, it should never be allowed to form either a horizontal or vertical line. This refers to the general mass of light. The horizontal bars of light seen at twilight are often very beautiful, and their formal straightness gives a grandeur and a sentiment of repose to be produced in no other way. This rule, in other words, would run thus :—The centre of the picture should not be light, with the two sides dark, or with the top and bottom only dark. When the light falls or is

Q

spread diagonally, it is more picturesque than when it is arranged horizontally or vertically. The same rule would, of course, apply to shadow.

There must be unity of effect in the light and shade, as well as in the composition. Chiaroscuro will often "pull a picture together" when the composition is scattered. Where there is too great a repetition of forms, light and shade will break them up or mass them together. Chiaroscuro should produce that effect which is produced upon the retina when the eye is intently fixed upon an object, and is not permitted to wander, and which some artists maintain should be obtained by sacrificing the inferior parts of the picture to the principal part. This theory, that the details of the larger portion of the picture must be out of focus, will not bear the light of argument. The theory is, that the eye sees only one point in perfect focus at the same time, and that there is something unpleasant and imperfect, even to the least experienced eye, in a picture where everything is made out—the drapery, accessories, &c., all minutely represented with the same finish as the head. This is a fallacy that has led many clever painters astray. It is true that the eye, theoretically, only sees one point at a time, but the eye alters its focus so instantaneously that practically it sees one part almost as well as another; and the same rules should apply to the picture as to nature. Notwithstanding that pictures are usually smaller than nature, if the eye is fixed on the chief feature, the other parts, however highly finished, will naturally go out of focus as much as they do in nature, which, as I have already explained, owing to the instantaneous alteration of focus in the eye, is not much. Here is an illustration. As I write, I am looking through a window; a few feet beyond the window is the railing of a balcony; beyond, a terraced garden; beyond that, a grove of trees; yet further, a church tower; and in the distance, some hills veiled in the blue mist. All this is seen through an aperture two feet square, and, as I look at it, the focus of the eye changes so rapidly that I can detect no want of definition—such definition as we get in a photograph—anywhere. The only indistinct part is the distant hill.

But there is no reason why this scene, if represented in a picture, should be a mass of mere detail. Sharp, as we call it in photography, it may be

all over, but, if it is to have pictorial effect, it must be massed : the church
tower, which is the principal object, must come out into the strongest
relief ; the rest must be subordinate ; and thus we should obtain that unity
which is necessary to pictorial effect. The picture is felt to be true and
natural when the eye is at once led to dwell on the chief group or the
principal object. By insensible degrees, the painter who is a master of
his art keeps down the parts which interfere with the centre of attraction—

> " All things seem only one
> In the universal sun."

And so, after a fashion, it should be in the picture produced by his light.

Unity of light and shade, as I have just stated, is imperative ; but there
is another quality which at a first glance would appear to be antagonistic to
unity, but which really aids it. In a former chapter I dwelt at some length
on the necessity of repetition in lines and forms : the same rule, only in a
stronger degree, applies to chiaroscuro. No light in a picture should be
allowed to be single or isolated, but should be repeated or echoed, not in its
full quantity or force—there must be no rival near the throne—but in an
inferior degree. The strength of Rembrandt, strange as the statement may
appear, was not so much in his great contrast of black and white, as in the
manner he harmonized and mellowed the violence of either by echoes and
faint repetition throughout the picture. It is the repeated but fainter
echoes of the chief light that harmonize and bring together the various
parts of a picture into the unity of a perfect whole. The repetition of the
air, varied and less pronounced, in a piece of music, produces a sympathy
and connection of thought throughout. The effect is analogous to that of
metaphor or simile in literature : a repetition must not be a symmetrical
likeness of its original, but should appear to belong to the same family. It
must avoid the symmetry of detail, but produce a sort of wholesale
symmetry. What is the secret of the delight we take in reflections, if it is
not similar to that we take in hearing the repetition of a sound, or in seeing
the echoed sympathy of one part of a picture with another? To many the
reflection is more beautiful than the reality.

CHAPTER XXVI.

CHIAROSCURO—VARIOUS ARRANGEMENTS OF LIGHT AND SHADE.

"The highest finish is labour in vain, unless, at the same time, there be preserved a breadth of light and shadow. It is a quality, therefore, that is more frequently recommended to students, and insisted upon, than any other whatever; and, perhaps, for this reason, because it is most apt to be neglected, the attention of the artist being so often entirely absorbed in the detail."—*Sir Joshua Reynolds.*

THE light and shade of a landscape cannot be materially altered by the photographer, nor is it necessary that he should alter it; but the chiaroscuro of nature is so continually changing that he may select the effect that gives the most pleasure to the educated eye. A few sketches of the arrangements of light and dark as employed by the best artists may assist him in making his selection.

It is desirable that all lights should have a focus, just as light falling on a globe is more brilliant on one small spot than on any other part; and all lights in a picture should be treated as parts of a whole, and subordinated in various degrees to the principal light. Fig. 1 represents a

Fig. 1.

simple form of chiaroscuro much used by many artists. In this arrangement the highest light is opposed by the darkest dark, and the light fades away in every gradation of middle tones. The two extremes assist each

other by contrast, and produce a most forcible and startling effect, with great breadth. It will be found in the works of Bonington, Collins, Cuyp, Both, and many other painters of coast and flat scenery, to which it is well adapted. Many admirable examples—especially by Collins—may be seen in the National Gallery. The reverse of this, in which dark takes the place of light, is shown in fig. 2. This effect may often be

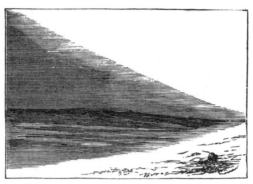

Fig. 2.

noticed in moorland scenery or in a flat country, when the clouds graduate upwards from a dark horizon. The shadow of a cloud may be thrown over the distance, while the foreground may be illuminated by intense sunlight; or the effect may be caused by belts of trees. However produced, the effect is very beautiful, and is one that, now greater attention is paid to passing effects and the sky, may be easily produced in photography. In this arrangement a mass of extreme dark in the light part of the foreground will be found invaluable; or, still better, a figure or other object in which is combined the extremes of black and white. This will be found to throw the rest of the picture—consisting of gradations short of black and white— into harmony, by creating a focus, as it were, more brilliant than, and overmastering, the other lights and darks. Turner's "Temeraire" is an example of this form of composition.

In fig. 3 the darkest shade is relieved by a light object, and the highest light by the principal spot of dark. Burnet, in writing of a similar design, says: "If a diagonal line be drawn through the picture, and the

extreme dark and extreme light be placed at opposite sides, we must of necessity have the greatest breadth of effect. If a balance or union between the two sides be wished, there is no other way but by borrowing a

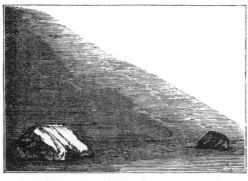

Fig. 3.

portion of the one and exchanging it for a portion of the opposite; and not only may this practice be made use of for the harmony of the whole, but the light and the shade will be thus rendered more intense by the force of opposition. Now, whether the dark which is carried to the light side be very small or very large, and *vice versâ*, we have the groundwork of some of the most powerful and most natural effects. If the light is placed near the horizon—as in evening skies, for example, such as it frequently is in Cuyp—we see it rising upward until lost in middle tint in the upper part of the picture, and the middle tint descending into shadow by means of trees, figures, &c., thus making a sweep round the picture, and thereby affording the greatest opportunity for breadth of effect. If the two extreme points are connected by intermediate figures, so as to form but one group, we have the greatest firmness, as the light part of the group will be relieved by a dark ground, and the dark part of the group by a light ground; if we pursue the contrary practice, and place the dark part of the group on the dark ground, we have more breadth and softness of effect. There is no want of examples in nature or in pictures to warrant our following either mode."

It is, perhaps, necessary to state that the illustrations are purposely

exaggerated, to show the effect more clearly; but the truth of nature should never be violated to produce an effect. Photography gives facilities for approaching sufficiently near to the rules of art without that. Midnight shadows should never be mixed with the light of day, even in painting, although it has been managed with great effect by some great masters of the art—Tintoretto and Carravaggio, for instance. Leslie, writing on the subject of exaggerated shadows as shown in the pictures of these masters, says : " This is the boldest fiction of chiaroscuro, but it is generally managed by the painters I have mentioned with such address that it silences criticism, and forces us to admire, whether we can approve or not. All that can be said in its defence is, that the elements of such a combination are from nature, though united as nature does not unite them. Conventionalities like this must be forgiven to genius, but I do not think they are to be recommended to imitation ; and in saying so I have no fear of repressing the daring of genius, for genius—such as the men I have mentioned possessed—will always have its own way. Great ability may, however, exist short of theirs; and I would gladly repress all who possess it from attempting things which the success even of greater painters cannot entirely sanction. And there is much need of this caution, because it is far more easy to imitate exaggeration of effect than to make simple truth so impressive as it has been made by Paul Veronese, by Claude, and by the best painters of the Dutch and Flemish schools, including Rembrandt, when he pleased to be included."

Photographers, therefore, must never rely on the excuse for departing from nature, " Painters did it thus." They must not defy, but court, criticism—leaving themselves at liberty to reject it if it is obviously wrong—and they must rely on nature for success. Photographers even of " daring genius " cannot afford to depart from nature, as these old painters did, partly because nature is a sure guide, and partly because it has not yet been settled what " daring genius "—as far as it applies to photography—really is.

CHAPTER XXVII.

CHIAROSCURO—VARIOUS ARRANGEMENTS OF LIGHT AND SHADE.

"When the composition is kept dark, forming a mass of shadow in the centre of the canvas, the light is often conducted round it by means of the sky, water, or light foreground; and as the dark becomes, in a manner, isolated, it receives great vigour and importance. If a clump of trees, such as we often find in Claude, is to be represented, their stems shoot out from a ground of the same darkness, thereby producing a union of the trees with the shadow which they cast on the ground. As a light in the centre of dark tints must thereby acquire an increased consequence, so a dark in the middle of light tints receives the same importance."—*Burnet.*

AN arrangement of light and shade not so much regarded now as a strict rule, called "the three lights," at one time was considered to be indispensable to a good picture, and is, indeed, a very pleasing effect of chiaroscuro, including in itself every element of success—unity, variety, and repetition. It was Sir Joshua Reynolds who first enunciated this precept: "The same rules which have been given in regard to the regulation of groups of figures must be observed in regard to the grouping of lights; that there shall be a superiority of one over the rest, that they shall be separated and varied in their shapes, and that there should be at least three lights: the secondary lights ought to be of nearly equal brightness, though not of equal magnitude, with the principal."

The following sketch will give some idea of the arrangement.

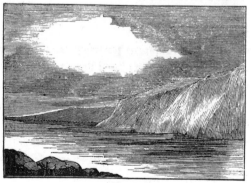

Fig. 1.

It will be seen that the three lights are placed at unequal distances from each other, and form an irregular triangle. The chief light—that in the

sky—is brighter and broader than the others; it is repeated by the secondary light on the cliff, and carried off by the light reflected in the water on the left hand.

The most beautiful effects are often produced with the simplest materials; but it is very difficult to persuade photographers, who have such ample means of rendering detail, and whose pictures are as easily and as highly *finished* if they are full of subject as if they had very little in them, to be content with sufficient material for pictorial effect. With painters all the force of the palette and all the skill of the artist are frequently employed by such simple materials as a straight and low horizon meeting the sky. On such subjects the most skilful resources of the art are necessary, and enable the artist to show his strength. How very seldom is a photographer content to keep his horizon low, and depend on the sky for effect! Fig. 2 is from a photograph in which this arrangement has been

Fig. 2.

observed, and in which the view, without being too much suppressed or neglected, has been subordinated with great advantage to the general effect. A proper union and sympathy between the parts of the picture have been kept up by means of the broad mass of light which occurs in the sky, and is repeated on the ground. This illustration also shows the extreme value of carefully chosen and placed figures in a landscape. The one figure being white and the other black, collects the scattered lights and shades in the picture, and reduces them to proper subordination. The use of extreme

R

black and white in small quantity and in juxtaposition is also exemplified in fig. 3.

A method pursued by Turner, and followed since by many artists, is most effective. Instead of relying on a small portion of light surrounded by large masses of dark, as Rembrandt did, Turner understood and exemplified in many of his best works the extreme value of small masses of dark set in a border of light, but never unsupported by other spots of dark. This was often obtained by rearing a dark tree against a light sky, balanced by dark figures in the foreground, which is usually light; between the foreground and the distance is generally a mass of shade uniting the two. The illustration (fig. 3) is constructed on his " View of Orvieto," and is one

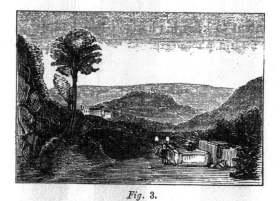

Fig. 3.

of the many pictures painted by Turner that shows the principle clearly. This was one of the pictures so treasured up by the artist, in order that he might leave them to the nation, that no money could buy them. The subject is composed of a bold sweep of landscape, to the left of which rise a tree and a dark mass of foliage ; in the foreground, which is varied with that minute subdivision of lights and darks which made this artist's effects (like photography, when rightly understood), so elaborate and yet so broad, the dark parts of the dresses of two women, who are washing at a classic fountain, repeat and support the dark tone of the tree; the dark vine leaves, brought out prominently on the light masonry, also perform the same office, and extend the shadow to the extreme right. The only bits of pure white

in the original are on the woman's dress in connection with extreme dark (see last chapter), and the piece of paper on the lute. (It is impossible to show these details clearly in a small woodcut.) These minute bits of pure white are placed with a definite purpose and with extreme art, and help to bring forward the foreground, and throw back the distance. In the distance, on a rocky eminence, stands the town of Orvieto, backed by mountains, which distance is treated with great tenderness and delicacy. The general arrangement of masses will be found somewhat similar to that described in Chapter XXVI., fig. 2.

Few photographs have been taken uniting extreme force in the foreground with delicate and tender distances and skies. There is no reason, save that of a disinclination to take much trouble over such a simple thing as a photograph, why they should not be done. If photographers would say to themselves, " This scene is as well worthy of my undivided attention and of all my skill as it would be that of a painter, who would not hesitate to spend some weeks in painting it," they would probably produce better results. I have never yet been able to see why a photograph should be confined to one exposure for foreground and distance, any more than it should be considered legitimate that an etching should have one biting only. In etching, the artist exposes his plate to the acid a longer time and bites deeper for the shadows than for the lights; if he did not, he would get no variety of light and shade, and his work would be thin and weak. In photographing such a view as the one of Turner's we have taken for illustration, I can see no reason why the foreground should not be obtained in one negative, giving sufficient exposure to bring out the necessary detail in the shadows ; and the distance and sky on one or more negatives, suiting the exposure to the effect required. The only technical objection would be, that it would require skill in the printing, which, in the eyes of many photographers, would be an immense advantage, the " fatal facility " of the art for producing rubbish being the great cause why photography as an art has not advanced further than it has done.

Difficulties in art are necessary to its existence. If there was nothing to overcome, there would be no incentive to exertion, and art would soon become a mechanical trade. Opie was always of opinion that the internal

difficulties of painting were its very best friends, and, in one of his discourses at the Academy, related the following apposite anecdote to illustrate his statement:—"Two highwaymen (says a certain author), passing once by a gibbet, one of them, with an ill-boding sigh, exclaimed, 'What a fine profession ours would be if there were no gibbets!' 'Oh, you blockhead,' says the other, 'how much you are mistaken! Gibbets are the making of us; for if there had been no gibbets every one would be a highwayman!'"

CHAPTER XXVIII.

CHIAROSCURO—BREADTH.

"Nature is always broad: and if you paint her colours in true relations, you will paint them in majestic masses. If you find your work look broken and scattered, it is, in all probability, not only ill composed but untrue."—*Ruskin.*

WHATEVER arrangement or system of chiaroscuro is employed in a picture, it must have breadth of effect, without which the eye will never rest upon it with pleasure. Just as a degree of irritation to the touch arises from uneven surfaces, so all lights and shades which are interrupted and scattered are more irritating to the eye than those which are broad and continuous. It must not be supposed, from this, that extreme contrast of light and shade in the proper quantity, and in the right place, is not agreeable, for upon contrast and opposition, as I have already shown, much of pictorial effect depends; but it is the flickering lights and perpetually shifting glare of ill-managed chiaroscuro that keep the eye in a state of constant irritation, and distract the attention from the subject of the picture. The effect to be avoided is that which Milton described before his weak and easily affected eyes had lost their light, when he wrote—

> "Hide me from day's garish eye,
> When the sun begins to fling
> His flaring beams."

In an endeavour to explain the cause of the beautiful effect of breadth as seen in twilight, an admirable writer says: "It may, perhaps, be said that the imagination, from a few imperfect hints, often forms beauties which have no existence, and that indifference may naturally arise from those phantoms not being realized. I am far from denying the power of partial concealment and obscurity on the imagination, but in these cases the set of objects when seen by twilight is beautiful as a picture, and would appear highly so if exactly represented on the canvas; but in full daylight, the sun, as it were, decompounds what had been so happily mixed together, and separates a striking whole into detached unimpressive parts."

It is always of service to the artist to examine the same scenes at different times of the day, and under different effects. He then has an opportunity of speculating on the cause of the beautiful appearance at one time, and of the commonplace look most scenes have at other times.

Objects which, in themselves, possess no interest, are frequently made to delight the eye, from their being productive of breadth. This cause seems to account for the pleasure we receive from many massive, heavy objects, which, without this charm, and considered singly, are positively ugly. Some pictures, though bad in every other respect, but possessed of breadth, attract and arrest the attention of the cultivated eye ; while others, admirable in detail and colour, but in which the harmonizing principle is wanting, will often be passed over as uninteresting. But breadth must not be carried out to effeminacy ; the most healthy system requires a tonic sometimes, and too much sweetness and breadth become sickly. Illustrations of pictorial art are often to be derived from music. It is so here. The first effect of mere breadth of light and shadow is to the eye that which mere harmony is to the ear : both produce a pleasing repose, which, if not relieved, becomes dull and wearisome. The eye requires to be awakened occasionally, for it must be remembered, however delightful repose is, repose leads to sleep, and sleep to death. But as harmony and design must be preserved in the wildest music, so must breadth be observed in the most complicated scenes.

The illustration to this chapter, the original of which is a fine example of breadth of effect, and of which I shall give a more detailed engraving further on, is taken from Turner's " Liber Studiorum," and was used by Mr. Lake Price in his articles on a similar subject to the present one in the *Photographic News* some years ago. Its excellence as an example of breadth must be my excuse for reproducing it. Mr. Lake Price observes, in reference to it :—" The fine subject of ' Norham Castle ' is a masterly example of this management [breadth of effect]. Here the dark mass of the castle occupies the centre of the picture, and is the focus of shadow, diminishing thence to the edges of the subject ; the *principal light* of the sky being brought into immediate contact with the strong dark, the qualities of increased brilliancy and great breadth are simultaneously

attained. The beautiful and poetic effect of this subject should animate some of our landscape photographers to endeavour to emulate similar effects from nature. The student will gain considerable knowledge of the

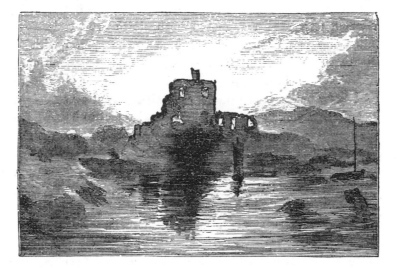

capabilities of chiaroscuro, in its application to landscape, by repeated and careful examination of the broad, varied, and masterly effects to be seen in Turner's 'Liber Studiorum,' which is in itself a compendium of light and shade applied to landscape composition."

Photographs of close views of trees are seldom satisfactory, the chief reason being that they require breadth of light and shade, without which the leaves and branches of the various trees appear to mingle together, and produce flatness and confusion. In most cases, this may be avoided by a judicious selection of the aspect or time of day on which such views are taken. The etching represents a view on the Ouse, from a photograph by Mr. Durrant, which would have been worthless if it had been taken under any other light. As it is, the photographer has selected that aspect in which the lights and shadows were most massed together, and the result is, therefore, a success.

Painters have found it difficult to unite breadth with detail, but it has been attained, in the works of some great masters, in great perfection,

showing that breadth is not inimical to finish, as insisted on by some writers and painters. The microscopically finished works of Gerard Dow and Van Eyck are never wanting in breadth, and the well-known pictures of Meissonier, highly elaborated as they are, are remarkable for the very qualities which it has been supposed high finish would destroy. But the photographer is not so much troubled as the painter with this fear of detail destroying breadth. The utmost extreme of definition is quite compatible with the most tender atmospheric gradations. The detail of nature need never be sacrificed for the sake of representing atmosphere. If definition and atmosphere exist together in the subject to be photographed, they should appear in the picture, or something is wrong : either the chemicals are out of order, the exposure is not well timed, the development or intensification ill-judged, or *the photographer has attempted to do on one plate that to which he should have devoted two or three negatives*, with combination printing.

Nothing, perhaps, is more pleasing or more flattering to the vanity and indolence of artistic mankind than the being able to produce an agreeable general effect with little labour and less study ; this they call " artistry," and think clever, but it is not the intention of painting, which should represent or suggest nature, and not an abstract idea of it. Mere sketches of breadth no more represent nature than do the " tone " pictures of some modern artists—in which the changes are rung on all the gradations, from the very limited scale of lavender to white—represent colour. These pictures, in which the painters probably endeavour to " snatch a grace beyond the reach of art," are very clever as far as they go, but they, like sketches that show only breadth, do not go beyond A or B in the alphabet of art.

CHAPTER XXIX.

CHIAROSCURO—PORTRAITURE—THE STUDIO.

"With respect to the conduct necessary to be pursued in obtaining this advantageous distribution of the lights and darks in a picture, there is little now can be said upon it, as our neighbours on the Continent have long since developed the principles of practice adopted by the great chiaroscurists."—*Barry*.

In photographic portraiture the chiaroscuro is to a very considerable extent under the control of the artist; there is, therefore, not so much excuse for imperfect and faulty lighting as there is in landscape photography.

The tendency of the lighting in photographic portraiture has been to harsh patches of black and white, or to miserable softness, full, it is true, of delicacy and half-tone, but insipid, and without character Neither of these varieties possesses what could be strictly called chiaroscuro, which term implies some notion of the arrangement and management of light and shade. There is something more in light and shade than what is shown in the modelling of a face. It is this subject, however, that we will at present consider.

The object to be attained in lighting a head, considered as a head only, without reference to the general effect of the picture, is roundness, and a certain degree of relief; not the relief attained by the stereoscope, but that degree of projection which is seen in all good pictures. How to obtain this relief shall be our next consideration. It will first be necessary to say a few words on the studio in which the portrait is produced. The general details of a glass house have been so often explained, that for my present purpose it is sufficient to say that in these remarks I refer to a ridge-roof studio, one side (the south) of which, up to the ridge, is opaque, the other half glass to within a few feet of the floor. I make no reference to tunnels, in which I do not believe, and which are only available in the hands of men who will make good pictures in spite of, and not because of, the difficulties with which they have to contend.

The glass side of the roof may be blocked up permanently for five feet

s

from each end; the remaining space of glass should be divided into four widths, covered with white blinds on spring rollers, pulling down from the top. I do not think blue or black blinds in addition of any consequence; they only produce complication and disorder. The side, also, if the studio be so situated that it receive light through it direct from the sky, should have corresponding blinds; but if the light reflected from buildings only be admitted, then the blinds are not necessary, this kind of light being very weak and ineffective in comparison with that from the sky.

We will suppose the south wall to be papered, or coloured with a middle tint of a grey or greenish-grey colour; the studio will then be ready for making experiments in light and shade on the face. To assist further

Fig. 1.

description, I give a plan of the roof, premising that the size of the floor is twenty-eight feet by fourteen feet.

Place a sitter in the usual position, at the end of the studio, to the right of the plan; or, perhaps, a marble bust or plaster cast will be better, because you can look it more steadily in the face, and it will not tire with your prolonged study and observation. Turn the face to the light, and let all the blinds be up, so that it may fall full upon it. The consequence will be that the features will appear faint and indistinct, without shadow. If the head be now turned away from the light until it present a three-quarter view to an observer standing where the camera is usually placed, the off-side of the face will appear in agreeable shadow, and the nose and other features will stand out in relief. But the best effect is not yet obtained. Although the light is broad, and relief is got, the light

is too broad and flat, and there is not sufficient subtlety or delicacy in the gradations in the lights, and not enough transparency in the shadows; the photograph would consequently have a harsh, black-and-white effect. If all the white blinds are drawn down about one-third of the roof space, the shadowed side of the face will appear softer and more in harmony with the light. We have now to produce the greatest amount of gradations in the lights. This is done by drawing down the two curtains (1 and 2) farthest from the sitter. It will now be found that the shining lights down the nose, on the forehead, and other parts, are produced to perfection, and that all gradations, from opacity to bare glass, to speak photographically, are to be seen on the bust, and that the whole face receives its proper projection and relief.

It will be thought by some that to exclude light in the manner described will prolong exposure, but experience teaches that the truth lies the other way. A properly lighted head does not take a longer exposure than one on which the fullest light attainable in the studio is thrown, and the results are not to be compared.

If it be considered desirable to take the head more inclining to profile, or if the sitter have features that project very considerably, the shadowed side will be found to be too dark. In this case reflectors are sometimes employed. This I think an objectionable proceeding. Any reflection giving more light than the natural reflection from the grey wall I have described

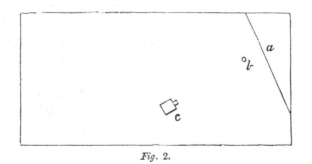

Fig. 2.

will produce a second spark of light in the eye, which has a very disagreeable effect. A much better method is to pull down blind No. 4, the one

nearest the sitter, and draw up Nos. 1 and 2; if there should still be too much shade on one side of the face, then the desired effect may be obtained by working diagonally across the studio, as shown in fig. 2.

In this arrangement the background (*a*) is placed aslant; the sitter (*b*) is seen from the camera (*c*) in a fuller light, but still with a three-quarter view; the shadows of the nose will be stronger, but confined to a less space, and the shadowed side of the face will be lighter. This arrangement is also very suitable for an exact profile, or one showing a glimpse of the off eye.

In a photograph of a well-lighted head will be seen the extremes of white and black in small quantity united by masses of ever-varying gradation. The extreme value of black and white in minute but visible quantity was never better stated than by Ruskin in the following passage, which, although it refers to colour, states the case as regards light and shade equally well :—

"Next, respecting general tone. I said just now, that, for the sake of students, my tax should not be laid on black and white pigments; but if you mean to be a colourist, you must lay a tax on them yourself when you begin to use true colour; that is to say, you must use them little, and make of them much. There is no better test of your colour tones being good than your having made the white in your picture precious, and the black conspicuous.

"I say, first, the white precious. I do not mean merely glittering or brilliant; it is easy to scratch white sea-gulls out of black clouds, and dot clumsy foliage with chalky dew; but when white is well managed, it ought to be strangely delicious—tender as well as bright—like inlaid mother-of-pearl or white roses washed in milk. The eye ought to seek it for rest, brilliant though it may be, and not to feel it as a space of strange, heavenly paleness in the midst of the flashing of the colours. This effect you can only reach by general depth of middle tint, by absolutely refusing to allow any white to exist except where you need it, and by keeping the white itself subdued with grey, except at a few points of chief lustre.

"Secondly, you must make the black conspicuous. However small a point of black may be, it ought to catch the eye, otherwise your work is too

heavy in the shadow. All the ordinary shadows should be of some *colour*, never black nor approaching black ; they should be evidently and always of a luminous nature, and the black should look strange among them; never occurring except in a black object, or in small points indicative of intense shade in the very centre of masses of shadow."

CHAPTER XXX.

CHIAROSCURO—GENERAL CONSIDERATIONS.

"The same principles of uniformity and variety or variegated unity which must be previously pursued in so arranging and constructing the figures and general forms of a picture that they may serve as a proper substratum for that chiaroscuro which brings them to the sight as an harmonious totality—these same principles, and these *only*, are the constituents of all similar agreeable effects."— *Barry*.

THE secret of success in lighting a figure depends not so much on any given formula for the adjustment of blinds and backgrounds, as upon a proper appreciation of what treatment is required to give character and individuality to heads that differ so much from one another as those which come under the consideration of professional photographers; but it will be found in practice that the use of the four white blinds described in the last chapter, and the use of the studio diagonally, will give a very wide range of effects.

It was an instruction from Queen Elizabeth to Zucchero, when he was about to paint her portrait, that he should put no shadow into her face. A similar story is told by Catlin of some Red Indians whom he painted. The Queen of England—in that period which has been called the Augustan age, when Shakespeare, Ben Johnson, and Spencer wrote—and the noble savages, were equally ignorant of art and its requirements. The portrait photographer of the present day will occasionally hear his sitter, on looking at a proof of his portrait, say, "One-half my face is not black." This is, no doubt, sometimes said, after the fashion of the virgin queen, through ignorance; but it will be more often found that the lighting of the head is in fault, that the light has been too violent, the exposure too short, or the intensification carried too far; and because of either or all of these causes combined, the gradations in the shadows, as well as the lights, are lost, and there is no transparency in the shadows, or balance of light and shade.

The light that illumes the head will, of course, be that which lights the figure; it therefore follows—the light being fixed—that the only other means of modifying the chiaroscuro of a portrait is by the colour of the

dress of the sitter and accessories, and by the background. Of the light and shade of the background I have sufficiently treated in Chapter XXI. ; the degree of importance given to the accessories will, in a great measure, both as regards lines and light and shade, establish the degree of consequence to be given to the head. In giving great prominence to the head, care must be taken that it be not wholly isolated. The accessories are the media which act less as a foil to the head, than as aids which assist it to keep its place without impairing its force, as the middle tones find value and clearness only by power of the lights or the strength of the shades.

The accessories should be employed not only to repeat forms, but also to repeat lights. If the head were left a white space in the midst of a large mass of dark, the effect would be that of a *speck*, instead of a *mass* of light. The light of the head should be several times echoed throughout the picture in fainter tones. There must be no exact equality in any of the repetitions, neither should there be many, for if the lights are few and unequal, the result will be breadth and repose ; if many and scattered, there will be confusion. To keep the chief mass of light clear and pure should be the constant and earnest aim.

The outlines of the figure or of the accessories should not be everywhere visible. When this is the case, the effect is thin, wiry, and flat, like carved wood without the relief of sculpture. Portions of the objects represented should melt into the background and shadows, which method will be found to produce rich, soft, and mellow effects.

The dress should be of that character best suited for producing harmonious results. It has been the practice of photographers to set their faces against particular colours as unsuitable, such as white or light blue, and always to recommend black silk. It is time this erroneous notion was done away with, and photographers should learn that if they fail to find white—especially silk or muslin—not only a possible, but a quite delightful, colour to photograph, they have not learnt all that it is possible for them to know of their art. What can be more beautiful or picturesque— conducive not only to light and shade, but to texture—than a muslin " Garibaldi " or jacket, worn with a silk skirt of any shade, so that it

is darker than white? What can be better for a vignette than the sketchy lightness that is produced by the white dresses and light blue ribbons sometimes worn by children? And yet white and blue are often tabooed.

It is a fault, much too common, that all subjects are treated alike; gentlemen, ladies, and children are tarred with the same brush, and that often a very black one indeed, when they should be separately studied and treated. Intense lights and darks in conjunction (for instance, a black velvet coat near the face), surrounded by middle tones into which the highest lights and deepest darks are carried, seems to be a system very suitable to the portraiture of men. Ladies and children should always, I think, be treated in a lighter style, with more refinement and delicacy.

And this brings me to a subject which, I think, should not be forgotten in a work on photographic chiaroscuro—definition and diffusion of focus.

For the last few years some photographs by a lady—many of them failures from every point of view, but some of them very remarkable for their daring chiaroscuro, artistic arrangement, and, in some few instances, delightful expression—have been brought prominently before the public. These pictures, for the qualities I have mentioned, have received the most enthusiastic praise from artists and critics ignorant of the capabilities of the art, and who, because of this want of knowledge of photography, have attributed the excellences which these photographs undoubtedly, as masses of light and shade, possess, to their defects. These defects are, so little definition that it is difficult to make out parts even in the lights; in the shadows it often happens that nothing exists but black paper; so little care whether the sitter moved or not during the enormous exposure which, I have been told, is given to these pictures, that prints are exhibited containing so many images that the most careless operator would have effaced the negative as soon as visible under the developer; and, apparently, so much contempt for what we may almost call the proprieties of photography, that impressions from negatives scratched and stained, and from which, in one or two cases, the film has been partly torn away, are exhibited as triumphs of art. The arguments of the admirers of these productions are, that the excellences exist because of the faults, and that if

they were in focus, or more carefully executed, their merit would be less. This is not true, and, if it were, I should certainly say, Let the merits go; *it is not the mission of photography to produce smudges.* I think the artist herself is beginning to feel this, for I have seen some later productions much more carefully worked out. If studies in light and shade only are required, let them be done in pigment or charcoal, with a mop, if necessary, but photography is pre-eminently the art of definition, and when an art departs from its *function* it is lost. I must not be understood to mean that I object to that almost invisible diffusion of focus produced by spherical aberration in a lens, or by unscrewing the back lens, as arranged in Dallmeyer's group combinations; this is a power of immense value to a photographer, especially in large pictures; for portraits larger than 10 by 8 the lens should always be unscrewed at least one turn; by this means all parts are brought into focus without visibly injuring the definition in the usual plane of focus.

Having stated sufficient to initiate the photographer into the mysteries of chiaroscuro, and to induce him, I hope, to a further study of art, I will conclude this portion of my subject with an extract from Sir Joshua Reynolds's Notes on Fresnoy's *Art of Painting*, in which he describes his method of study, and which may be followed with advantage by the student :—

" I shall here set down the result of the observations which I have made on the works of those artists who appear to have best understood the management of light and shade, and who may be considered as examples for imitation in this branch of the art.

" Titian, Paul Veronese, and Tintoret were among the first painters who reduced to a system what was before practised without any fixed principle, and consequently neglected occasionally. From the Venetian painters Rubens extracted his scheme of composition, which was soon understood and adopted by his countrymen, and extended even to the minor painters of familiar life in the Dutch school.

" When I was at Venice, the method I took to avail myself of their principles was this : when I observed an extraordinary effect of light and shade in any picture, I took a leaf of my pocket-book and darkened every

T

part of it in the same gradation of light and shade as the picture, leaving the white paper untouched to represent the light, and this without any attention to the subject or to the drawing of the figures. A few trials of this kind will be sufficient to give the method of their conduct in the management of their lights. After a few experiments I found the paper blotted nearly alike: their general practice appeared to be to allow not above a quarter of the picture for the light, including in this portion both the principal and secondary lights; another quarter to be as dark as possible; and the remaining half kept in mezzotint or half-shadow.

"Rubens appears to have admitted rather more light than a quarter, and Rembrandt much less, scarce an eighth; by this conduct Rembrandt's light is extremely brilliant, but it costs too much; the rest of the picture is sacrificed to this one object. That light will certainly appear the brightest which is surrounded with the greatest quantity of shade, supposing equal skill in the artist.

"By this means you may likewise remark the various forms and shapes of those lights, as well as the objects on which they are flung; whether a figure, or the sky, a white napkin, animals, or utensils, often introduced for this purpose only. It may be observed, likewise, what portion is strongly relieved, and how much is united with its ground; for it is necessary that some part (though a small one is sufficient) should be sharp and cutting against its ground, whether it be light on a dark, or dark on a light ground, in order to give firmness and distinctness to the work; if, on the other hand, it is relieved on every side, it will appear as if inlaid on its ground. Such a blotted paper, held at a distance from the eye, will strike the spectator as something excellent for the disposition of light and shadow, though it does not distinguish whether it is a history, a portrait, a landscape, dead game, or anything else; for the same principles extend to every branch of the art.

"Whether I have given an exact account, or made a just division, of the quantity of light admitted into the works of those painters, is of no very great consequence; let every person examine and judge for himself; it will be sufficient if I have suggested a mode of examining pictures this way, and one means, at least, of acquiring the principles on which they wrought."

CHAPTER XXXI.

EXAMPLES OF COMPOSITION—A GROUP OF FIGURES.

THE principles of composition and chiaroscuro having been stated, it will be of use to the student to have pointed out to him how these rules have been observed or neglected in various examples; I, therefore, in this and the following chapters, intend to give illustrations from pictures or drawings, as widely diversified in character as possible, with critical remarks on their construction.

My first example is one of those clever book illustrations which have done so much to familiarize the present generation with good art, and which give us enormous advantages over our fathers—who had to pay a great price for inferior artistic work—in our opportunities of study. The great advance in the practice of wood engraving has, perhaps, done more than anything else to bring true art home to the people.

The present example is a somewhat hard and formal illustration of angular composition, and shows much clever mechanical arrangement without any subtlety. In this the art is shown almost boastfully, when it should have been the artist's endeavour to suppress too great a parade of knowledge. But it is better to have too much art than none at all, and this example is better for our purpose than one more delicately arranged, because the arrangement is more visible to the student.

We will now proceed to analyze the construction of the lines of this picture.

First, then, observe that the leading lines and points of all the figures run into one another, so as to form a series of pyramids or parts of pyramids. The central head—that of the old lady—forms the apex of the first pyramid, which is supported by the two little girls on each side of her; the diagonal lines of this group, crossing at the top of the grandmother's head, run on the one side to the old man's hat, which crowns the group, and on the other is continued by the figures coming through the door. The pyramid capped by the old man is formed on the right

hand side by the arm of the child he is holding, who reaches down to her brother's head. The dark dress of this boy forms an important mass in supporting the composition; this mass is repeated on the other side by the velvet jacket of the girl looking up. It will be observed that some trouble has been taken to form another diagonal line here with the three children's heads. The arm of the boy in the black velvet dress, cut off, as it is, by the side of the picture, appears to me to be a serious defect in the composition. The upright lines of the door contrast with the flowing lines of the figures, and give stability to the whole. It may be taken as a rule that a few straight lines in a composition, by contrasting with the curves, always add to the general effect.

The smaller illustration, from a drawing by F. W. Topham, belongs to a much higher order of art than the larger example. This also is constructed on the pyramidal form of grouping, and is so arranged as to admit of very effective chiaroscuro. It will be noticed that the deepest dark is brought into immediate contact with the highest light, while the

other portion of the picture is kept in varying but intermediate tones, thus securing the greatest amount of brilliancy and breadth. It is probable that in the original drawing the sky seen through the open door was more subdued in tone. There is a sentiment in the composition and chiaroscuro quite apart from, yet very suitable to, the subject.

CHAPTER XXXII.

EXAMPLES OF COMPOSITION—TURNER'S "STACKYARD."

THE landscape photographer could not improve himself in the esthetics of his art more thoroughly and easily than by an exhaustive study of Turner's *Liber Studiorum*, more especially if he had opportunity of comparing the original drawings with the engravings and the various states of the plates, showing the many corrections and alterations of the artist in his endeavour to reach perfection. Fortunately, this study is possible to those within reach of the South Kensington Museum, where a large proportion of the drawings, as well as the engravings—either in the originals or by photographic copies—are exhibited. Many of the engravings were etched by Turner himself, who seemed so fond of some of the plates that he found it impossible to let them go, but kept retouching and finishing until they eventually were almost transformed into different subjects to the first sketch. These alterations are of extreme value to the student, showing, as they do, the progress of artistic thought. Ruskin has said that one of the original etchings is a drawing-master in itself.

This famous work, which consisted of seventy-one drawings in sepia, fifty-one of which are at South Kensington, and in fine condition, originated in rivalry with Claude's *Liber Veritas*, a book in which this famous painter registered a sketch of every picture he painted, in order to authenticate his works. In the *Liber Studiorum* Turner intended to show his command of the whole compass of landscape art. The comprehensiveness of the scheme will be understood by a glance at the list of six heads into which the engravings are divided; viz., historical, pastoral, elegant pastoral, mountain, marine, and architectural. Turner never did anything in a fragmentary manner. He used the only method of attaining success: he did what he had to do with all his might. While on the subject of this great work of our greatest master, I may incidentally allude to the enormous increase in value of works of art of late years: the subscription price for the *Liber* series

was £17 18s., but a good copy now sells for 200 guineas. Mr. Stokes formed a complete collection, consisting of etchings, proofs, and duplicates of each plate in its various states. This collection was offered to the authorities of South Kensington Museum for £2,500, and refused; it afterwards sold in detail for more than £3,000. But expensive proofs are not necessary for the student. Photography has unlocked this treasure-house of art, that all who care may enter. Three or four years ago the late Mr. Thurston Thompson made two magnificent sets of photographs from the original drawings, which were very widely circulated, and are as valuable for study as the originals; and Messrs. Cundall and Co. have, I believe, reproduced these pictures in carbon.

Lessons may be learnt from every drawing in the series, but I have selected "The Stackyard" for illustration, because of its simplicity, and because it shows how interest may be imparted to the poorest materials, when in the hands of a true artist, by judicious selection of the point of view, so that the objects may compose picturesquely and artistically, and by skilful distribution of light and shade. I do not, of course, suggest that the photographer has equal power with the painter in arrangement and light and shade, but he possesses these qualifications, as I have repeatedly stated, in a much greater degree than is generally supposed. The enormous power, for instance, possessed by the photographer in the possibility of partial or local development, for regulating light and shade, is seldom thought of, much less used. In the "Stackyard" the general form is wedge-shaped, repeated by smaller forms of the same kind within the general form. The thin ends of the wedges are always supported or accented. See the general outline supported by the man with the barrow and the willow trees; notice, also, how the pool in the foreground assists in forming the wedge. The point of the wedge formed by the rick, the two men, the ladder, &c., is supported by the white horse, while the group is balanced by the horse lying down in the foreground. It will be observed, in this picture, as in the sketch by Topham in the last chapter, that the principal dark, the interior of the barn, is in close contrast with the chief light, the white horse. This is an arrangement which, if it can be secured in a composition, always gives brilliancy and vigour.

The illustration is a reduction, by Mr. Fruwirth's process, from an admirable wood engraving by W. J. Linton, in the *Illustrated London News*. It rarely occurs that the touch of the master is so faithfully reproduced in an engraving as we see it here; this fidelity of reproduction may be especially noticed in the trees behind the barn, and in the sharp touches of shadow throughout the picture.

CHAPTER XXXIII.

EXAMPLES OF COMPOSITION—WEST'S "FAMILY GROUP."

THE arrangement of a family group is certainly one of the most difficult things to succeed in accomplishing perfectly in photography; more difficult even than the composition of a picture that would take a much higher rank in art, but of which the materials were more under the command of the artist as regards selection and disposition. In a portrait group every face must be prominent, no figure must be sacrificed for the sake of pictorial effect, and, therefore, there can be little or no subordination, one of the chief elements of success in art. This difficulty is felt by painters who can devote time and particular attention to each figure, and who, moreover, can place their figures on different planes; but the photographer has still less opportunity of taking artistic liberties with this kind of subject, and it is only by double-printing that he can hope, in some measure, to succeed; even then he has difficulties to contend with that will often cause him to despair of success.

West's group of portraits of his own family, which affords the illustration to this chapter, is a capital example of a family group. This was a favourite picture with Leslie, who says of it: "We undervalue that which costs us least effort, and West, while engaged on a small picture of his own family, little thought how much it would surpass in interest many of his more ambitious works. Its subject is the first visit of his father and elder brother to his young wife, after the birth of her second child. They are Quakers, and the venerable old man and his eldest son wear their hats, according to the custom of their sect. Nothing can be more beautifully conceived than the mother bending over the babe sleeping in her lap. She is wrapped in a white dressing gown, and her other son, a boy six years old, is leaning on the arm of her chair. West stands behind his father, with his palette and brushes in his hand, and the silence that reigns over the whole is that of religious meditation, which will probably end, according to the

Quaker custom, in a prayer from the patriarch of the family. The picture is a very small one, the engraving from it being of the same size. It has no excellence of colour, but the masses of light and shadow are impressive and simple, and I know not a more original illustration of the often-painted subject, the ages of man. Infancy, childhood, youth, middle life, and extreme age are beautifully brought together in the quiet chamber of the painter's wife. Had he been employed to paint these five ages he would have given himself a great deal of trouble to produce a work that would have been classical, but, compared with this, common-place; while he has succeeded in making a picture which, being intended only for himself, is for that reason a picture for the whole world; and if painters could always thus put their hearts into their work, how much would the general interest of the art be increased!"

The student will by this time be able to analyse for himself the composition of this picture; I only introduce it to show what beautiful results arise from extreme simplicity of treatment. The object of the visit is the new-born child. Notice how everything is made to lead the eye to the "little stranger," especially the chiaroscuro. Observe, also, the very simple yet effective background, and the manner in which it is used to relieve the groups, the dark portion supporting the light mass formed by the mother and child, and the light, even-tinted wall throwing out the darker forms of the men. The black shoes of the grandfather and uncle play no inconsiderable part in the composition, and help to join the two groups.

Good as this picture is as an example of grouping, I would not advise the photographer to try to imitate it exactly in any group he may have to photograph, but he may allow it to guide him in the composition of a similar group. I have repeatedly insisted, and I again recommend, that the student should not attempt to imitate the works of others until he has thoroughly grounded himself in the principles of art, and knows the causes of the beauties of line and tone in good works, and these I would not have him imitate servilely. To one who has mastered the grammar of his art, and is able to originate fine thoughts, suggestions from the works of others are often useful. A notable instance of this I had the pleasure of seeing lately. When M. Adam-Salomon visited England last year, he brought

with him one of the most delightful things I have seen by him : a noble boy, partly reclining on a chair, with his head supported on his hand, and with the face turned upwards.　This charming portrait, of which words cannot give an idea, the artist informed me was suggested by a print after Sir Thomas Lawrence's "Master Lambton;" but although the idea was suggested by the engraving, the working out was very different, and the beauty of the photograph was the result of M. Salomon's knowledge of art and his skill in adaptation, and did not originate in the fact that he had taken this picture for imitation.　In the hands of one who had no acquaintance with the rules of composition and chiaroscuro the attempt must have ended in failure, as great as the abortive results of those photographers who collect a set of poses, and fit their sitters to them haphazard.

CHAPTER XXXIV.

EXAMPLES OF COMPOSITION—WILKIE'S "SIR WALTER SCOTT AND FRIENDS."

As the composition of family or social groups is so difficult, I introduce yet another example, this time with most of the figures standing. It is by Wilkie, and represents "Sir Walter Scott and his Friends," the figures being dressed in rustic costume, and treated in a picturesque manner: a subject on which I shall have something to say in another chapter. The fact of the design being by Wilkie, of whom it may be almost said he never misplaced a line, is sufficient to recommend it to the attention of the student. The chief object in the composition is Sir Walter Scott, and he is placed near the centre; but the artist has avoided the error of getting the head precisely in the middle, which is the weakest place in any picture. He is also further distinguished from the surrounding figures by being the only one represented seated; this gives the figure a dignity which contrasts well with the others. The pyramid formed by Sir Walter is supported by the flagon and cloth in the foreground. The student will note that these objects—the highest light and the deepest dark in contrast—form the key-note of the group. He will also notice something analogous in every well-designed group of figures: "The string shows through all the beads." Many of the pictures selected to illustrate these concluding chapters will be found to have it, although they were not chosen to illustrate this especial point.

It should especially be noticed, that every line and form is arranged so that a series of pyramids intersecting each other are created; that the apex of each pyramid is especially emphasized: see the dark hat of the tall standing figure, which forms the point of one of the principal pyramids, and the milk-pail which caps the other; then notice how the pyramidal groups intersect or mingle with each other, the staff of Sir Walter Scott forming part of the side of the pyramid of which the milk-maid is the principal figure, and whose foot makes one of the base angles of the other

group. Another pyramid, which has for its apex the head of the woman in a bonnet, runs into the adjoining similar form ; and the black basket on the woman's arm, combined with the dark form of Sir Walter's favourite deer-hound, admirably supports the whole group. Of this dog it may be mentioned, by the way, that the owner used to say he always liked to have him with him in his walks, if for nothing else but to furnish a living object in the *foreground of the picture;* and he noticed to a companion how much interest was given to the scene by the occasional appearance of a black hound at unexpected points. Sir Walter always talked and wrote of scenery like a painter, yet for pictures as works of art he never pretended to have any regard.

There has been much discussion as to the position of the horizon in a figure photograph, some asserting it may be almost anywhere, even as low as the feet, so that it is conducive to pictorial effect, while others hold that it must be level with the head of the figure, because the horizon is always level with the eye of the observer ; but for this to be true, the eye of the artist must be on a level with the head of the model, which never need be the case ; in fact, a photograph of a standing figure taken with the lens level with the head would, if the lens were not of very long focus, be considerably distorted and out of drawing in the legs and feet ; on the other hand, if the lens were very much lowered, as would be the case when the horizon is represented low, the face would be shown at a great disadvantage, presenting the chin and the nostrils as the most prominent objects. A middle course appears to be best, where the lens is stationed opposite the breast, and its focus requires it to be not less than sixteen feet from the model ; the horizon would then be a little below the shoulders, and leave the head clear against the sky ; in our illustration, Wilkie has placed it rather higher, but he has made it so indistinct that it does not interfere in the least degree with the figures.

It may be taken as a rule that, other things being equal, the lower the horizon the larger will the figure appear.

Even in his humblest subjects, Wilkie composed grandly. In noticing this fact, Burnet observes : " Many who may notice these remarks will perhaps conclude that Wilkie, in familiar subjects, may be compared to

Raffaelle in the great compositions of historical painting, and that he may be subjected to the same chilling critical expression: that he arrived at excellence, not so much from his power of genius, as his long study and application. But nothing great or lasting can be achieved without minute investigation into the works of nature, and as we perceive the means she takes to produce the endless variety of effects, we are rendered more capable of imitating her." It was not so much the overpowering impulse of genius that made Wilkie a painter, as hard study. Genius is not to be despised, but it is of very little use if it be not supplemented by that success-compeller—work.

CHAPTER XXXV.

EXAMPLES OF COMPOSITION—ELMORE'S "STOCKING LOOM"—WEST'S
"DEATH OF WOLFE."

ONE of the most effectual means of impressing truths on a pupil's mind is to
reiterate them again and again from many points of view. It is for this
reason that I have introduced several illustrations showing how the
pyramidal form—that of most use in figure composition—has been the
ruling idea in the several artists' minds in the construction of their groups,
and how no group is allowed to exist without a contrasting balance or
support. These principles are further plainly illustrated in the wood-cut

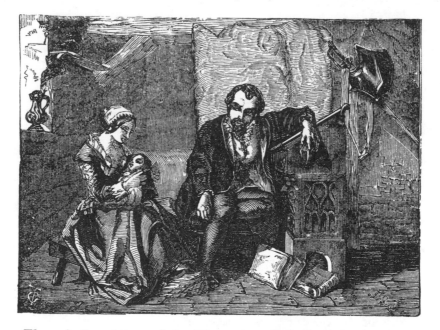

from Elmore's fine picture of the "Invention of the Stocking Loom." The
fault of the picture, in the eyes of some critics, is, that the subject is

not sufficiently evident, but requires explanation. This, in my opinion, is a very small matter, although it certainly is an advantage when a picture explains itself, and does not necessitate any reference to a catalogue. If I went into a description of the details of the composition, I should only be repeating what I have said of other groups ; I will, therefore, pass to an extension of the same principles in a more complicated subject.

Everybody knows West's great picture of the "Death of General Wolfe ;" I have, therefore, not thought it necessary to occupy space with a large illustration of it, but content myself with a diagram of the leading lines, which will bring its various parts to the recollection of the student. This picture is a very perfect example of a hollow group, or circular composition, so called from the figures and objects forming it being placed nearly on the circumference of a circle, and which arrangement is applicable to the highest works of art, from its simplicity and extensive sweep, and to the lowest, from its being finely adapted for the purposes of light and shade.

Mr. Lake Price has carefully analysed this picture in his lessons on composition in the early volumes of the *Photographic News*, and, as the volume containing it has become scarce, I cannot do better than avail myself of his analysis of the composition.

"We observe the stricken hero prostrate in the centre of the picture, the sympathy of his officers and soldiers in the fall of their general being well expressed. The 'red man,' hard of nerve himself, looks on with interest to see the resignation of the white chief to his fate ; whilst the cry from the battle-field, 'They run! they run!' is perfectly given by the panting figures on their right, and the more episodal one in the distance. The arms of the pointing figures cross each other, thus composing. The animated figure of the trapper or huntsman is most necessary, and gives the foil and sentiment to the still repose of the group immediately round the dying man. The grenadier, standing rather apart, judiciously separates the grouping, and prevents it being monotonous and crowded. The colours and their straight staff carry up and break the top line of the composition, and give value to the action. The advancing figure is prevented over-balancing by the crouching Indian beneath, which

makes a mass with him. The balancing line of the Indian's gun cannot
be dispensed with, though the artist has judiciously broken it by the
intervening knee; nor the cap of the grenadier on the ground, which
composes with the lines of his figure, and completes the group; whilst the

dark hat under Wolfe finishes the circle, and gives distance to the lighter
parts behind. The gun on the ground completes the base-line carried
through the foreground. This is a most perfect composition, and should be
well studied. We have first the story, told in a touching and distinct
manner; next, we have the main lines, traversing the subject horizontally,
balancing each other, whilst the lines of the figures, as seen in the analysis,
reply perfectly, and balance with each other; at the same time each figure
either composes with its own base, or forms part of another mass, the whole
arrangement, in its linear composition, being admirably susceptible of
subsequent chiaroscuro."

It was with this picture that common sense in historical painting in
England commenced. Before this period the most ridiculous absurdities
were perpetrated in the costume, not only in historical pictures, but in
every other class of painting. The picturesque dress of the day was
thought too barbarous for the sham classical taste of the time of James the
First. This taste, revived by Verrio and Laguerre, was in the height
of fashion when West commenced his "Death of General Wolfe." A

portrait painter seldom allowed his sitter to appear in his own dress; if his subject were a lady, she was transformed into a shepherdess with a spud in her hand, tending sheep in Arcadia; if a youth, the distinction of sex was indicated by giving him a crook instead of a spud, and Pandean pipes. Men were dressed in armour of an earlier period, and it appeared to be a law, as binding as those of the Medes and Persians, that in historical subjects (which should be treated allegorically, if possible) the figures should be dressed in Greek or Roman costume, or not so much the costume of the actual Greeks and Romans, as a dress in which they were supposed to appear. If a battle-piece were represented, the king or general, "the noblest Roman of them all," was set in the front, bearing no possible proportion to the rest of the combatants. Thus, if the dubious costume were to be believed, actions of Englishmen in the seventeenth and eighteenth centuries were performed by the people of extinct nations. But to make the thing still more absurd, although the dress was exchanged for Roman armour, the enormous wigs of the period were retained! Fine examples of this false classicality are to be found in the statues about London, especially in Westminster Abbey and St. Paul's Cathedral, where, by-the-way, there is evidence of a further decadence in artistic truth: the classic heroes of the early Georges were at least dressed, if dressed absurdly; but passing by Dr. Johnson and others who are wrapped in blankets, we come to the monuments erected to the memory of those who fell at Waterloo, and find that some of them, with that enthusiasm which disregards appearances or cares for uniform, actually went into battle *in puris naturalibus*, without any clothes at all. West, much against the advice of his friends, dismissed this pedantry, and restored nature and propriety in his noble work. Cunningham, in his life of West, speaking of this picture, says: "The multitude acknowledged its excellence at once; the lovers of old art, the manufacturers of compositions called by courtesy classical, complained of the barbarism of boots, and buttons, and blunderbusses, and cried out for naked warriors, with bows, bucklers, and battering-rams." Sir Joshua Reynolds was so blinded by the fashion of the time, that he entreated the artist to recollect the danger which every innovation incurred of contempt and ridicule, and

urged him to adopt the costume of antiquity, as more becoming the greatness of the subject than the garb of modern warriors. West's answer was, that the same truth which gives laws to the historian should rule the painter; if, instead of the facts of the action, fiction were introduced, what would posterity think of the truth of the painter? Reynolds afterwards acknowledged, when he saw the completed picture, that the artist was right: "West has conquered," he said to a friend; "he has treated his subject as it ought to be treated. I foresee that this picture will not only become one of the most popular, but will occasion a revolution in art." At that time, truth of effect in art was so little regarded, that Garrick thought it right to play Macbeth in a full court suit, and murdered Duncan, in a bag-wig, with a dress-sword!

I have gone at such length into this subject in order that I may point out a similar error in our practice of to-day—one not so glaring and absurd as the classical armour which seemed quite right to our ancestors appears to us *now*, but one which is simply a new application, only in a less degree, of the same error—I mean the practice of dressing a sitter for a portrait in fantastic garments, for the purpose of making him up into a picture. The object of portraiture is to make a resemblance of a man as he is, and very little liberty should be allowed or taken in doing it. I am not now speaking of photographs of which the object is to make a picture apart from portraiture—in these anything may be done, so that general truth is observed—but a portrait professes to represent a prosaic fact, and should fulfil its function.

CHAPTER XXXVI.

EXAMPLES OF COMPOSITION—MULREADY'S "CHOOSING THE
WEDDING GOWN."

Mr. Fruwirth's useful process of phototype, which not only reproduces
engravings for the press, but also enlarges or reduces them, enables me to
present one of the most perfect compositions of modern times, which,
happily, belongs to the nation, and will remain an object of study as long
as it exists.

Perhaps nothing in the whole range of art can be brought into com-
parison with the works of Mulready for *technical* perfection. In truth of
drawing, elaborate finish, and exquisite colour, he excelled long before the
works of the modern pre-Raphaelites made these qualities indispensable in
pictures, and to these perfections he added most supreme skill in com-
position. His subjects were not always equal to his powers, and one cannot
help regretting that he wasted such splendid art on themes such as "Boys
Firing a Cannon," "The Loan of a Bite," "Bob Cherry," and others of a
similarly low character; but even these incidents become, under his hand,
elevated, and redeemed from the commonplace and vulgar. The nation is
rich in possessing—through the generosity of Mr. Vernon, and, more
especially, of Mr. Sheepshanks—a large collection of his works, illustrating
his progress from the commencement to the end of his career. Painted in
his best period, "Choosing the Wedding Gown," of which an illustration is
given in this chapter, is one of his finest creations, and is an admirable
example for the student to have constantly before his eyes.

During the earlier chapters of this attempt to teach the laws of art to
photographers, when I had to deal chiefly with principles, and to enforce
their use, I abstained as much as possible from giving long quotations from
well-known works, being fully aware that nothing tires a reader more than
numerous extracts, often ill-adapted to the purpose for which they are
intended; but in the later chapters, in which examples are introduced

showing how these laws have been applied by others, I prefer, when possible, using the criticisms of other writers, because they confirm, in a measure, the principles I have endeavoured to teach. For this reason I here

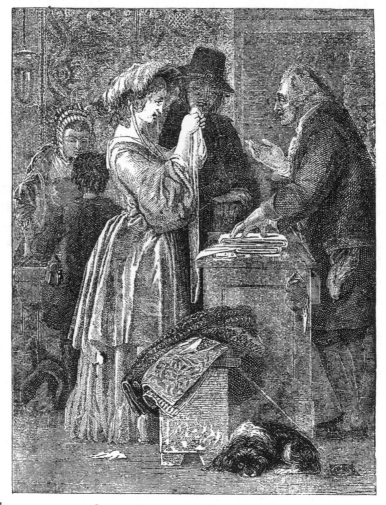

introduce some remarks on the design and colouring of this picture from the *Art Journal*, whose valuable illustrated articles on "British Artists" afford examples admirably adapted to the use of the student in composition and

chiaroscuro: "As an example of Mulready's strictly domestic pictures, 'Choosing the Wedding Gown,' exhibited in 1846, is admirable; as a specimen of brilliant colouring it is superlatively excellent; nothing in modern art—it may be said in the art of any age in this class of subject—has surpassed, or even equalled it. This splendour is not reached by the free use of positive colour, but by the most subtle and delicate application of tints, both in the lights and shades, worked up from the lowest to the highest scale, and culminating in pure red, ultramarine, &c., and all presenting the most perfect harmony, because founded and carried through on well understood and immutable laws. Then look at the composition: mark the arrangement of the two principal figures; how easily and naturally they are placed, and how carefully both attitude and action have been studied to preserve a right balance, as well as to support the subject. The extended hand of the silk-mercer, for example, was a necessity to fill up a space which would otherwise have been vacant; it serves as a counterpoise to the uplifted hands of the lady, and it marks the impressiveness with which the shopkeeper commends his goods. And, lastly, notice the beauty of the fair purchaser's face—the future Mrs. Primrose—and with what earnestness she examines the piece of rich stuff; the kindly solicitude of her affianced husband, the worthy doctor; and the persuasiveness of the bland and smiling mercer. In the background is his wife attending to a customer; the artist has bestowed no less pains on the good dame than on the other and more prominent persons in the composition. In fact, whether we look for colour, form, expression, or design, we see each and all exhibited in the most attractive, powerful, and recondite manner."

Beyond all this, the student will see other and more strictly technical beauties, corresponding exactly with those I have pointed out in other examples: the prominence of the principal figure; the opposition of the highest light with the chief dark in the centre of the composition; the balance afforded by the mass of rich stuff on the stool and the dog; even the ring on the floor is not without its artistic value; the opposition and contrast given to the curved and undulating lines by the straight lines of the piece of stuff in the lady's hand, and in other places; and, lastly, the repetition of the main incident in the background.

Y

CHAPTER XXXVII.

EXAMPLES OF COMPOSITION—GOODALL'S "THE SWING."

THE supposed difficulties of photographing children have prevented many photographers from obtaining some of the most beautiful subjects that could come before a camera. Many, even now, when sitters are scarcer than they were, have a great objection to seeing children enter their studios, and resign themselves to their fate in a grumbling humour, as if they were very ill-used in having to deal with such troublesome subjects—which is not the best frame of mind to be in when they are about to deal with children, or, indeed, any other subjects for their art—while others will have nothing to do with anything under six years of age. During the carte mania, it was difficult to get a child's portrait taken at all, except by those whose pictures were so bad that they had little to do, or those who took a delight in the work. I must confess that I am one of the latter, and nothing gives me greater pleasure than to have three or four beautiful children in the studio, with a carte-blanche as to what I shall produce, and with plenty of time at my disposal. I take a pride in never letting a child go away unaccounted for photographically, however young or lively. By far the most beautiful photographic portraits that have been done have been those of children; their attitudes are more free and unconstrained than those of older persons, while their expression is generally more natural. The wet process is now so perfect that the exposure, when necessary, may be reduced to a very short portion of time, and all that is necessary to success, apart from artistic knowledge, is sufficient tact in managing the young sitters, who are very clever and quick in finding out whether they are in the hands of a novice or an adept.

One of the most charming groups of children's portraits that have ever been painted is that given in the present illustration by F. Goodall, a class of subject of which the artist was *facile princeps*, before he altered his style and went to Egypt for inspiration. It is called " The Swing," and represents a group of beautiful children enjoying themselves under the trees a

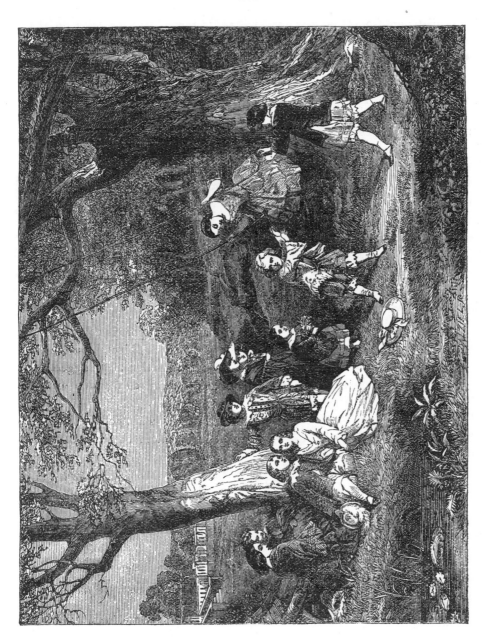

short distance from the mansion, whose terraced walks appear in the background. Of course it would be very difficult in photography to represent a similar subject, although it is quite possible; but I introduce it here, not only for the purpose of saying a word in favour of children as subjects for the photographer, but also in order to show, as I have endeavoured to do throughout these chapters, that the same artistic laws apply to all subjects, however different they may be in character, and however diverse in effect. For instance, I pointed out in Chapter XXXIII., in which a meeting of Quakers was represented, how the black shoes of the two sitting figures served to join the groups; in the present illustration we have the picture divided into two principal groups, the children seated and standing under the tree looking on, and the little lady in the swing and the two beautiful boys on each side of her; these groups are connected together by the light spot formed by the hat in the foreground, which, at the same time, is the supporting base-point of each pyramid; place the finger over this spot of white, and the arrangement of lines will appear weak, and without purpose.

Artists should take the greatest care that this support is never wanting in their pictures. It may be formed by a light or dark object, by a contrasting line, or by any device that experience or imagination may suggest; but it must always be there. Nothing looks so awkward as a group or figure unsupported.

Modern costume is often condemned; but what could be more picturesque, and yet without any exaggeration, than the dresses of the figures represented in this picture?

CHAPTER XXXVIII.

EXAMPLES OF COMPOSITION—FACES IN SHADOW.

WHY are photographers so afraid of shadow as their works indicate? It is seldom that a photographic portrait by an English artist is seen with more than sufficient shadow to ensure a certain amount of roundness and modelling in the head; and the effect of a head in shadow, or with the light coming from behind, is never found. On the Continent, photographers have seen the advantage of occasionally varying their effects. In Germany, especially, very beautiful things have been done with the face in shadow, and the light, coming in from the back, skimming the side of the head. Very delicate and transparent effects, of which the engraving is a sample, are produced by this means. The subject, entitled "The Sisters," is from an engraving published by Goupil; our illustration being a reduction, by Mr. Fruwirth's process, of a wood engraving in an excellent little publication entitled the *Children's Friend*. It is not necessary to have a window in the background end of the studio to admit the light; it will be found quite sufficient and effective if a portion of the roof be used. A clearer understanding of the method will be obtained from a reference to the diagram of the roof of the studio described in Chapter XXIX. The white

spaces represent glass, covered with white blinds, numbered 1, 2, 3, and 4. To produce the effect of light coming in from behind, the sitter is placed under No. 2, or rather nearer to the bar which divides 1 and 2. Blind No. 1

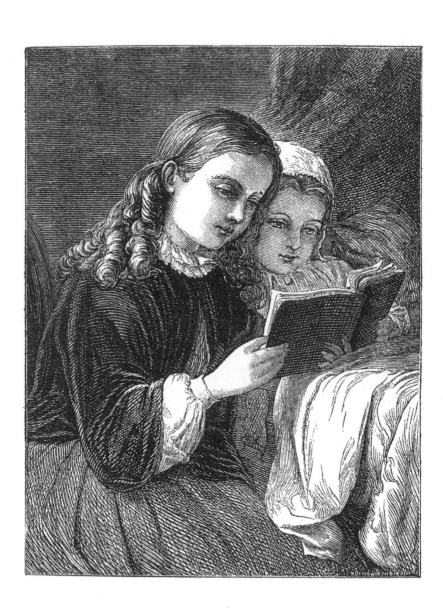

is pulled up, leaving clear glass, and blinds 2, 3, and 4 are pulled down; being made of white calico, they admit a small amount of light, which allows a very soft shadow on the face. The camera is placed under No. 4, or any distance beyond necessary to the size of the picture required. The exposure necessary will be found to be very little longer than for a portrait lighted in the usual manner. If the negative be not over-intensified—at first it is difficult to believe that the broad mass of the face should be left so thin—the result will be exceedingly fine, luminous, broad, and without heaviness. I have left out of the account the side of the studio, which should be blinded in the same proportion as the roof. If photographers could be persuaded to depart occasionally from the usual and monotonous manner of producing portraits, which makes their photographs so very " photographic " and unlike other works of art, they would soon find other variations in the mode of lighting, which would create variety in their productions, and, in all probability, give their patrons a new interest in their works. The frontispiece to this volume, printed by the Photo-Relief Company, by Mr. Woodbury's process, representing two children, is another illustration of this mode of lighting, taken in a studio with the blinds arranged in the manner I have just described.

One of the evils which has prevailed amongst photographers, and a very natural one, is, that they have studied too much from photographs. When they have seen a good effect in photography, they have admired it, and tried to imitate it; an aim laudable enough in itself, especially if very occasionally indulged, but which has, nevertheless, been carried out to such an extent as to produce, in the mass of photographic portraits, a dreary, common-place monotony, modifications of one or two or three leading styles being perpetuated *ad nauseam.*

I was consulted, some years ago, as to the wisdom of publishing a little work on posing and arranging, to consist chiefly of lithographic copies of actual photographs by the best masters, and was asked to undertake or superintend its preparation for the press. In the midst of the rapid demand for portraits, which allowed very little time for study or arrangement in the glass-room, such a work, it was deemed, would be eagerly sought after, and, I have no doubt, might have been a successful business speculation.

It would, however, in my estimation, have been a mischievous book, and, for the sake of photography, I at once condemned the idea, and used my influence in preventing its issue. Photographs themselves were plentiful enough, and were too commonly imitated and copied; but to make copies of such things, and distribute them for imitation, appeared to me worthy of all condemnation. It is true, there are a few masters of artistic effect in photography whose works might form valuable studies; but sufficient of the photographs themselves of these men are for the most part accessible where they are required for art study; and, as I have just said, photographic portraits are already too much alike, and modelled too much on one style. I have striven in these chapters to impress upon the student the importance of avoiding direct imitation as a practice; and, for suggestive studies, I should recommend him to go outside of photography, and examine the wealth of engraved pictures readily accessible. Many of the old mezzotint engravings to be picked up for a few pence each on London book stalls are invaluable. A habit of studying these would much improve the notions of chiaroscuro of most photographers, and teach them the value of shadow, and the importance of securing transparency in shadow. The horror which photographers have had of shadow has been chiefly due, I believe, to the fear of blackness and unrelieved heaviness. A good mezzotint will show how much general depth of tone may be secured without blackness; it will show also how the distribution of half lights in the midst of shadow effects this. With the materials arranged to give light and shade in the photograph similar to that seen in a good mezzotint, the photographer will find that good lighting and full exposure will give him results not very far inferior to those in the engraved pictures.

CHAPTER XXXIX.

EXAMPLES OF COMPOSITION—TURNER'S "NORHAM CASTLE."

WHILST Turner is usually supposed to depend for his excellence upon the rendering of the more subtle and chromatic effects of nature, a careful examination of his pictures will show how strict was his adherence to the recognized laws of composition and chiaroscuro. The Temeraire and the Ulysses, pictures essentially associated with the glowing effects of colour given by the setting and rising sun, when reproduced in monochrome will be seen to be singularly accurate illustrations of the most simple forms of artistic arrangement.

There is scarcely a picture or sketch by Turner but which will afford a lesson in composition to the student, as I have had frequently to point out. This is especially noticeable in his great book of lessons, the *Liber Studiorum*. In a former chapter, an example (the "Stackyard") from this magnificent work was given, and in Chapter XXVIII. I gave a sketch, showing the arrangement of light and shade only, of one of the finest pictures in the collection, that known as "Norham Castle." This drawing is so fine, and affords such an admirable lesson in effect to the photographer, that I have thought it worth while to give a more accurate and detailed reproduction of it, reduced by Mr. Fruwirth's process from an admirable woodcut in the *Illustrated News*, together with the critical remarks appended to it in that journal, which forcibly indicate its chief points of excellence and interest:—" In the 'Stackyard' we see the painter's power of imparting interest to the humblest incidents and homeliest occupations of rustic life by judicious choice of the point of view, skilful composition and distribution of light and shade, and suggestive handling—the last noticeable, especially in the masses of foliage. In the 'Norham Castle' we are reminded of Turner's marvellous versatility. Although the cows drinking at evening, the boat, the skiff, and hut are as familiar and commonplace as any of the elements of the first-named drawing, yet every one must feel that

z

this is as different in its dominant sentiment of solemn serenity and impressive repose as it is in its leading subject of a venerable, brave, and sturdy stronghold, preserving its dignity and grandeur, and even gaining in awfulness, in ruin and decay. This drawing illustrates, also, one of Turner's most favourite expedients for securing powerful effect, with a real perspective, in which he has never been approached. We allude to the placing of a tree or building immediately before or near to the source of light. A painter thus secures not only the power of accenting the mass and contour of the object so relieved in the most powerful way, but he obtains the utmost limit of effect by the opposition of his highest light and pro-foundest dark, and, by this mode of giving, so to speak, the extremities of his gamut, he enables the eye to be sensible of and measure the tenderest tones and semitones in other parts of the picture. We trust the reader will appreciate, by looking at our engraving, the variety afforded by this artistic principle to the gradations throughout, and the luminous and aerial quality imparted to the sky. Of the appropriateness of relieving against the setting sun that frowning ruin and that watchturret, which has seen the same sun sink beneath it for centuries, it would be idle to speak."

CHAPTER XL.

EXAMPLES OF COMPOSITION—A PORTRAIT.

As this is my penultimate chapter, I take the opportunity of introducing an example of portraiture, that I may say a few final words on that important subject to the photographer.

The illustration is engraved from a picture by Desanges, one of the most graceful portrait painters we have, but who, perhaps, will be better known to the reader as the painter of the Victoria Gallery, illustrating the principal actions for which the Victoria Cross was awarded, and which for some years formed one of the chief attractions of the Crystal Palace. In this picture will be found nearly every quality that goes to the making of a good portrait—breadth, simplicity, and unity ; balance, contrast, and variety. It is. dignified and graceful, refined in feeling and expression, and the figure is set before the spectator for itself alone, and without any distracting embellishments, which, without adding to the interest of a portrait, often suggest departure from truth.

Photographic portraiture has not, in a broad sense, yet advanced sufficiently far on the road to perfection to make its professors as a body very proud of their art, but during the last two or three years it has made great strides. Several causes have combined to help it to progress more rapidly of late than in former years. The exhibition of M. Adam-Salomon's pictures at the French Exhibition of 1867, and their introduction to the great body of English photographers by the Editor of the *Photographic News*, gave an enormous impulse to the production of good work; even those who most believed in the beauty of their own work saw that in photographic portraiture there was something beyond ; they saw a certainty that the end of the art had not been reached, and these pictures gave the promise of a possibility of something still more glorious being achieved in portraiture by their art. Some were, no doubt, sorry for this, as they felt

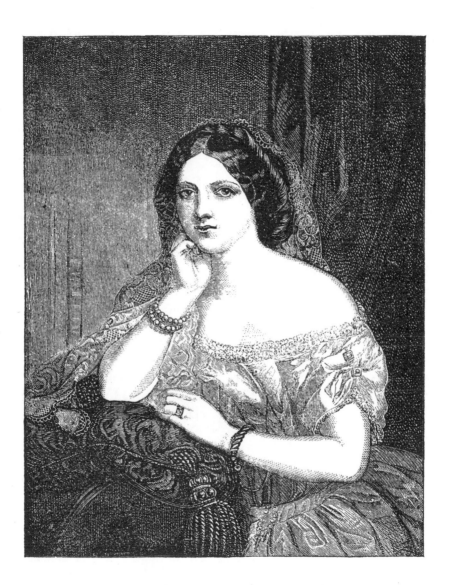

they must give up the hope of ever approaching the works of the great master; while others, more reliant and hopeful, buckled on their armour, and fought honestly to win some honour in the same path. Whether many will ever equal the original works is problematical; but the present result is not doubtful: better work has been done. That this is so was almost ludicrously shown at the 1868 Exhibition of the Photographic Society, the walls of which were covered by portraits of every degree of merit, from the lowest to the highest, which had evidently been inspired by the works of M. Salomon. Deprecating, as I do, this servile copying of any man's work, to which English photographers, for lack of originality in themselves, are much too prone, it must be patent to all impartial minds that an advance has been made in photographic portraiture all over the country which could scarcely have been anticipated or believed. Photographers have shown that they have the capacity to imitate a good thing; let them advance another and yet more difficult step—those who follow are always behind—let them rise above mere imitation, and produce original works. There is one fault visible in most of these "Salomonaic" pictures from which even the originals are not quite free, and against which it is perhaps as well to warn the student. In the endeavour to arrive at technical excellence and fine chiaroscuro, expression seems to have been almost forgotten, and the portraits suffer from the neglect.

Another cause of the improvement in the *art* has been the depression in the *business*. Many who were not fitted for it have had to return to their former employments. It is, perhaps, a cruel thing to say, but the art is all the stronger because the weak ones have been killed off. The public, who would take any rubbish a few years ago, is now more discriminating, and will not accept bad pictures, however cheaply (I would rather say low in price, for bad things are not cheap) soot and whitewash abortions may be offered by despairing "artists" who have mistaken their vocations. But one of the chief causes for this cheering advance in the quality of the pictures produced at the present time—if I may say so without being thought to refer to my own writing—is the sound and practical art knowledge that has been given to photographers of late years by the *Photographic News*, and which is so opposed to the mystic and "high-

falutin" substitute for common sense with which the art had been previously surrounded.

Before the advent of these several causes of improvement, the art, except in the hands of a few, was very like that described by the Vicar of Wakefield, when he tells us of the painting of his great family picture. As ridicule is sometimes as good a teacher as sober sense, I am tempted to extract the passage.

"My wife and daughters, happening to return a visit at neighbour Flamborough's, found that family had lately got their pictures drawn by a limner who travelled the country and took likenesses for fifteen shillings a head. As this family and ours had long a sort of rivalry in point of taste, our spirit took the alarm at this stolen march upon us, and, notwithstanding all I could say—and I said much—it was resolved that we should have our pictures done too. Having, therefore, engaged the limner, our next delibe- ration was to show the superiority of our taste in the attitudes. As for our neighbour's family, there were seven of them, and they were drawn with seven oranges—a thing quite out of taste, no variety in life, no composition in the world. We desired to have something in a brighter style ; and, after many debates, at length came to a unanimous resolution of being drawn together in one large historical family-piece. This would be cheaper, since one frame would serve for all, and it would be infinitely more genteel; for all the families of any taste were now drawn in the same manner. As we did not immediately recollect an historical subject to hit us, we were contented each with being drawn as independent historical figures. My wife desired to be represented as Venus, and the painter was requested not to be too frugal of his diamonds in her stomacher and hair ; her two little ones were to be as Cupids by her side ; while I, in my gown and band, was to present her with my books on the Whistonian controversy. Olivia would be drawn as an Amazon, sitting upon a bank of flowers, dressed in a green Joseph richly laced with gold, and a whip in her hand ; Sophia was to be a shepherdess, with as many sheep as the painter could put in for nothing ; and Moses was to be dressed out with a hat and white feather."

Everybody remembers—for it has become proverbial—the fate of this grand historical portrait picture : how it was too big to allow of its being

got through any of the doors of the house, and how it was obliged to remain in the kitchen. The description of it is but a very slight exaggeration of the absurd anacreonisms perpetrated in the last century, a subject on which I touched in Chapter XXXV. And do not we now, in the nineteenth century, when everything is matter-of-fact, see in photography, which should not lie, the most absurd, the most grotesque blunders possible? Columns, curtains, pedestals, profile pianos, pilasters, sham windows, wooden fireplaces,—do not these words call up visions of artistic abominations, horrible to the now more cultivated eye? It has been the reproach of photography that its results fade. The fault I find with it is, that they are too permanent; and early, and to me awful, prints are continually rising up in all their ghastliness to shame their makers.

What photographer takes up an old album in a friend's house without a sort of fear of opening it, and being reproached by his own handiwork? But he may take heart of grace; the very disgust he feels at looking at his early productions shows that he is not only a better photographer and a better artist now than he was then, but that he is on the way to still greater success.

CHAPTER XLI

CONCLUSION.

"I trust these lessons will have served to dissipate the idea that to acquire art to a useful and gratifying extent, a genius is needed; that they have proved a knowledge of it to be the result of education; and that art may be possessed by all in a valuable degree, if it can only be attained by few in a remarkable degree."—*J. D. Harding.*

My task is done. Beginning with the simplest elements of composition, I have led the student through the mazes of this often complicated subject, using the simplest language I could command, and often preferring to state a great principle more than once, rather than risk that it should not be made perfectly clear to the reader, preferring plain, unvarnished statements to the wonderful flights of fancy by which art has been sometimes made to look so formidable to the photographer. There is often as much art in knowing where to stop as in proceeding in a proper manner; and I have especially endeavoured to avoid teaching too much—that is, leading the photographer further into the depths of the subject than his art can follow; as I said in my first chapter, I have endeavoured to show how the body is constructed, leaving the soul to others. Babes thrive better on milk than on curacoa, and I have been writing for the youngest student in art. One of the easiest modes of escaping from the difficulties of analysis and the perils of explanation is to go off into fits of wonder, and talk mysteriously of mystery. The fear of being thought shallow has not deterred me from being clear; I have not tried to appear profound because I was unable to fathom my own ideas; and I have avoided, as much as possible, technical language, which is sometimes made the refuge of obscurity, and the pompous sham which is often required to be taken for depth.

Sir Joshua Reynolds, in his last discourse, says, "I am convinced that one short essay, written by a painter, will contribute more to advance the theory of our art than a thousand such volumes as we sometimes see; the purpose of which appears to be rather to display the refinement of the author's own conceptions of impossible practice than to convey useful

A A

knowledge or instruction of any kind whatever. An artist knows what is and what is not within the province of his art to perform, and is not likely to be for ever teazing the poor student with the beauties of mixed passions, or to perplex him with an imaginary union of excellences incompatible with each other." It was with this sentence in my mind that I commenced this series of papers. Without much previous practice in writing a sustained series of papers, I relied on my knowledge of the subject for success—knowledge of the few simple but immutable laws of art which I had learnt as a painter, and found of immense value in my practice as a photographer. Thus much for the matter. For the manner I must claim indulgence. I have written as I should have spoken to a pupil, not for the purpose of displaying eloquence, but with the intention of teaching art. What I have written I have practised; and what I have practised I have written. In these articles, to quote Sir Joshua again, "I have, in no part of them, lent my assistance to foster new-hatched, unfledged opinions, or endeavoured to support paradoxes, however tempting may have been their novelty, or however ingenious I might, for a minute, fancy them to be; nor shall I, I hope, anywhere be found to have imposed on the minds of young students declamations for argument, a smooth period for a sound precept. I have pursued a plain and honest method, and I have taken up the art simply as I found it exemplified in the practice of the most approved painters."

So much of myself and my intentions. Now, again, a few more words to the student, and for the last time. There is something more in art than what I have endeavoured to teach; something more than composition, chiaroscuro, and pictorial effect. Composition may be called the skeleton of a picture, and chiaroscuro the flesh in which that skeleton is clothed; but there is something beyond this. As the living body has a living soul, so has art; something that the French try to express by the phrase "*Je ne sais quoi;*" that indefinite something about which those who know least write most, because it is indefinite and intangible, and about which the ignorant world take rhapsody for knowledge. Who can penetrate into the dim regions of the unknown—teach the unteachable? Who can describe and reduce to lessons the "know not what?" Yet, without this indefinite,

intangible, hidden, unknown soul, a picture is but a scientific performance, and gives no more idea of nature than does a rag doll represent the life. "So, then," it may be said, "art comes by inspiration—comes by second nature." In its highest phases it perhaps does ; but, nevertheless, it comes by laws that it is possible to note, and which it is possible to teach. Those laws govern the forms which art takes, and a knowledge of those laws prepares the student for the higher inspiration.

It has been said, "The poet's born, not made ;" but Ben Jonson, with a higher and wider truth, and on an occasion when the first proposition may have been held to be true in a very eminent degree, in his address " To the memory of my beloved Mr. William Shakespeare," said—

> " For though the poet's matter Nature be,
> His *Art* doth give the fashion. And, that he,
> Who casts to write a living line, must sweat,
> (Such as thine are) and strike the second heat
> Upon the muse's anvil : turn the same,
> (And himself with it) that he thinks to frame ;
> Or for the laurel he may gain a scorn,
> *For a good poet's made as well as born*."

And so it is with the artist. Innate taste is not sufficient to make a painter or a photographer. As a poet has to learn the grammar of the language in which he writes, so must the artist learn the principles on which his work is based. If the student trust to that vague thing called taste, he trusts to a broken reed ; let him rather endeavour to acquire that more certain and profitable culture which comes from study and practice.

In conclusion, I cannot do better than impress upon my reader the absolute necessity, if he wish to become an artist, of incessant application, not only to study, but to the production of the results of study—pictures. To call yourself an artist before you have produced a picture is but to give yourself an empty name. To be an artist, it is necessary to do something more than take an occasional bad landscape or portrait in photography, or to paint a poor background, spoil a photograph with colour, or make crude sketches with the brush. Nothing beyond this can be done without hard work. The greatest compliment Michael Angelo ever paid Raphael— although it is doubtful if he thought so at the time—was, that Raphael did

not get so far by his genius as by his industry. This industry means nothing else than the success an artist seeks in the unwearied improvement of his work. Industry is not so much persevering activity or diligence in general as absorption in the one thing to be accomplished. The mark should be right before the student; the higher the better; ambition is a grand quality, so that it does not degenerate into egotism, and is more productive of good and great work than any other desire of man. Strike high, and do not believe in failure; work incessantly and rightly, and good work will be the result.

COMBINATION PRINTING.

COMBINATION PRINTING.

In some of the later chapters of this work I have introduced complicated groups of figures with landscape and other backgrounds, which, to those who are unacquainted with the scope of our art, may appear impossible in photography. My object in introducing engravings from paintings of complicated forms has not been to offer to photographers examples for exact imitation, but that it may be shown how immutable laws exist in all good works of art, whether that art is exemplified in the lowest subjects, or the highest; that the same laws of balance, contrast, unity, repetition, repose, and harmony are to be found in all good works, irrespective of subject; and that the arrangement of the general form of nearly all pictures in which true art is visible is based on the diagonal line and the pyramid. I have thought it of more consequence to fix these facts on the mind of the student than to set before him examples for imitation, however good, which he would have blindly to follow without understanding and without profit.

But the scope of photography is wider than those who have only taken a simple portrait or landscape suppose. There has not been a single group introduced into these lessons that could not have been reproduced from life by the means our art places at our disposal. I do not mean to assert that a subject containing so many difficulties as Goodall's "Swing" (Chapter XXXVII.), for instance, has ever been done in photography; but it is not so much the fault of the art, as of the artists, that such a picture has not been successfully attempted. It has not been the failing of the materials, unplastic as they are when compared with paint and pencils; it has been the absence of the requisite amount of skill in the

photographer in the use of them, that will account for the dearth of great works in photography. The means by which these pictures could have been accomplished is Combination Printing, a method which enables the photographer to represent objects in different planes in proper focus, to keep the true atmospheric and linear relation of varying distances, and by which a picture can be divided into separate portions for execution, the parts to be afterwards printed together on one paper, thus enabling the operator to devote all his attention to a single figure or sub-group at a time, so that if any part be imperfect from any cause, it can be substituted by another without the loss of the whole picture, as would be the case if taken at one operation. By thus devoting the attention to individual parts, independently of the others, much greater perfection can be obtained in details, such as the arrangement of draperies, refinement of pose, and expression.

The most simple form of combination printing, and the one most easy of accomplishment and most in use by photographers, is that by which a natural sky is added to a landscape. It is well known to all photographers that it is almost impossible to obtain a good and suitable sky to a landscape under ordinary circumstances. Natural skies are occasionally seen in stereoscopic slides and very small views, but I am now writing of pictures, and not of toys. It rarely happens that a sky quite suitable to the landscape occurs in the right place at the time it is taken, and, if it did, the exposure necessary for the view would be sufficient to quite obliterate the sky; and if this difficulty were obviated by any of the sun-shades, cloud-stops, or other inefficient dodges lately proposed, the movement of the clouds during the few seconds necessary for the landscape would quite alter the forms and light and shade, making what should be the sky—often sharp and crisp in effect—a mere smudge, without character or form. All these difficulties are got over by combination printing, the only objections being that a little more care and trouble are required, and some thought and knowledge demanded. The latter should be considered an advantage, for photographs, of a kind, are already too easy to produce. Of course, when a landscape is taken with a blank sky, and that blank is filled up with clouds from another negative, the result will depend, to a very great degree, upon the art knowledge of the photographer in selecting a suitable sky, as well

as upon his skill in overcoming the mechanical difficulties of the printing. It is not necessary here to enter into a description of the art aspect of the matter, as that has been discussed in a former portion of this work; so we will confine ourselves to the mechanical details.

The landscape negative must have a dense sky, or, if it be weak, or have any defects, it must be stopped out with black varnish. In this case it is better to apply the varnish to the back of the glass; by this means a softer edge is produced in printing than if painted on the varnished surface. With some subjects, such as those that have a tolerably level horizon, it is sufficient to cover over part of the sky while printing, leaving that part near the horizon gradated from the horizon into white.

I may here remark, that in applying black varnish to the back of a negative, occasions will often be found where a softened or vignetted edge is required for joining, where a vignette glass or cotton wool cannot be applied; in such cases, the edge of the varnish may be softened off, by dabbing slightly, before it is set, with the finger, or, if a broader and more delicately gradated edge be required, a dabber made with wash-leather may be employed with great effect.

When an impression is taken, the place where the sky ought to be, will, of course, be plain white paper; a negative of clouds is then placed in the printing-frame, and the landscape is laid down on it, so arranged that the sky will print on to the white paper in its proper place; the frame is then exposed to the light, and the landscape part of the picture is covered up with a mask edged with cotton wool. The sky is vignetted into the landscape, and it will be found that the slight lapping over of the vignetted edge of the sky negative will not be noticed in the finished print. There is another way of vignetting the sky into the landscape, which is, perhaps, better and more convenient. Instead of the mask edged with cotton wool, which requires moving occasionally, a curved piece of zinc or card-board is used. Here is a section of the arrangement. The straight line represents the sky negative, and the part where it joins the landscape is partly covered with the curved shade. Skies so treated must not, of course, be printed in sunlight.

It is sometimes necessary to take a panoramic view. This is usually

done, when the pantascopic camera is not employed, by mounting two prints together, so that the objects in the landscape shall coincide; but this is an awkward method of doing what could be much better accomplished by combination printing. The joining of the two prints is always disagreeably visible, and quite spoils the effect. To print the two halves of a landscape, taken on two plates, together, the following precautions must be observed: both negatives must be taken before the camera-stand is moved, the camera, which must be quite horizontal, pointing to one half of the scene for the first negative, and then turned to the remaining half of the view for the second negative. The two negatives should be obtained under exactly the same conditions of light, or they will not match; they should also be so taken that a margin of an inch and a-half or two inches is allowed to overlap each other; that is to say, about two inches of each negative must contain the same or centre portion of the scene. It is advisable, also, that they should be of the same density, but this is not of very great consequence, because any slight discrepancy in this respect can be allowed for in printing. In printing, vignette, with cotton wool, or a straight-edged vignette glass, the edge of the left hand negative on the side that is to join the other, taking care to cover up the part of the paper that will be required for the companion negative; when sufficiently printed, take the print out of the frame, and substitute the right-hand negative; lay down the print so that it exactly falls on the corresponding parts of the first part printed (this will be found less difficult, after a little practice, than it appears), and expose to the light, vignetting the edge of this negative, also, so that the vignetted part exactly falls on the softened edge of the impression already done. If great care be taken to print both plates exactly alike in depth, it will be impossible to discover the join in the finished print. If thought necessary, a sky may be added, as before described, or it may be gradated in the light, allowing the horizon to be lighter than the upper part of the sky.

Perhaps the greatest use to which combination printing is now put is in the production of portraits with natural landscape backgrounds. Many beautiful pictures, chiefly cabinets and cards, have been done in this way by several photographers. The easiest kind of figure for a

first attempt would be a three-quarter length of a lady, because you would then get rid of the foreground, and have to confine your attention to the upper part of the figure and the distance. Pictures of this kind have a very pleasing effect. In the figure negative, everything should be stopped out, with the exception of the figure, with black varnish; this should be done on the back of the glass when practicable, which produces a softer join; but for delicate parts—such as down the face—where the joins must be very close, and do not admit of anything approaching to vignetting, the varnish must be applied on the front. A much better effect than painting out the background of the figure negative is obtained by taking the figure with a white or very light screen behind it; this plan allows sufficient light to pass through the background to give an agreeable atmospheric tint to the distant landscape; and stopping out should only be resorted to when the background is too dark, or when stains or blemishes occur, that would injure the effect. An impression must now be taken which is not to be toned or fixed. Cut out the figure, and lay it, face downwards, on the landscape negative in the position you wish it to occupy in the finished print. It may be fixed in its position by gumming the corners near the lower edge of the plate. It is now ready for printing. It is usually found most convenient to print the figure negative first. When this has been done, the print must be laid down on the landscape negative so that the figure exactly covers the place prepared for it by the cut-out mask. When printed, the picture should be carefully examined, to see if the joins may be improved or made less visible. It will be found that, in many places, the effect can be improved and the junctions made more perfect, especially where a light comes against a dark—such as a distant landscape against the dark part of a dress—by tearing away the edge of the mask covering the dark, and supplying its place by touches of black varnish at the back of the negative; this, in printing, will cause the line to be less defined, and the edges to soften into each other. If the background of the figure negative has been painted out, the sky will be represented by white paper; and as white paper skies are neither natural nor pleasing, it will be advisable to sun it down.

If a full-length figure be desired, it will be necessary to photograph

the ground with the figure, as it is almost impossible to make the shadow of a figure match the ground on which it stands in any other way. This may be done either out of doors or in the studio. The figure taken out of doors would, perhaps, to the critical eye, have the most natural effect, but this cannot always be done, neither can it be, in many respects, done so well. The light is more unmanageable out of doors, and the difficulty arising from the effect of wind on the dress is very serious. A slip of natural foreground is easily made up in the studio; the error to be avoided is the making too much of it. The simpler a foreground is in this case, the better will be the effect.

The composition of a group should next engage the student's attention. In making a photograph of a large group, as many figures as possible should be obtained in each negative, and the position of the joins so contrived that they shall come in places where they will be least noticed, if seen at all. It will be found convenient to make a sketch in pencil or charcoal of the composition before the photograph is commenced. The technical working out of a large group is the same as for a single figure; it is, therefore, not necessary to repeat the details; but I give a reduced copy, by Mr. J. R. Johnson's new carbon process, of a large combination picture, entitled "Autumn," which I made some years ago, a description of the progress and planning of which may be of use to the student. I have chosen this picture because the junctions are more plainly visible, and, therefore, the manner more clear to the student, than in my recent productions.

A small rough sketch was first made of the idea, irrespective of any considerations of the possibility of its being carried out. Other small sketches were then made, modifying the subject to suit the figures available as models, and the scenery accessible, without very much going out of the way to find it. From these rough sketches a more elaborate sketch of the composition, pretty much as it stands, and of the same size, was made, the arrangement being divided so that the different portions may come on 15 by 12 plates, and that the junctions may come in unimportant places, easy to join, but not easy to be detected afterwards. The separate negatives were then taken. The picture is divided as

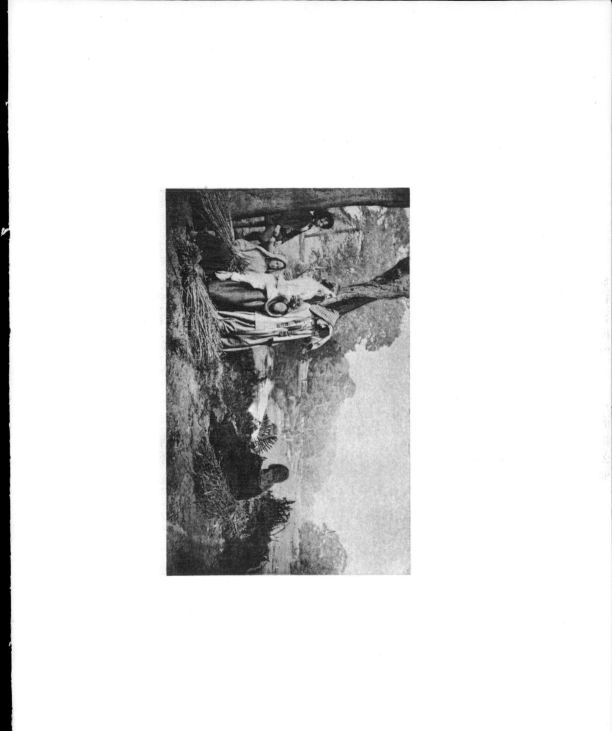

follows. The first negative taken includes the four figures to the left, the tree trunks, and stile, with the wheat sheafs and ground immediately under them. The join runs round the edges of the figures, and down the foreground, where it is rather clumsily vignetted into the next negative, consisting of the remaining figure and the rest of the foreground. The landscape is in two pieces, vignetted into each other just over the arm of the girl with the hand to her head, the only place where they come in contact.

At first sight, it will appear difficult to place the partly-printed pictures in the proper place on the corresponding negative. There are many ways of doing this, either of which may be chosen to suit the subject. Sometimes a needle may be run through some part of the print, the point being allowed to rest on the corresponding part of the second negative. The print will then fall in its place at that point. Some other point has then to be found at a distance from the first; this may be done by turning up the paper to any known mark on the negative, and allowing the print to fall upon it; if the two separate points fall on the right places, all the others must be correct. Another way of joining the prints from the separate negatives is by placing a candle or lamp under the glass of the printing-frame—practically, to use a glass table—and throwing a light through the negative and paper, the join can then be seen through. But the best method is to make register marks on the negatives. This is done in the following manner. We will suppose that we wish to print a figure with a landscape background from two negatives, the foreground having been taken with the figure. At the two bottom corners of the figure negative make two marks with black varnish, thus **L J** ; these, of course, will print white in the picture. A proof is now taken, and the outline of the figure cut out accurately. Where the foreground and background join, the paper may be torn across, and the edges afterwards vignetted with black varnish on the back of the negatives. This mark is now fitted in its place on the landscape negative. Another print is now taken of the figure negative, and the white corner marks cut away very accurately with a pair of scissors. The print is now carefully applied to the landscape negative, so that the mark entirely covers those parts of the print already

finished. The landscape is then printed in. Before, however, it is removed from the printing-frame, if, on partial examination, the joins appear to be perfect, two lead pencil or black varnish marks are made on the mark round the cut-out corners at the bottom of the print. After the first successful proof there is no need for any measurement or fitting to get the two parts of the picture to join perfectly; all that is necessary is, merely to cut out the little white marks, and fit the corners to the corresponding marks on the mask; and there is no need to look if the joins coincide at other places, because, if two points are right, it follows that all must be so. This method can be applied in a variety of ways to suit different circumstances.

There are one or two things to consider briefly before concluding this subject.

It is true that combination printing, allowing, as it does, much greater liberty to the photographer, and much greater facilities for representing the truth of nature, also admits, from these very facts, of a wide latitude for abuse; but the photographer must accept the conditions at his own peril. If he find that he is not sufficiently advanced in knowledge of art, and has not sufficient reverence for nature, to allow him to make use of these liberties, let him put on his fetters again, and confine himself to one plate. It is certain (and this I will put in italics, to impress it more strongly on the memory) that *a photograph produced by combination printing must be deeply studied in every particular, so that no departure from the truth of nature shall be discovered by the closest scrutiny.* No two things must occur in one picture that cannot happen in nature at the same time. If a sky is added to a landscape, the light must fall on the clouds and on the earth from the same source and in the same direction. This is a matter that should not be done by judgment alone, but by judgment guided by observation of nature. Effects are often seen, especially in cloud land, very puzzling to the calm reasoner when he sees them in a picture, but these are the effects that are often best worth preserving, and which should never be neglected, because it may possibly happen that somebody will not understand it, and therefore say it is false, and, arguing still further on the wrong track, will say that combination printing always produces falsehoods, and must be condemned. A short anecdote may perhaps be allowed here. A short time ago I sent a

photograph of a landscape and sky to a friend whose general judgment in art I admit to be excellent, but he knew that I sometimes employed combination printing. His reply was, " Thank you for the photograph; it is a most extraordinary effect; sensational, certainly, but very beautiful; but it shows, by what it is, what photography cannot do ; your sky does not match your landscape; it must have been taken at a different time of day, at another period of the year. A photograph is nothing if not true." Now it so happened that the landscape and sky were taken at the same time, the only difference being that the sky had a shorter exposure than the landscape, which was absolutely necessary to get the clouds at all, and does not affect the result. Another instance has arisen in my picture of " Autumn," which I have just been dissecting for the benefit of the student. Four of the figures, as I have explained, were taken on one plate, at one operation; yet a would-be critic some years ago wrote at some length to prove that these figures did not agree one with another; that the light fell on them from different quarters; that the perspective of each had different points of sight; and that each figure was taken from a different point of view. I mention these two cases to show that it is sometimes a knowledge of the means employed, rather than a knowledge of nature—a foregone conclusion that the thing must be wrong, rather than a conviction, from observation, that it is not right—that influences the judgment of those who are not strong enough to say, " This thing is right," or " This thing is wrong, no matter by what means it may have been produced."